B7836

MONA LISA

Also by Roy McMullen

Art, Affluence, and Alienation: The Fine Arts Today
The World of Marc Chagall
Victorian Outsider: A Biography of J. A. M. Whistler

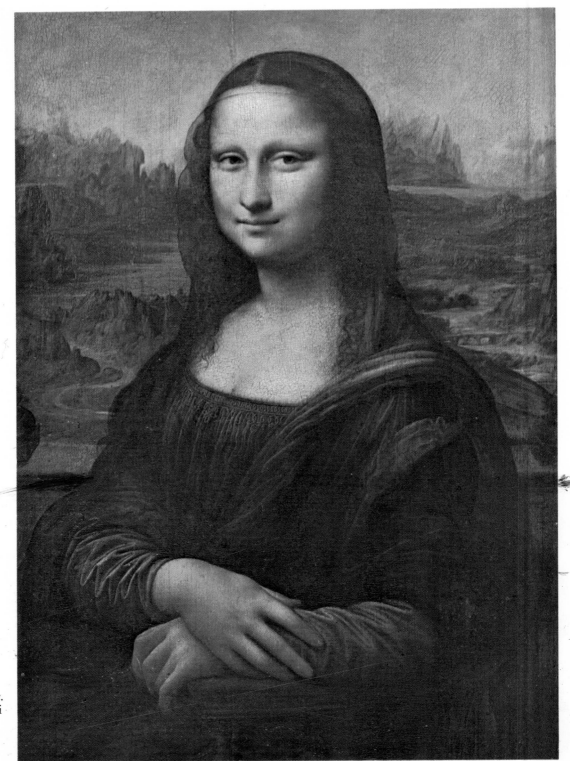

Mona Lisa.
Leonardo Da Vinci

ROY McMULLEN

MONA LISA

THE PICTURE
AND THE MYTH

M

SBN: 333 19169 2

First published 1975 in the United States by
Houghton Mifflin Company, Boston.

Published 1976 in the UK by
MACMILLAN LONDON LTD
London and Basingstoke
Associated companies in New York
Dublin Melbourne Johannesburg and Delhi

Printed in the United States of America

PREFACE

Much of this book is a compilation, intended for the general reader and viewer, of material selected from the sources listed in the notes and the bibliography. For invaluable assistance in the compiling I am grateful to the personnel of the Study and Documentation Service at the Louvre and to Jacques Foucart, director of the service and curator in the museum's department of paintings.

For help in the gathering of the illustrations I want to thank particularly the staff of Arts Graphiques de la Cité in Paris. The Leonardo drawings from the collection in the Royal Library, Windsor Castle, are reproduced by gracious permission of Her Majesty Queen Elizabeth II.

Paris, 1975 R. M.

CONTENTS

A LEONARDO CHRONOLOGY

1452 April 15. Birth at Vinci, a village near Prato.
1469–76 In Verrocchio's studio in Florence.
1472–75 Uffizi *Annunciation. Ginevra Benci.*
1475–78 *Benois Madonna.*
1478 *Madonna with the Carnation.* Louvre *Annunciation.*
1480–81 *St. Jerome. Adoration of the Magi.*
1482–99 In Milan, with Lodovico Sforza as patron.
1483 Louvre *Virgin of the Rocks.*
1484 At work on equestrian statue of Lodovico's father.
1485 *Lady with an Ermine.* Notebooks under way.
1490 *Musician.*
1493 Model of horse for Sforza statue exhibited.
1497 *The Last Supper. La Belle Ferronière.*
1498 *Virgin and Child with St. Anne and St. John.*

1499 Sforza period ended by French capture of Milan.

1500 In Mantua, Venice, and Florence.

1502 In the Romagna as engineer for Cesare Borgia.

1503–06 In Florence. *Battle of Anghiari* and *Mona Lisa* begun.

1506–13 In Milan, with Louis XII as indirect patron.

1506–08 London *Virgin of the Rocks*.

1510 *Virgin and Child and St. Anne.*

1513–16 *St. John the Baptist.*

1513–16 In Rome, with Giuliano de' Medici as patron.

1517–19 In France, with Francis I as patron.

1519 May 2. Death at manor of Cloux, near Amboise.

Note. Many of the above dates, in particular those given to paintings, are only approximate.

MONA LISA

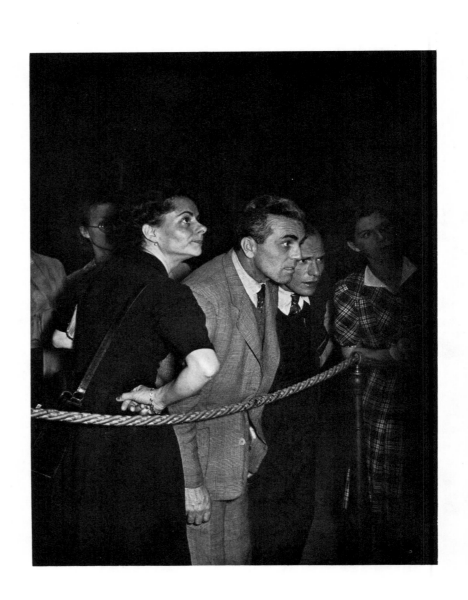

I

A QUESTION

THE *Mona Lisa* is without doubt the most famous work in the entire forty-thousand-year history of the visual arts. It provokes instant shocks of recognition on every continent from Asia to America, reduces the Venus of Milo and the Sistine Chapel to the level of merely local marvels, sells as many postcards as a tropical resort, and stimulates as many amateur detectives as an unsolved international murder mystery. Moreover, it has been famous for a remarkably long, almost uninterrupted period. When it was still in Leonardo's studio in Florence, and very probably not yet finished, it was already inspiring imitations. By the middle of the sixteenth century it was being pronounced divine rather than human in its perfection; by the middle of the nineteenth it was a goal for pilgrimages and the object of a cult that mixed romantic religiosity with eroticism and rhetoric. It is decidedly not just a painting like other paint-

ings; it might be better described, on the basis of the record, as a cross between a universal fetish and a Hollywood-era film star.

All this raises a question. How should a modern viewer, someone who is not given to irrational or extravagant reverence, respond to such a peculiarly celebrated masterpiece? Several sorts of answer, none of them recommendable, can be mentioned as evidence that the question is genuinely bothersome, even alarming, to many people. One sort was manifested at the Louvre on December 30, 1956, by a bearded young Bolivian named Ugo Ungaza Villegas: he stared morosely at the picture for a moment and then threw a rock at it, damaging a speck of pigment near the subject's left elbow. Another sort was proposed in 1963 by Theodore Rousseau, curator of paintings at the Metropolitan Museum of Art, in the midst of the critical uproar and traffic jams that greeted the arrival of the picture in New York. "To enjoy the *Mona Lisa*," he wrote, "a man of the twentieth century must be capable of putting out of his mind everything that he has ever read about it." Somewhere between countercultural violence and antiliterary feigned ignorance can be situated the answers of careful scholars who try to see the work as simply a Renaissance portrait, stripped of its accumulation of anachronistic interpretation, and those of cautious sophisticates, anxious to avoid admiring the overly admired, who usually say, "It's not really his best picture, you know." (Perhaps it isn't, but it is certainly his most effective.)

The answer proposed in this book will be that to enjoy the *Mona Lisa* properly a man of the twentieth century should have well in mind both the picture and the myth — the premise being the ancient one, never successfully challenged in spite of many attempts by avant-garde artists and theorists, that what we know about a work of art is as much a part of it as what we see. By "the picture" will be meant the *Mona Lisa* in conjecturally its

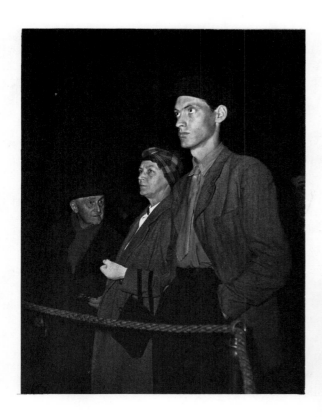

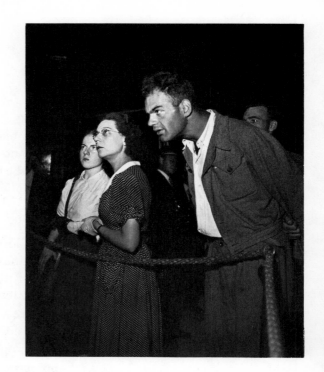

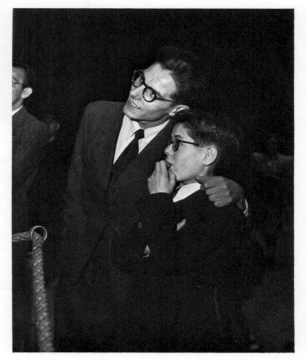

1. Three studies of Mona Lisa
viewers at the Louvre in 1952

original state, context, and significance: in other words, the painting as it could have been, although not necessarily was, viewed and interpreted by Leonardo himself or by one of his close, knowledgeable contemporaries. By "the myth" will be meant the second mode of existence the work has had in millions of lively imaginations all over the world during the last four and a half centuries, a mode marked by variation and extension of the original picture and also by idolatry, perversion, crankiness, crime, loathing, yearning, exploitation, facetiousness, and the emanation of something that might be called mana. The first eight of the following chapters will be mostly about the picture, and the remaining seven mostly about the myth.

There can be nothing very rigorous, of course, in such a terminology and such a division of the subject, and there should be no implication of sweeping approval or disapproval. A fair appreciator is obliged to grant that a painting may have several legitimate modes of existence, that all the modes tend to merge in our actual experience of the work, and that one man's "myth" can be another man's "picture." Nevertheless, the two notions can serve as aids to discussing a formidably complex phenomenon, and they can also stir some thoughts as one walks through the Louvre to the wall where that arcane presence, protected by a stout railing, bulletproof glass, and conditioned air, quizzically accepts the never-ending homage of the crowd. There was a time, by no means primeval, when many art objects had their half-religious worshipers, their literary nimbuses, their extrapictorial or extrasculptural modes of existence — in short, their myths. For a good while now, as we have become at once more aesthetical and more matter of fact in our enjoyment, the myths have been fading; whole populations of museum Aphrodites, Madonnas, gods, saints, and heroes have been deprived of their mana and diminished to the category of mere pictures and

statues. Almost alone, the *Mona Lisa* has resisted, even reversed, the reductionist trend. It thus merits attention not only as a fine, puzzling picture and a thing of unique renown, but also as a splendid historical anomaly, a live coelacanth in our cultural aquarium.

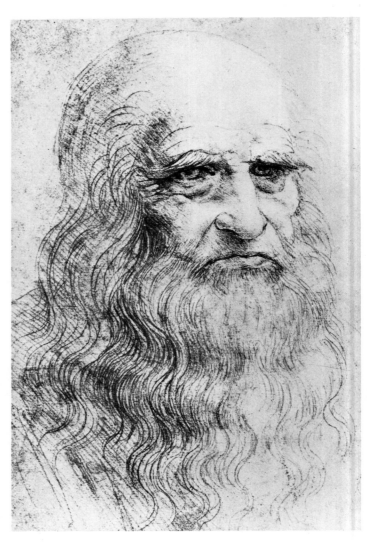

2. *Self-portrait.*
Leonardo

II

THE NEW PYTHAGORAS.

THE PICTURE would evidently be different if it had not been painted by Leonardo. Almost as evidently, it would be different if it were merely not known to have been painted by him. For the qualities discoverable in the work have always been inseparable from the strangeness and fascination of its creator and his period: behind the myth of the *Mona Lisa* there is a myth of the artist, and behind that a myth of the Italian Renaissance, and each myth reinforces the others. (It will be understood that the word "myth" is not being used here with any disparaging overtones, but simply and loosely in the sense of an enduring product of a collective imagination.)

Much of our earliest information on the subject comes from Giorgio Vasari's short biography, which was published in Florence in 1550, thirty-one years after Leonardo's death, and again in a revised edition in 1568, on both occasions as part of

the author's best-selling *Lives of the Most Excellent Painters, Sculptors, and Architects*. Not unexpectedly, the account opens with a paean:

> In the normal course of events many men and women are born with various remarkable qualities and talents; but occasionally, in a way that transcends nature, a single person is marvellously endowed by heaven with beauty, grace, and talent in such abundance that he leaves other men far behind, all his actions seem inspired, and indeed everything he does clearly comes from God rather than from human art. Everyone acknowledged that this was true of Leonardo da Vinci, an artist of outstanding physical beauty who displayed infinite grace in everything he did and who cultivated his genius so brilliantly that all problems he studied he solved with ease. He possessed great strength and dexterity; he was a man of regal spirit and tremendous breadth of mind . . .

The same praise comes more succinctly from the alert and chic Cecilia Gallerani (22), a Sforza mistress who knew Leonardo in Milan in the 1480s. "I don't think," she says in one of her letters, "that his equal can be found." Charles d'Amboise, the French governor of Milan, writing to the Florentine gonfalonier in 1506, stresses the range of the paragon's accomplishments:

> The sublime works of art which Master Leonardo da Vinci, your fellow-townsman, has left in Italy and especially in this city [probably a reference to the *Last Supper*] have disposed all who have seen them to love him . . . And it pleases us to admit to having been among those who loved him before knowing him. But after noting and valuing his qualities firsthand we see that actually his name, although famous in painting, has remained unsung, by comparison with the renown it deserves, in the other activities in which he has given proof of his ability.

The unknown Florentine writer who is referred to by art his-

torians as the Anonimo Gaddiano, and whose manuscript is datable to the late 1530s, sums up: "He was so rare and so universal that you can say he was a miracle of nature . . ." Clearly, we are dealing here with a recognized incarnation of the Renaissance idea of the artist as hero and all-around demiurge.

We are dealing, too, with the widely current Renaissance idea of the magus — the seer, the occultist, the old wise man — as hero. In a self-portrait (2) drawn when he was about sixty Leonardo might pass for a Chaldean wizard, or an Indian guru; and the impression of a carefully contrived, or at least complacently accepted effect is strengthened by a description of him recorded by the Anonimo Gaddiano:

> He had a good figure, well proportioned, graceful and elegant. He wore a rose-colored mantle that reached only his knees, at a time when long mantles were fashionable. He had a beautiful head of hair, curled and carefully combed, that fell to the middle of his chest.

Contrived or not, his appearance, combined with his known initiation into scientific lore and his magic as a painter, struck many mythicizing fancies. Around 1500 the humanist poet Giovanni Nesi placed him among "the seven sages" and ranked him, by geographical allusion, with Pythagoras:

> In carbon vidi gia con arte intera
> Imago veneranda del mio Vinci
> Che in Delo e in Creta e Samo me' non era . . .

> In charcoal I see drawn with complete art
> The worthy image of my dear Vinci
> Not inferior to that seen by Delos, Crete, and Samos . . .

In 1509 Raphael seems to have had the inventor of the *Mona*

Lisa in mind while painting the shaggy, visionary Plato (3) of the *School of Athens;* and a decade or so later the popular Milanese master Bernardino Luini depicted the personage as Heraclitus. As late as the last quarter of the sixteenth century the influential Lombard art theorist Giovanni Paolo Lomazzo was still evoking that majestic head and the conviction that it "truly suggested the nobility of knowledge, as once did Hermes Trismegistus and the antique Prometheus."

The career of the artist is easy to summarize, for it falls into neat periods marked by important journeys and a sadly small number of important works (see the chronology on page viii). He was born in 1452 at or very near Vinci, an undistinguished village between Florence and Pistoia; according to local records he was the illegitimate son of a woman named Caterina and of Ser Piero da Vinci, who eventually became a Florentine notary. After some preliminary middle-class Tuscan schooling — commercial arithmetic and a good deal of Dante — he entered Verrocchio's workshop as an apprentice, and he continued to work in Florence until he was nearly thirty. Strongly characteristic of this early period are such paintings as the *Ginevra Benci*, which prefigures the psychological subtlety of the *Mona Lisa*, and the unfinished *Adoration of the Magi*. Sometime around 1482 he went to Milan and entered the service of Lodovico Sforza as, among other things, painter, sculptor, architect, musician, and engineer; during the next seventeen years he produced notably the Louvre version of the *Virgin of the Rocks*, the first sections of his notebooks, the *Last Supper*, the cartoon for the *Virgin and Child with St. Anne and St. John,* and the clay model, destroyed before it could be cast, of the giant horse intended to become part of a statue honoring Lodovico's father. Forced out of Milan in 1499 by the French occupation of the city, he wandered to Mantua and Venice, functioned for a while as a

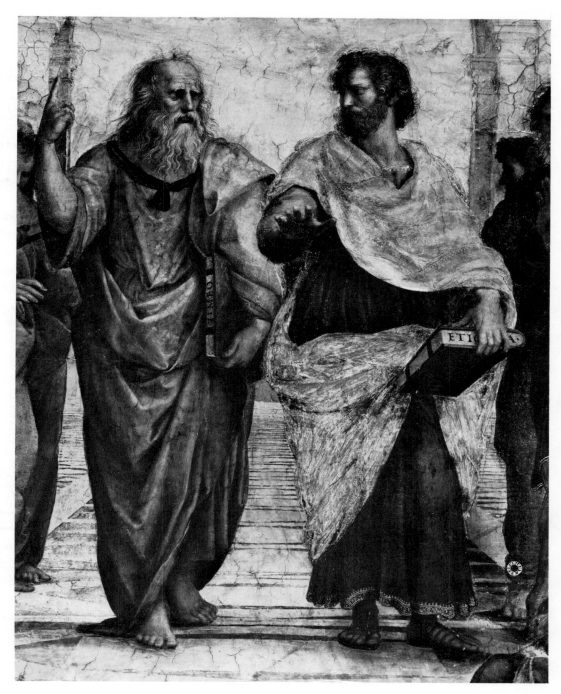

3. Plato and Aristotle in *The School of Athens*. Detail. Raphael

military engineer for the bloodthirsty Cesare Borgia, and then returned to Florence, where he worked on the *Mona Lisa* (for more about the date of the picture, see the following chapter) and the eventually destroyed *Battle of Anghiari*. From 1506 to 1513 he was in Milan again, this time in the service of the French governor and thus indirectly of King Louis XII; from these years the important productions are the London (National Gallery) version of the *Virgin of the Rocks*, apparently executed with the help of studio assistants, and the *Virgin and Child and St. Anne*. His final masterpiece is the *St. John the Baptist*, painted probably between 1513 and 1516 when he was in Rome working for Giuliano de' Medici. After that he accepted the patronage of King Francis I and retired to France for the last three years of his life.

Even from such a brief summary one can conclude that being a demiurge and the new Pythagoras did not mean being unworldly in any of the usual ways. In fact, unlike the average painter trained in fifteenth-century republican Florence, Leonardo was very much a court artist and something of an aristocratic aesthete. We are told by a younger contemporary, Paolo Giovio, that at Milan he was "the arbiter of all questions relating to beauty and elegance, especially in pageantry," and that he "sang beautifully to his own accompaniment on the lyre to the delight of the entire court." Among his drawings and notes there are enough projects for masquerades and scenic allegories to suggest that they constituted his principal activity for long periods — and also that he greatly enjoyed devoting his immense talent to such frivolities. He could flatter ducal or royal favorites with the skill of the practiced courtier and the light irony of the socially secure; in the preserved draft of a letter he addresses Cecilia Gallerani familiarly as "my dearest Goddess," *amantissima mia Diva*. Although his notebooks reveal that he was often

short of money, he managed to live much of the time as if he himself were a great lord, and not merely the gifted son of a notary. "He owned, one might say, nothing," Vasari remarks, "and he worked very little, yet he always kept servants as well as horses." In Milan his residence was at the Corte Vecchia, near the cathedral, in the same building as the apartments of Isabella of Aragon. In his second Florentine period, while he was working on the *Battle of Anghiari*, he was provided with the papal hall in the convent of Santa Maria Novella. At Rome he was installed in the Belvedere of the Vatican, in rooms specially prepared for him by Giuliano de' Medici. The ambassadorial style in which he was inclined to travel is indicated by a decree, signed by Cesare Borgia at Pavia in 1502, which orders all governors of castles to welcome "our highly esteemed engineer Leonardo" and supply proper facilities for him "and his suite."

The worldliness was accompanied, however, by spells of fierce misanthropy, by unabashed political cynicism, and quite frequently by an emotional distancing of ordinary human concerns, a view from Sirius. Although grotesque heads are not uncommon in Renaissance pictures, those drawn by Leonardo (4) have a special sort of depravity and ugly inanity, and their

4. *Grotesque Heads.* Leonardo

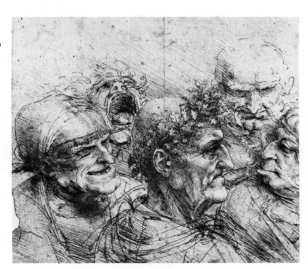

implications are confirmed by a comment in the notebooks: "Some there are who are nothing else than a passage for food and augmentors of excrement and fillers of privies . . ." Although he lived in an age of turncoats, the cool celerity with which he switched his loyalty from Sforza to Borgia to Florence to Louis XII to the Medici and finally to Francis I remains disturbing. And although he had many benefactors and good friends, from his teacher Verrocchio to such illustrious contemporaries as Bramante, Machiavelli, and Piero di Cosimo, there is nothing in his mass of manuscripts that suggests his feelings for them. Nor is there a hint of normal family affection. His mother is never mentioned, and his father is the subject of a particularly striking piece of distancing:

> On the 9th of July 1504, Wednesday, at seven o'clock, died Ser Piero da Vinci, notary at the Palazzo del Podestà, my father — at seven o'clock, being eighty years old, leaving behind ten sons and two daughters.

The note ends there, with no sign of filial sentiment.

This strong contempt for ordinary people, this amoral behavior, and this astral remoteness can be explained partly, of course, as consequences of his awareness of his godlike superiority. There are no symptoms of false modesty in the granite face that juts out above the beard of the new Pythagoras. But the notebooks reveal that he was by no means a monster of self-esteem, and it must be remembered that he had other reasons besides his genius for feeling isolated from normal men. He was a certified bastard, he was almost certainly homosexual, and he was left-handed (which is not the anticlimax it may seem).

While there were stock jokes and some legal disadvantages attached to bastardy in Renaissance Italy, there was almost no stigma. On the contrary, it was apt to be regarded in advanced circles as evidence of *virtù*, of personal rather than inherited

merit. After all, many important people were bastards. Cesare Borgia, like all papal children, was one; so had been the great condottiere Francesco Sforza, Lodovico's father. Leon Battista Alberti, an impressive early example of the all-around Florentine artist and thinker, had boasted of the glorious fact that he was born out of wedlock. Filippino Lippi was more Florentine proof of the quality that could be associated with the natural status. And the illegitimacy of Leonardo was accompanied by early circumstances that must have made it for him, even in his maturity, a particularly emphatic reminder of his singularity. His mother, who was probably a maidservant, had married a local peasant shortly after her adventure with Ser Piero da Vinci, and the boy when very young had been taken into the home of his grandparents and his father, first in his native village and then in Florence. There he had remained an only child, obviously bright, evidently cherished, throughout his formative period, for his father, in spite of a series of marriages, had not had any other children until more than twenty years later.

Although the homosexuality cannot be proved absolutely, nearly all the signs point in one direction. Leonardo never married, and never, so far as is known, experienced even the beginning of a heterosexual love affair. Women are rarely mentioned in his writings, and their presence in his paintings can usually, if not quite always, be explained in terms of a commission or of traditional iconography. They are outnumbered in his drawings and private scribbling by pretty boys, masculine legs and buttocks, and prominent male organs. The notebooks contain a passage that can be interpreted as evidence of a repugnance for conventional sexual intercourse:

> The act of copulation, and the members involved in it, are of
> a hideousness such that if it were not for the beautiful faces

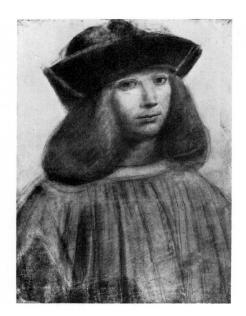

5. *Francesco Melzi*. Giovanni Antonio Boltraffio

6. *Salai*. Leonardo

and ornaments of the actors, and their modesty, nature would lose the human species.

In Florence in 1476, when he was twenty-four and still working in Verrocchio's shop, he was on two occasions the object of anonymous accusations of sodomy; he was finally freed by a magistrate on the condition that there must be no more accusations. Many years later, probably in Rome around 1514, he may have faced the blackmail that has often been the lot of homosexuals, for in the draft of a letter he refers to an unnamed enemy who "wishes to sow the usual scandals" and who "has menaced me that, having found means of denouncing me, he would deprive me of my benefactors." By that time his household, his regular "suite," consisted principally of four young men. One was a certain Lorenzo, who was a servant and perhaps also an apprentice; another was Il Fanfoia, a presumed disciple about whom almost nothing is known except his brassy name. The third was Francesco Melzi (5), a wealthy, cultivated, sweet-faced youth who had a fine villa on the banks of the Adda near Milan, some talent as a painter, and above all a capacity for unfaltering devotion; it is largely to him that we owe the preservation of Leonardo's writings and sketches. The fourth was another Lombard painter, Gian Giacomo Caprotti (6), who is usually referred to by his nickname "Salai" ("Devil") and who, it can be safely assumed, is the curly-headed, sensual-looking, rather stupidly handsome Apollo who often appears in Leonardo's drawings, sometimes in contrast with an old man (7) whom one can imagine as a retired Roman general, or perhaps a character from Petronius. Salai had entered the household in 1490 at the age of ten, and his behavior had earned him a scolding in the notebooks as "thief, liar, obstinate, glutton." The behavior had not, however, kept Leonardo

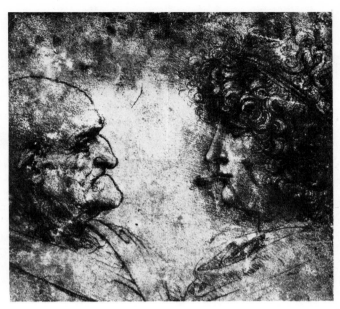

7. *Old Man and Youth.*
Leonardo

from bestowing a steady flow of affection and money on the adolescent and then the grown charmer. Down through the years the manuscripts speak of florins for Salai, of shirts and pourpoints for Salai, of "three gold ducats which he said he wanted for a pair of rose-colored hose with their trimming," of scudi "to Salai to make up his sister's dowry," of Salai, Salai, Salai.

Memories, gossip, and speculation concerning this long infatuation persisted in Italy for at least a generation after Leonardo's death. The hero-worshiping Vasari limits himself to mentioning Salai as "a very attractive youth of unusual grace and looks, with very beautiful hair which he wore curled in ringlets and which delighted his master." But the less respectful Lomazzo, in a dialogue of the dead written around 1560, imagines Leonardo as getting together somewhere with Phidias, presumably because the latter was a sympathetic Greek, and discussing the matter with complete candor:

Leonardo: . . . Salai, whom in life I loved more than all the others, who were several.

Phidias: Did you perhaps play with him the game in the behind that Florentines love so much?

Leonardo: And how many times! Have in mind that he was a most beautiful young man, especially at about fifteen.

Phidias: Are you not ashamed to say this?

Leonardo: Why ashamed? There is no matter of more praise than this among people of merit. And this is the truth I shall prove to you with very good reasons . . .

The painter continues with the classical argument that homosexual love is of a higher order than the heterosexual kind, which is needed merely for the production of offspring, and he winds up with a patriotic peroration:

Besides this, all Tuscany has set store by this embellishment and especially the savants in Florence, my homeland, whence, by such practices as fleeing the volubility of women, there have issued forth so many rare spirits in the arts . . .

Although this labored and relatively late pleasantry should not be taken too seriously, one can suppose that Lomazzo, who knew many people in Milanese artistic circles, was not relying entirely on his malicious imagination.

The documentation on the left-handedness is much more direct. Although there is a confusing sixteenth-century report that the artist merely suffered from a paralysis of his right hand toward the close of his career, other early sources, with support from modern analysis of the autographic evidence, indicate that he always wrote, sketched, and painted with his left; and it seems likely that he did so naturally. In any event, the important mystery is not the left-handedness as such, but what might

be called its excessiveness. Whereas, for instance, the average left-handed person, forced to cope with what is for him a looking-glass world, may occasionally lapse into transposing the letters of a short word, and read *top* for *pot*, Leonardo went to the extreme of writing nearly all of the some five thousand surviving pages of his notebooks in a right-to-left script (8) that is the mirror image of normal Western handwriting. And we can only speculate about his reasons for doing so. A few scraps of his correspondence and some place names on his maps reveal that when easy legibility was essential he was quite capable, like other left-handed people, of writing from left to right. The reversed script cannot have been intended by him as a kind of cipher, for the fact that it is reversed is perfectly obvious — and easily surmountable with a little practice. Perhaps, although there are only hints of corroboration for the idea in his pictures, notes, and known optical experiments, he shared to an abnormal degree

9. *Church.* Leonardo

the delight of many Renaissance painters, from Jan van Eyck forward, in the magic of reflections. Perhaps, too, although there is no warrant for such guessing in strictly scientific psychology, the delight should be associated with his homosexuality, his left-handedness, and his artistic temperament as part of a general inclination to reverse, to mirror, the asymmetry of the average masculine mind and nervous system. Probably, to take the mirror notion a little more literally, the writing can be called a symptom of a basic narcissism, which can be linked to his emotional remoteness, his misanthropy, and his general solitariness. "While you are alone," he remarks in some notes addressed to young painters, "you are entirely your own, and if you have one companion you are but half your own . . ." The prose style of the manuscripts can suggest on a first reading, especially in translation and in print, anything except a private voice: it is by turns elevated, oratorical, sententious, scholastic, poetical, and colloquial; and often it recalls the polite debating manner of the conversational jousts fashionable in courtly Renaissance society — the style of Baldassare Castiglione's *Book of the Courtier.* But on the original pages a number of devices work with the reversed script to pull the variety together and create a single tone. There is no conventional punctuation; instead there are bar lines like those used in musical notation, and many dots that serve to separate words, not to end sentences. Sometimes the dots appear after each of the words in a relatively long passage, as if to indicate a staccato, hammering delivery. Frequently the words are fused into purely phonetic units; *le forme di tutti* (the forms of everything), for example, is written, with the letters themselves reversed, as *ittutid emrofel.* The final, somewhat unsettling effect is of a lonely man talking furiously to himself, half out loud, in front of a glass that mirrors both himself and his discourse.

10. *Flowers.* Leonardo

After the handwriting, the most surprising thing about the manuscripts for an unprepared peruser is apt to be the extremely mixed content (9–13). Fierce warriors, rearing horses, and melancholy old men appear on a sketch sheet that is also used for studies of machinery and the angel of the Annunciation. Comments on the structure of the intestines jostle theories of poetry. A typical page of notes, written about the time, or perhaps a little before, the *Mona Lisa* was being conceived, reads in part as follows:

> Concave mirrors; philosophy of Aristotle; the books from Venice; Italian and Latin vocabulary; Bohemian knives; Vitruvius; Messer Ottaviano Palavicino for his Vitruvius; go every Saturday to the hot bath where you will see naked men . . . Inflate the lungs of a pig and observe whether they increase in width and in length, or in width diminishing in length . . . Horace has written on the movements of the heavens . . .

11. *Heart.* Leonardo

12. *Horseman.* Leonardo

13. *Crossbow.*
Leonardo

Elsewhere one encounters complicated riddles, detailed projects for alarming practical jokes, a grandiose idea for bringing snow to a summer festival, an abrupt memorandum on a possible model for pictures: "Giovannina has a fantastic face, is at Santa Caterina, at the hospital." Flowers, animals, human anatomy, architecture, and weaponry are among the objects of the same ardent curiosity. So is the ancient realm of the tall tale told deadpan; a summary of "news of things here in the East" tells of a giant from the Libyan desert who lived "in the sea on whales, grampuses, and ships" until he was temporarily captured after slipping on bloody mud; and a bestiary derived partly from Pliny includes the spectacular wild ox of Paeonia:

> . . . its horns are in a way bent inwards so that it cannot butt; hence it has no safety but in flight, in which it flings out its excrement to a distance of four hundred braccia in its course, and this burns like fire wherever it touches.

Scattered through the miscellany, like islands in a sea of litter, are vivid patches of coherence; an account of an alpine incident,

for instance, which may or may not have actually occurred, can be read as a parable on the situation of the inquiring scientist in a dangerous universe:

> Unable to resist my eager desire and wanting to see the great multitude of the various and strange shapes made by formative nature, and having wandered some distance among gloomy rocks, I came to the entrance of a great cavern . . . I rested my tired head on my knee and held my right hand over my downcast and contracted eyebrows, often bending first one way and then the other, to see whether I could discover anything inside, and this being forbidden by the deep darkness within, and after having remained there some time, two contrary emotions arose in me, fear and desire — fear of the threatening dark cavern, desire to see whether there were any marvelous thing within it . . .

Sometimes the islands merge into amorphous continents. There are quite long sections on geology, paleontology, astronomy, optics, mathematics, and hydraulics; and the observations on painting are substantial enough to have been assembled, after the artist's death and with the addition of material copied in the sixteenth century from notes subsequently lost, into a so-called treatise, the *Trattato della Pittura*.

From the whole mass of papers there emerges the ghost of an arrogant, pathetic ambition to publish an organon embracing each of the major arts and sciences, with the possible exception of literature. But everything was constantly being ruined by confusion and procrastination; and in the meantime even Renaissance people were being dismayed by the bad effect of such all-out all-aroundness on the production of pictures. Castiglione, writing in 1508, obviously had Leonardo in mind while providing a character in *The Book of the Courtier* with a complaint that (in the Elizabethan translation)

one of the chiefest painters in the worlde, neglecting his arte wherein he was very excellent, hath applied himself to learn Philosophy, wherein he hath such straunge conceits and monstrous fansies, that withall the [art of] painting he hath he can not paint them.

In 1502 the redoubtably persistent Isabella d'Este, after trying in vain for two years to obtain a picture for her collection at Mantua, was obliged to swallow a report from her harassed agent in Florence that the artist's "mathematical experiments have so distracted him from painting that the sight of a brush puts him out of temper." Leonardo himself seems to have had frequent and anguished misgivings, especially in the latter part of his career, about his scattered energy and his tendency to undertake a multitude of great enterprises while finishing very few. "Tell me," he writes over and over again, with the insistence of a wail, "if anything was ever done" — tell me, tell me, *di mi, di mi.* At one point he warns himself, in a minuscule hand that suggests a whisper, against his search for omniscience: "We ought not to desire the impossible." On his deathbed he confessed bitterly, according to Vasari, "that he had offended God and mankind by not working at his art as he should have done."

In view of the scientific reputation he would acquire in the late nineteenth century, after the publication of the bulk of the manuscripts, were his misgivings and the complaints of his art-loving contemporaries really justified? Today it is difficult not to feel that they were, at least to a considerable extent. There was indeed something monstrous about his thirst for miscellaneous knowledge, and something Faustian about the high price he was willing to pay for satisfying it. Although his nonartistic achievements are admittedly impressive, uninformed astonishment has exaggerated their value; the fact is that the history of science and technology would be about what it is if he had never

lived. And we would unhesitatingly trade all his "straunge conceits," all his half-medieval compilations, all his new-Pythagorean posturing, all his wilder speculation, all his ingenious, unworkable inventions, for only one more picture from that gifted left hand. Nevertheless, his paintings cannot be fully appreciated without some reference to his nonartistic work, just as they cannot be fully appreciated without some reference to his solitariness, homosexuality, mirror aspects, and much else. His passion for anatomy, botany, optics, and mathematics, although finally pure and disinterested, was initially related in a practical way to his art; and a good deal of the culture displayed in the notebooks was a continuation of the education he had picked up as an apprentice in Verrocchio's workshop, where everything from Annunications and portrait busts to jewelry and architectural ornaments was turned out, and where the intellectual atmosphere appears to have been unusually bracing even for fifteenth-century Florence. Also, throughout his life there was a constant exchange of influences between the scientific researcher and the essentially romantic painter who coexisted beneath the flowing beard and the rose-colored mantle. The researcher tended to transform paintings, the *Mona Lisa* included, into instruments of inquiry — devices for probing the mystery of consciousness and for peering into the "threatening dark cavern" of the universe "to see whether there were any marvelous thing within it." At the same time the romantic painter tended to transform scientific disciplines into vehicles for philosophy and art; under his influence geology, for instance, became partly a meditation on temporality, and the study of human anatomy became a way of arranging facial muscles into an enigmatic smile.

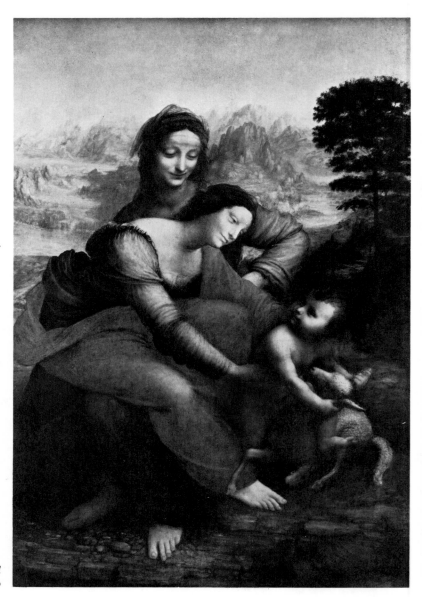

14. *Virgin and Child and
St. Anne.* Leonardo

III

SOME DATES

ALTHOUGH THE *Mona Lisa* seems to have been well known in several parts of Europe by the second quarter of the sixteenth century, anyone who sets out to discover exactly when it was executed soon finds himself confronted by a surprising, troubling scarcity of solid evidence. The panel is unsigned and undated. There are no traces of a commission, no records of payment, and no recognizable allusions to the work in the fairly abundant Italian correspondence of the early 1500s. Leonardo does not mention even the project in his notebooks, and while we have from him many hundreds of drawings, far more than from any roughly contemporary Renaissance master, there is nothing that has been convincingly interpreted as a preliminary study for the painting.

The most significant hint concerning the date comes, not from Leonardo, but from Raphael. The latter is known to have ar-

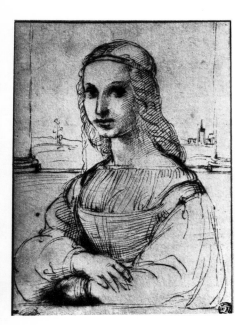

15. *Florentine Portrait.* Raphael

rived in Florence from Umbria late in 1504, at the age of twenty-one, and to have worked in the city intermittently until around 1508, when he moved on to Rome and to the opportunities offered by the decoration of the Vatican. While he was in Florence he did what young provincial painters, prodigies included, have always done in international art centers: he absorbed influences, and he did so with unusual enthusiasm because of the eclectic nature of his talent. Prominent among the influences was that of Leonardo, who had just reestablished himself in the Tuscan capital and rejoined the local painters' guild after an absence of about twenty years; and among the results is a series of Florentine portraits by Raphael that are clearly related to the *Mona Lisa*. A good example is a drawing (15) that has been dated as early as 1504. The sitter has a mousy look of recent puberty that cannot be compared with the superb maturity of Leonardo's personage, and the sketchy, matter-of-fact landscape, or cityscape, has none of the older artist's suggestion of a cosmic drama. But the composition of the drawing as a whole, the three-quarter pose, the loggia, the crossed hands, and even such a detail as the right sleeve are all derivative beyond any reasonable doubt. So are the columns of the loggia, for numerous ancient copies and variations of the *Mona Lisa* reveal that the shafts were once as visible in the painting as they are in the drawing, before some obtusely procrustean framer, perhaps at Fontainebleau early in the seventeenth century, cropped a few inches from the right and left sides of Leonardo's panel.

The implications of Raphael's borrowing are supported by some in Vasari's biography. Here the *Mona Lisa*, although not precisely dated, is described at length in the middle of an account of what Leonardo did during his second residence in Florence — during the period, that is, when Raphael was frequently in the city. Vasari cannot always be trusted, of course,

and his narrative sequences can be misleading; just before describing the *Mona Lisa* he tucks in a mention of the portrait of Ginevra Benci, which was certainly painted about thirty years earlier. But when he is not contradicted by other authorities there is no reason to scorn him. As a Florentine painter and architect he was professionally interested in local artistic events, and he did much of his research in the 1540s, at a time when many people who had known Leonardo well were still alive.

Putting the implications of the Raphael drawing and those of Vasari's narrative together, many historians have concluded that the *Mona Lisa* was painted in Florence sometime around 1503, about five years after the charcoal cartoon for the *Virgin and Child with St. Anne and St. John* (16) and about seven before

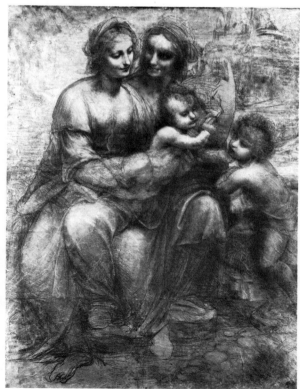

16. *Virgin and Child with St. Anne and St. John.* Leonardo

the oil *Virgin and Child and St. Anne* (14). There are nagging objections, however, to such a neat solution. For one thing, Vasari blurs his order of events by remarking that Leonardo "worked on this painting for four years, and then left it still unfinished" — which is certainly not its present state. For another, an attentive look at the picture, in particular at the free handling of the mountains in the distant background and at the subtle gradations of tone from light to dark in the face and hands, can suggest a stage in the painter's stylistic evolution much later than 1503 and quite close to, perhaps even after, the period of the oil *Virgin and Child and St. Anne.* Finally, there is a disrupting fragment of information that seems to have come straight from the mouth of Leonardo himself, while he was living out his last, largely unproductive years in the manor of Cloux, near the chateau of Amboise, under the solicitous patronage of Francis I. On October 10, 1517, the artist was visited by Cardinal Louis of Aragon, whose secretary, Antonio de' Beatis, took notes on the fact, among other interesting details, that they were shown three pictures. Two of these are easily identifiable from the brief descriptions as the *St. John the Baptist* and the *Virgin and Child and St. Anne,* both of which after Leonardo's death found their way from Cloux into the French royal collection and eventually into the Louvre. The third, de' Beatis says, was a portrait of "a certain Florentine lady done from the life at the request (*ad instantia*) of the late Magnificent, Giuliano de' Medici." Was this, as seems extremely likely, the *Mona Lisa,* which also found its way into the royal collection? If it was, and if the phrase *ad instantia* was not the result of a misunderstanding by de' Beatis, the idea that the picture was painted in about 1503 becomes awkward to defend. For on the available evidence Giuliano de' Medici cannot be shown to have been Leonardo's patron before the latter part of 1513, when the artist

decided to try his luck in Rome at the court of Pope Leo X, Giuliano's older brother.

A few scholars, relying partly on de' Beatis and partly on their feelings about Leonardo's stylistic evolution, have decided that the picture must have been painted in Rome sometime after 1513 and before 1516, when Giuliano de' Medici died and the painter left for France. Others, ignoring de' Beatis and leaning heavily on stylistic considerations, have come out for Milan and sometime after 1506, when the painter returned to the city after his second Florentine period. If, however, we accept such non-Tuscan locations and such relatively late dates as referring to the beginning of the work, we are plainly in trouble with the believers in Florence and 1503. We are forced to suppose that Vasari did not know at all what he was talking about, and that the close resemblance of the *Mona Lisa* to Raphael's drawing of 1504 and his other Florentine portraits is either an uncanny accident, or an illusion, or somehow, to be even more fantastical, a consequence of the middle-aged Leonardo's having been influenced by the young man from Urbino.

An obviously more reasonable, although rather neglected, solution for the problem is simply to assume that the *Mona Lisa* was a very long while under way. Such an assumption reconciles much of the seemingly conflicting evidence, both external and internal; and it also takes into account the artist's notorious dilatoriness. What Raphael saw and partly copied when he arrived in Florence in 1504 may have been merely a preparatory study, or at most a charcoal cartoon of the sort brilliantly represented by the surviving *Virgin and Child with St. Anne and St. John*. The painting advanced slowly, we can suppose, until about 1506, when Leonardo took it with him on leaving Florence for Milan; this supposition can explain Vasari's mistaken impression, derived perhaps from an elderly Florentine informant, of a

permanently unfinished state after four years of progress. (Vasari himself could never have seen the picture, for it was at Cloux by 1517, when he was only six years old and still living in his native Arezzo, and he never visited France.) Probably mostly in Milan after 1506 and possibly, although not so probably, in Rome after 1513, Leonardo recovered his resolution sufficiently to finish the work in a series of magnificent fits and starts; this can explain the conviction of many good judges that the style is much later than the date of 1503 implied by Raphael's derivative drawing. These guesses leave us, to be sure, still with the difficulty raised by the testimony of de' Beatis. We cannot avoid assuming that, at some unknown period and in some unknown way, there was a connection between the *Mona Lisa* and Giuliano de' Medici. Perhaps, although there is not a shred of evidence to support such a view, a connection existed as early as 1503. Perhaps — and this seems a slightly better interpretation of what Leonardo presumably said on that October day in Touraine — the picture was simply finished in Rome at the request or insistence, *ad instantia*, of Giuliano. In any event, it certainly was not commissioned by him at that time, for it was already, in one form or another, at least ten years old.

This decade of 1503–1513 in Italy is worth pausing over in order to imagine the *Mona Lisa* in its original historical context. Florence (17) had recovered from the political, emotional, and cultural shocks provoked by the expulsion of the Medici, by the appearance of a powerful French army in Tuscany, and by the hysterical rise and flaming fall of Savonarola. The new government, with honest Piero Soderini as a permanent gonfalonier, or chief executive, was able to maintain at least a semblance of re-

17. *Florence.* Sixteenth century

publican stability until 1512, when the Medici, accompanied by the familiar partisan yell of *palle, palle* (from the balls on their coat of arms) and by the hideous efficiency of Spanish infantry, reinstalled the disguised, profitable dictatorship the family had exercised in the time of Lorenzo the Magnificent. In 1504 the city fathers still had enough of the old spirit to commission the *Battle of Anghiari* from Leonardo and the *Battle of Cascina* from Michelangelo as mural decorations for the Sala del Gran Consiglio in the Palazzo Vecchio. (Both battles had been early, very local affairs, but Florentine victories.) At about the same mo-

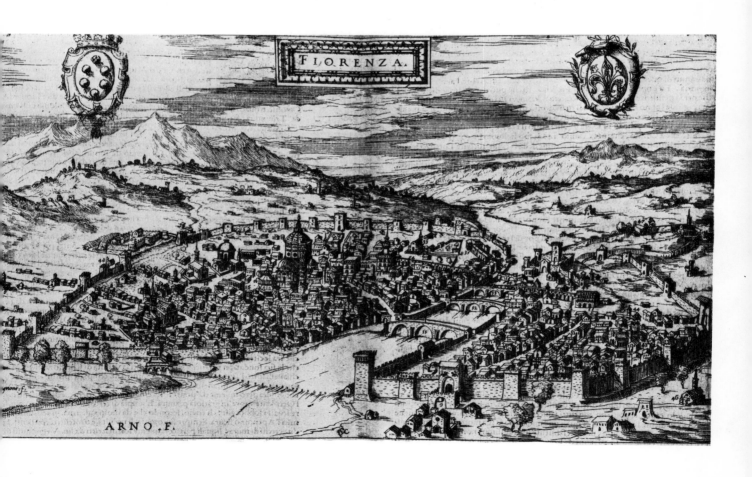

ment a committee of artists, among them Leonardo, was deliberating on the proper public place for Michelangelo's recently completed *David*, a statue intended, in Vasari's words, "to show that the city should be boldly defended and righteously governed." During these years Fra Bartolommeo, functioning as the head of the workshop in the convent of San Marco, a position once held by Fra Angelico, was turning out his soberly original variations on the Madonna-with-saints theme; and the eccentric Piero di Cosimo was painting his disturbing fantasies. In brief, it would be a mistake to suppose that Florence by this period had lost its artistic energy. Yet there must have been a chill in the atmosphere, and a growing fear of being deserted. Domenico Ghirlandaio, Piero della Francesca, Benozzo Gozzoli, and Piero and Antonio Pollaiuolo had died in rapid succession during the 1490s. Luca Signorelli had gone to Orvieto in 1499. Filippino Lippi died in 1504, and Perugino retired to Perugia in 1506. By 1508 Michelangelo, Leonardo, and Raphael had left the city. Alone with his memories of the bright summer of the quattrocento, passably neurotic and hopelessly out of fashion, Botticelli survived obscurely until 1510. The *Battle of Anghiari* was then a never-to-be-completed fragment and the *Battle of Cascina* a never-to-be-executed cartoon.

Milan (18), too, had suffered some traumatizing shocks. Louis XII of France had annexed the duchy in 1499 after a military campaign marked by more than the usual Renaissance treachery and bestiality, and had bundled the reigning if scarcely legitimate duke, Lodovico Sforza, Il Moro, off to die in a dungeon in the Loire valley. The capital's formerly insouciant, extravagant court, where Leonardo had been a dazzling performer for so many years, had been replaced by a more businesslike administration headed by the French governor Charles d'Amboise. There had been a long period of torment under the army of

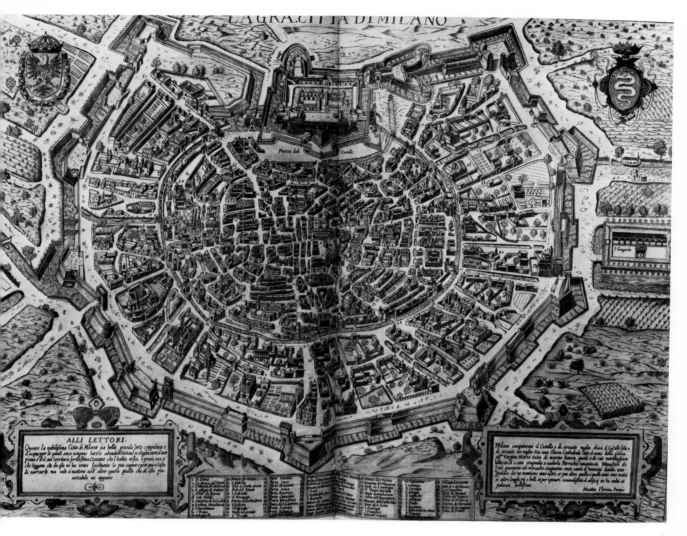

18. *Milan*

occupation, and then a period of famine and plague. The cowed, exhausted Milanese had finally resigned themselves, however, to a colonial status, and when Leonardo returned in 1506, presumably with the *Mona Lisa* in his luggage, the city was in

the midst of a relative tranquillity that was to last until 1512, when the French were driven out. The visual arts seem to have been getting along, if not exactly flourishing. Among the estimable older local painters were Vincenzo Foppa, who combined a fondness for Venetian light and color with hints from Flanders and Bramante, and Ambrogio Bergognone, who liked gentle religiousness and wan landscapes. But what there was of a Milanese, or Lombard, stylistic tradition was on the whole too weak and regional to avoid being broken and submerged by the exotic influence of Leonardo. An entire generation of artists, among whom the young Luini would prove the most successful, was imitating, standardizing, and sentimentalizing the Florentine master's pyramidal compositions, rounded forms, seductive smokiness, and ambiguous smiles.

During the decade in question Rome (19) was in an advanced stage of the process of transforming itself from a medieval backwater into a formidable temporal power and the art capital of Europe. Julius II, the warrior pope elected at the conclave of 1503, was recovering the grip of the papacy on Perugia, Bologna, Faenza, Rimini, Parma, and Piacenza and at the same time maneuvering successfully to drive the French "barbarians" from the Peninsula. If he was not dashing out to give battle at the head of his troops, he was apt to be busying himself with aesthetic triumphs. When the Laocoon was dug up, in 1506 in a vineyard near the baths of Trajan, it was brought to the Vatican along roads strewn with flowers. That same year the foundation stone of the new St. Peter's was laid. By 1508 Michelangelo was painting the ceiling of the Sistine Chapel; by the following year Raphael was at work on his *School of Athens* fresco in the Stanza della Segnatura, one of the rooms in the suite intended as papal offices. By 1513, when Julius II died and the energetic dilettante Giovanni de' Medici became pope as Leo X, half of the

more talented painters, sculptors, and architects in Italy had be-
gun to innovate for the Holy See. To ride down from Milan to
Rome that fall, as Leonardo and his bevy of young men did, was
to move from the charm, pageantry, naturalism, humanism, in-
genuousness, and frequent gaucherie of the fifteenth century
into the serenity, classical harmony, and technical confidence of
the first part of the sixteenth — from the Early Renaissance into
the High Renaissance.

19. *Rome.* 1549

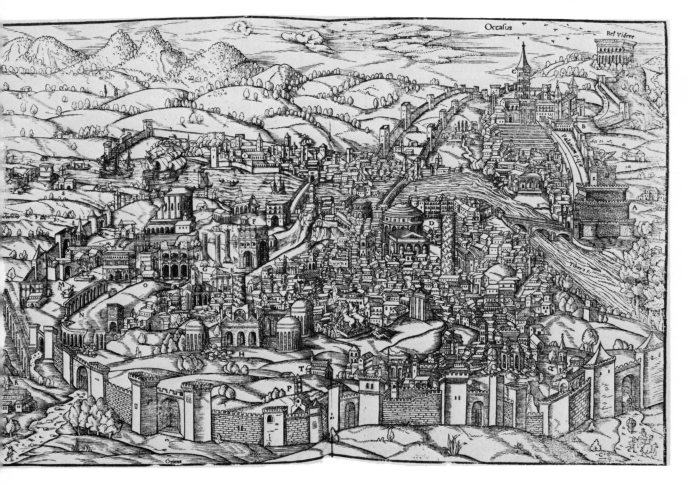

It would be foolish to try to draw an explanation of the *Mona Lisa* from a scattered sampling of its moment and milieu. But the picture would certainly be quite different, and possibly less puzzling, if it had been painted in a decade of old hierarchies and antecedent certitudes instead of in one of political and cultural transition.

IV

A CERTAIN LADY

WHO WAS the original owner of the most celebrated version of the enigmatic smile? The earliest answer is the not very helpful one that was picked up by de' Beatis at the manor of Cloux in 1517: she was merely a "certain Florentine lady," a *certa donna fiorentina*. After that there is silence on the subject until 1550 and the ebullient Vasari, whose answer is reassuringly, anecdotally specific:

> For Francesco del Giocondo Leonardo undertook to execute the portrait of his wife, Mona Lisa. He worked on this painting for four years, and then left it still unfinished; and today it is in the possession of King Francis of France, at Fontainebleau . . . Altogether this picture was painted in a manner to make the most confident artist — no matter who — despair and lose heart. Leonardo also made use of this device: while he was painting Mona Lisa, who was a very beautiful

woman, he employed singers and musicians or jesters to keep her full of merriment and so chase away the melancholy that painters usually give to portraits.

"As a result," the account concludes, "in this painting of Leonardo's there was a smile so pleasing that it seemed divine rather than human; and those who saw it were amazed to find that it was as alive as the original."

Parish registers and other public records have yielded a few facts about the Mona — from *madonna*, madam — Lisa in question and a bit more about her father and her husband. She was born in 1479 and would thus have been about twenty-four when Leonardo began the picture. Her birthplace was in Florence in the Via Maggio, on the left bank of the Arno beyond the Ponte Santa Trinita; as a child she could have watched the masons who were putting the final classicizing touches to Brunelleschi's nearby church of Santo Spirito. Her father was a Florentine notable named Antonio Maria di Noldo Gherardini; although a gentleman, he seems to have been far from wealthy, for in a note to the tax authorities in 1480 he states that he cannot provide his baby daughter with a dowry. Somehow this grave handicap was overcome or ignored (did a smile help?) during the following years, and Lisa was married in 1495, when she was sixteen, to Francesco di Bartolomeo di Zanobi del Giocondo, who was twice a widower and nineteen years her senior. She then crossed the Arno and settled down in a house in the parish of Santa Maria Novella, where she supposedly lived until the unknown date of her death. The Giocondo family had become rich in the silk trade, and Francesco was prudent or supple enough to remain a leading citizen throughout the political and economic crises that marked the close of the fifteenth century and the beginning of the sixteenth. In 1499 he was one of the Buonomini,

the twelve "goodmen" who functioned as an important advisory group in the Florentine republic, and in 1510 he was one of the eight priors in the Signoria, the principal governmental body. He was also, it appears, a pious man and to some extent a patron of the arts, for he is recorded as having commissioned a *St. Francis Receiving the Stigmata.* The painter was Domenico Puligo, one of Ghirlandaio's numerous pupils.

None of these facts is inconsistent with Vasari's story, and so it is not surprising that the painting should have finally become habitually referred to in English-speaking countries as the *Mona Lisa,* in Italy as *La Gioconda,* and in France as *La Joconde.* But habit is not proof, and it is strange that a Florentine biographer who had never seen the picture should have been, so far as we can tell, the only person of his time who was privy to the secret of the identity of the sitter. Why did Leonardo, in his conversation with de' Beatis and Cardinal Louis of Aragon, fail to mention Lisa and Francesco del Giocondo? Why did he refer instead to Giuliano de' Medici? Why did sixteenth-century inventories at Fontainebleau list the work as simply a picture of *une courtizene in voil de gaze,* a courtesan in a gauze veil? Why did the well-informed Francesco Melzi, who remained in France for a while after his master's death, fail to straighten out the title with the keeper of the French royal collection? Even more odd than these symptoms of unawareness or unconcern is the single partly relevant reference to the Giocondo family that does occur in the first half of the century, for in this the Anonimo Gaddiano says that Leonardo painted a portrait of Francesco, not of Lisa. The passage has been interpreted, by people who believe that the sitter was really Lisa, as merely a slip on the part of the Anonimo, and the interpretation is strengthened by the lack of any trace of a portrait of Francesco del Giocondo by Leonardo. But it is thoroughly possible that it was Vasari who

made the slip, for he is known to have used the Anonimo's manuscript as a source in writing the *Lives*.

Stimulated by the weakness of the evidence in favor of Lisa del Giocondo, art historians have produced a sizable literature in support of other candidates for the honor of having been the sitter. There have been flurries of interest in Isabella d'Este, for example, largely because of fairly ample documentation on her relations with Leonardo. After leaving French-occupied Milan in 1499 he visited her court at Mantua, and while there he found time to do two portrait sketches of her in charcoal. One of these he took with him when he left, and in Venice a few weeks later he showed it to an acquaintance who wrote to Isabella praising its lifelike quality. The other drawing seems to have remained in Mantua until the spring of 1501, when the marchioness, understandably irritated, informed her agent in Florence that her husband, Francesco Gonzaga, had just made a gift of it to somebody. At this point the artist may have tried to placate her by executing a third version, which may be the somewhat battered cartoon (20) that has survived. She was not, however, at all placated; in 1504 she was still reminding Leonardo that he had promised her a painted portrait. Did he finally yield to her mixture of flattering appeals and imperious demands? Was the result the painting that is now mistakenly called the *Mona Lisa*? Those who say yes can point to the obstinacy of Isabella, to the beginning of the work at about the time of her series of demands, and to the fact that in 1504 she was thirty years old, an age that fits the painted evidence perhaps a little better than Lisa's. Those — the majority of scholars — who say no can point to the lack of conclusive documents and above all to the surviving cartoon. That it represents Isabella has been demonstrated by comparisons with contemporary portrait medals, and that it is by Leonardo has been generally granted, in spite of the

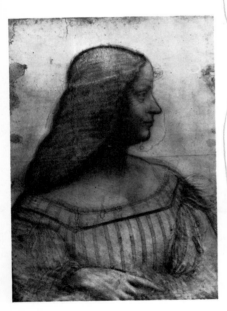

20. *Isabella d'Este.* Leonardo

reworked state and the botched right arm. But an unprejudiced viewer, even if he imagines the pose turned from the profile, would not be apt to think that this straightforward virago was the oblique creature who sat for the *Mona Lisa.*

There has been support also, especially among Italian students of the picture, for the candidacy of Costanza d'Avalos, Duchess of Francavilla. On the basis of part of the record she and her entourage can seem anything but Leonardesque, for she was the widow of the warlike Federico del Balzo, the sister of the warlike Innico d'Avalos, and the aunt of the warlike Marquis of Pescara, the condottiere who defeated and captured Francis I at Pavia in 1525. She herself was a talented military leader; in 1503, during Louis XII's attack on Naples, she took over her dead brother's post as governor of Ischia and became a heroine to Italian patriots by successfully defending the island against French warships. She was primarily, however, a Renaissance grande dame of the Isabella d'Este variety; she moved in intellectual circles that included Vittoria Colonna, the future object of Michelangelo's platonic affection, and she made her tiny court on Ischia a center that, with the help of sunshine and the landscape, was attractive to painters and men of letters. Among the latter, from about 1505 on into the following decade, was Enea Irpino, a minor but graceful poet from Parma who wrote sonnets and other short pieces in the Petrarchan manner, with Costanza in the role of Laura. Six of his poems celebrate a portrait of his beloved which he attributes, either directly or by implication, to Leonardo. In one passage we are given to understand that "my Vinci" painted her in her widow's costume, "under the beautiful black veil," *sotto il bel negro velo.* In another Irpino is intoxicated with admiration and love as he contemplates the picture. "This," he writes, "is my lady alive," *questa è Madonna, viva,* and he continues with an enumeration:

questa è la bella bocca, onde parole
Amor si dolce e si soave forma.
 Questi son gli occhi, colmi d'alto zelo;
questo il bel collo e 'l petto, ove già finse
la propria immensa sua bellezza il cielo.
 Quel bon pittor egregio, che dipinse
tanta beltà sotto il pudico velo
superò l'arte e sè medesmo vinse.

this is the lovely mouth, where words
so sweet and gentle are formed by Love.
 These are the eyes, brimming with noble zeal;
this the lovely neck and breast, where is figured
by heaven its own immeasurable beauty.
 That good and famous painter, who depicts
so much beauty under the modest veil,
overcomes art and vanquishes himself.

Although the emphatic *vinse* could be simply a convenient rhyme, it is more probably a reference to the name of the "good and famous painter," for the play on Vinci and *vincere*, to vanquish, occurs elsewhere in sixteenth-century Italian verse. Also, although the description of the picture is largely conventional, the details, in particular the reference to the veil, fit quite well the so-called *Mona Lisa*. Add that no other painting by Leonardo which might represent Costanza d'Avalos has been discovered, and the conclusion can seem to follow automatically. There are, however, some hard questions to be faced. Was Costanza, who was born in 1460, young enough in appearance to have been the sitter for the *Mona Lisa* more than forty years later? How did a painting, or a preliminary study for one, which undoubtedly influenced Raphael in Florence around 1504, happen to be available shortly afterward, apparently in a finished state, for Irpino's adoration on an island in the Gulf of Naples? Where and when could Costanza have sat for the por-

trait? There are some indications that she could have visited the Colonna family in Rome around 1502, but there is not much likelihood that Leonardo was in the city at that time. He may have been there two or three years later; the thin evidence is a record of his having paid a Florentine tax on a bundle of his clothes that arrived from Rome in 1505. Other records of his whereabouts, however, show that the trip, if it occurred, could not have been long enough for the execution of the painting now in the Louvre.

After Lisa, Isabella, and Costanza we are in the zone of wildly marginal candidates. Various French and Milanese wives and concubines have been put forward, all with unconvincing documentation. Returning to the annoying, indigestible testimony of de' Beatis, a few scholars have argued, without persuading many of their colleagues, that the sitter was a mistress of Giuliano de' Medici's, who supposedly got rid of the spellbinding, incriminating picture just before or after his marriage in 1515 to Philiberta of Savoy, a young aunt of Francis I's. Philiberta herself has been nominated. It has even been suggested, as part of a slanderous effort to put together all the sections of the puzzle, that Mona Lisa was the mistress involved. How she managed to cuckold Francesco del Giocondo, where she could have slept with Giuliano during the long exile of the Medici from Florence, or how, if the liaison occurred in Rome after 1513, it could have inspired the painting or sketch that Raphael saw in 1504 — all this has been left unexplained. Floating in the confusion are possible clues that are too flimsy to lead to anything, and yet strong enough to make one wonder about the real significance of other possible clues. Lomazzo, for instance, refers in passing to the sitter as "Mona Lisa, a Neapolitan." The note-taking de' Beatis visited the chateau of Blois in 1517 the day after the conversation at the manor of Cloux and saw a picture of a Lombard woman which he

liked but thought "not quite as good as the portrait of Signora Gualanda." Is this to be read as a reference to the portrait by Leonardo of a certain Florentine lady and as a mishearing of "Gualanda" for "Gioconda"? If it is, then Isabella, Costanza, and their sister candidates are all out of the running. But the mysterious Signora Gualanda is finally too vaporous to support such speculation.

It is a little late to attempt to change the title of the *Mona Lisa*. In the minds of millions of visitors to the Louvre, along with perhaps a majority of art historians, Vasari has won the argument. Plainly, however, we do not know who the sitter was, and probably we shall never know. Almost as plainly, the artist did not care in the least about our knowing; indeed, it is not much of an exaggeration to say that he seems to have been quite willing to let us guess that there were several sitters. Isn't it about time, therefore, to drop the old, vexing, impossible quest and try a different strategy of appreciation? A number of twentieth-century scholars have thought so, and one of their most attractive, although not much developed, suggestions has been that the picture should not be regarded as a portrait in the strict sense of the term: not as a work, that is, which was ordered by a patron and intended by the painter as primarily a likeness of a real person. Instead it should be regarded as something Leonardo painted to please himself and to express a personal outlook. It is what he might have called a *finzione* — a feigning, a fiction, an invention. Hence, while there may have been one or more models, there was no sitter, properly speaking.

There is a lot to be said for the idea. Admittedly, not too much importance should be attached to the lack of a written commission and of recorded payments, for the documents could easily have been lost. Their absence, however, fits in meaningfully with the lack of a name for the supposed sitter, with the

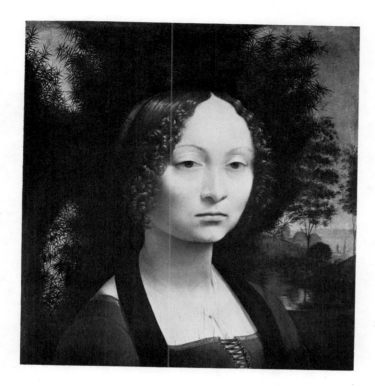

21. *Ginevra Benci.* Leonardo

lack of exactly contemporary allusions to the picture, with the long period of execution and its implication that there was no delivery date, and above all with the striking fact that Leonardo never did make delivery: instead of turning the work over to Francesco del Giocondo, Giuliano de' Medici, or some other supposed patron, he kept it with him in Florence, Milan, Rome, and France right up to the day of his death. Moreover, these implications of a private creation, a nonportrait, become stronger when we compare the *Mona Lisa* with the series of known portraits painted by him, or generally attributed to him. All have noticeable marks of specificity. The face of Ginevra Benci (21) glows against a background of juniper (*genevra* in

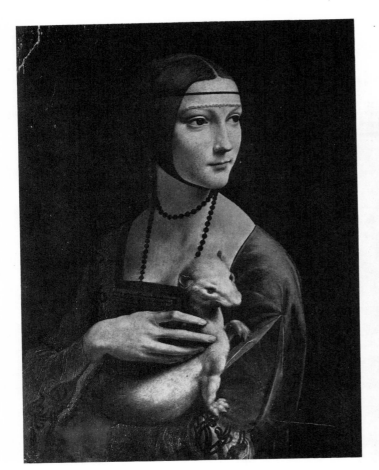

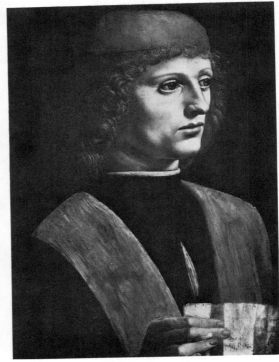

Romance dialects) foliage that evokes her name; and a sprig of juniper on the back of the panel transforms the work into a painted equivalent for one of Pisanello's portrait medals, with effigy on one side and emblem on the reverse. The young woman in the *Lady with an Ermine* (22) is identifiable as Cecilia Gallerani, Il Moro's mistress, because the ermine was one of her ducal lover's emblems and because the Greek word for the ani-

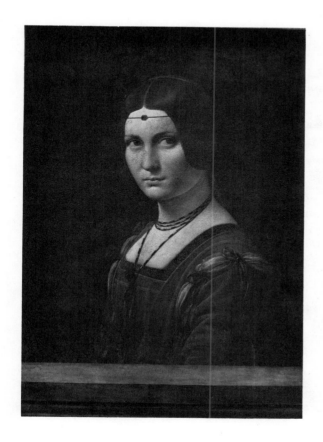

22. *Lady with an Ermine*. Leonardo

23. *Musician*. Leonardo

24. *La Belle Ferronière*. Leonardo

mal, *galé*, forms part of her name. In the *Musician* (23) the sitter is identifiable as a singer (and probably as Franchino Gaffurio, choirmaster in the Milan cathedral) by the score he holds. Ginevra has the curled hair and the laced bodice of a fashionable upper-class Florentine of the 1470s; Cecilia and the unknown woman in *La Belle Ferronière* (24) have the flat hair, the headbands, the doubled necklaces, and the ornate costumes

that were the mode, partly under Spanish influence, at the court of Milan in the late 1480s. In sharp contrast with all these naming, classing, and dating devices, the details of the *Mona Lisa* include no identifying emblem and no jewelry, and the hair and costume seem to have been deliberately neutralized so as to imply no particular place and no particular time.

The notion that painters might create according to their personal inspiration, as poets did, was relatively new at the beginning of the sixteenth century; and it was a long way from having the currency it would eventually have, after the breakup of the guilds and the decline of direct patronage in favor of the art market. Religious pictures were still being produced under contracts that specified the traditional details and colors that were wanted, and allegories were often painted according to programs that were supplied by the patrons or by their humanist friends. But freedom was in the air. The demand for naturalism that had appeared in the fifteenth century had loosened the constraints imposed by an iconography inherited from the Middle Ages. In Leonardo's generation the loosening was accelerated by the growing independence of artists as professional men, by the development of new conceptions of "genius" and the "fine" arts, and by an increasing desire for pictures and statues that were primarily works of beauty or samples of the creators' individual qualities and skills — of what contemporary Italians tended to sum up in the fashionable word *virtù*. By the early 1500s Giorgione was painting frescoes (now destroyed) in Venice in which, as Vasari would remark, "he thought only of demonstrating his technique as a painter by representing various figures according to his own fancy." Michelangelo was asked to sit down in the papal presence. When Isabella d'Este tried to impose a subject on Giovanni Bellini, she was rebuked by an advisor who reminded her that great artists liked to do their own

inventing. By the decade after Leonardo's death commissions from important patrons were sometimes merely polite, unspecific requests. In 1523 Michelangelo received one from Cardinal Grimani in Venice for a work "of which the choice of material and subject is yours, whether painting, or bronze, or marble — do whatever is most convenient to you." In 1524 Sebastiano del Piombo had one from Federigo Gonzaga for just anything at all, so long as it did not concern saints, and the painter replied with lordly vagueness that he would produce something "stupendous." Here, although the case is a bit exceptional, we are nearly in the modern era: the humble craftsman of medieval times has become a liberated maker and shaker.

Leonardo was an active participant and propagandist in this shift toward aesthetic liberty and this momentous change in the status of painters. In 1501, in a locale provided by the Servite friars in Florence, he staged what has been called the first one-man show since the exhibitions that were sometimes organized in ancient Athens; the work on view was a now lost cartoon representing the Virgin and Child with St. Anne, and Vasari says that "for two days it attracted to the room where it was exhibited a crowd of men and women, young and old, who flocked there, as if they were attending a great festival, to gaze in amazement at the marvels he had created." (We can wonder what would have happened if the picture had been the *Mona Lisa*.) The independent attitude the magus displayed toward aristocratic patrons sometimes verged on insolence, and even in its milder manifestations it would have been unthinkable in the Florentine workshops of the quattrocento. In Rome, to judge from the drafts of his letters to Giuliano de' Medici, he carried his idea of his status to the point of behaving occasionally like a miffed prima donna; at the manor of Cloux he seems to have proceeded on the premise that he was a genius in residence whose mere conversation was

sufficient return for a royal subsidy. That such behavior was deliberate is clear from long passages in the manuscripts in defense of the right of painting to be ranked among the liberal arts, as opposed to the manual, which were not considered proper occupations for gentlemen. Sometimes the argument is conducted at the level of an amateur debater trying to score points:

> If you, oh musician, say that painting is a mechanical art because it is performed with the use of hands, you must admit that music is performed with the mouth, which is also a human organ . . .

Sometimes, too, the effort is to rise by pulling fellow artists down. The typical Renaissance sculptor (probably Michelangelo, whom Leonardo detested) is described as a sweaty manual laborer and contrasted with the refined painter:

> The marble dust flours [the sculptor] all over so that he looks like a baker; his back is covered with a snowstorm of chips, and his house is made filthy by the flakes and dust of stone. The exact reverse is true of the painter . . . [who] sits before his work, perfectly at his ease and well dressed, and moves a very light brush dipped in delicate color; and he adorns himself with whatever clothes he pleases. His house is clean and filled with charming pictures; and often he is accompanied by music or by the reading of various and beautiful works . . .

The gist of the argument, however, is that painting is the product of imagination, knowledge, and reason, not just of manual skill. It is a "poetry which is seen," and it is also a semidivine yet thoroughly scientific method of re-creating and thus understanding reality:

> If you despise painting, which is the sole imitator of all

visible works of nature, you will certainly despise a subtle invention which brings philosophy and subtle speculation to the consideration of the nature of all forms . . . And truly this is a science and the legitimate issue of nature; for painting is born of nature — or, to speak more correctly, we shall call it the grandchild of nature; for all visible things were brought forth by nature, and these her children have given birth to painting. Hence we may justly call it the grandchild of nature and related to God.

It is easy to believe that the author of these lines was interested in something beyond a likeness of a Lisa, an Isabella, or a Costanza.

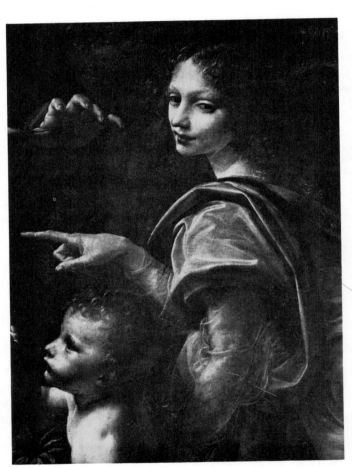

25. Angel, detail from
Virgin of the Rocks (Louvre
version). Leonardo

V

DIVINITIES, KNOTS, AND UNICORNS

To DISCARD the assumption that the *Mona Lisa* is primarily a portrait is not, of course, to conclude right away that the picture represents nobody in particular. Italian painters of the early sixteenth century, however much they may have relished their new freedom and their displays of *virtù*, were for the most part strangers to anything like art for art's sake and even to anything like a theory of nonliterary, purely painterly painting. In a Florentine, Milanese, or Roman studio between 1503 and 1513 a fully elaborated figure that was not a likeness of a living person was almost inevitably a depiction of a religious, mythological, legendary, or allegorical personage; and what can be called the readability of the personage was usually helped by suitable clothes and symbolic accessories. Does this art-historical context suggest anything about the figure in question?

It does. An innocent look at her — a look resolutely freed

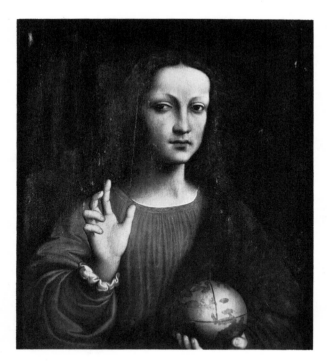

26. *Salvator Mundi.*
Follower of Leonardo

from preconceptions fostered by Vasari or by one of his portrait-minded successors — can lead to a theory that at some stage in the long process of her creation Leonardo intended her as a religious personage. A somewhat saintly effect is produced by the partly undone hair falling in little curls to the shoulders, by the lack of jewelry, by the simple, undatable dress, and especially by the transparent mantle (which may be a combination of two or three large veils of varying thickness) that is draped over the head, caught in the crook of the right arm, and thrown over the left shoulder in a Greco-Roman manner. Viewers with a minimum of experience with Renaissance religious pictures can easily imagine that her feet are bare, or shod in antique sandals. The whole timeless costume is in agreement with the general

rule for sacred imagery that was adopted in Italy toward the close of the fifteenth century, when painters became sensitive to anachronisms and to the need for what Leonardo called "decorum" — suitability in pictorial details. A similar attire, toga-on-the-shoulder effect included, appears on Mary in both the *Virgin and Child and St. Anne* (14) and the London cartoon (16), again on the figures in the *Last Supper* (65), on the angel in the *Virgin of the Rocks* (25), and on the Christ in a *Salvator Mundi* (26) that was painted by a follower after one of the master's projects or lost works. In fact, on much the same basis on which we can say that the *Mona Lisa* does not seem to belong in the series of Leonardesque portraits, we can say that it does seem to belong in the series of Leonardesque religious pictures. Moreover, the costume analogies can be multiplied by reference to the Madonnas, Apostles, Christs, and angels created by Raphael, Perugino, and other contemporaries, until what was initially just an impression begins to feel like a conviction.

There is a difficulty, however, as there nearly always is in a theory about the *Mona Lisa*. Which member of the Christian pantheon could Leonardo have had in mind? A recently discovered inventory of some of his manuscripts and drawings, made for a sale in 1614, lists a cartoon about two feet high, now lost, "in which is reproduced from a living model a lady saint shown from below the waist, in black chalk, with a perspective of buildings." Although the mention of the background suggests that the work could scarcely have been a preparation for the painting in the Louvre, the entry does show that the artist could have been thinking, perhaps around 1503, about a saint in the Lisa pose. He could also, of course, have been thinking about a representation of the Virgin Mary, in particular the relatively rare type of Annunciation (27), sometimes called an *Annunziata*, in which the angel Gabriel has departed and She is

27. *Annunciation.* Antonella da Messina

alone with Her book and the accomplished fact of Her holy pregnancy. But where is the attribute of the possible saint — the wheel of a Saint Catherine, or the miniature tower of a Saint Barbara, or the roses of a Saint Dorothy? And where is Mary's book? The complete absence of a traditional identifying accessory points to the conclusion that our putative non-Lisa, whatever she may have been for a moment in some lost early version, was not finally meant to be read as a Christian heroine.

Should she be read as a mythological or allegorical personage? The timeless togalike costume of an imaginary Greco-Roman antiquity was not invariably religious in its implications; it was also used, notably from about the time of Botticelli's humanist program pictures (28) forward, for countless Renaissance nymphs, goddesses, Virtues, and Vices. Moreover, there is evidence that Leonardo, although without a humanist education (he taught himself Latin when he was past forty), was interested in myths and allegories to a degree beyond the requirements of his work as a court artist in charge of masquerades and festivals. He carefully studied and frequently quoted Ovid, for example, in an Italian translation; and one of the books in his small personal library was Federico Frezzi's *Quadriregio*, an early fifteenth-century account of a trip to heaven through the realms of Venus, Satan, Vice, and Virtue. In the allegories he himself invented and sketched, often with accompanying notes, he exhibits a real passion for the transformation of an abstract idea into a visible form — for what he calls in one passage "a fiction that signifies." The same passion, allied with a liking for the sort of ancient female personage who was partly a divinity, partly a personification, and partly a seductive human being, may have once been quite perceptible in his paintings. Lomazzo, for instance, writing in 1590, mentions a since disappeared picture of a smiling Pomona, the old Roman goddess of fruit trees, which

28. *Tornabuoni Allegory*. Detail. Botticelli

29. *Colombine.*
Francesco Melzi (?)

Mona Lisa detectives would give a lot to be able to analyze, for it was painted for Francis I — hence late in Leonardo's career — and the figure was "covered on one side by three veils, which is a most difficult thing in this art." Another indication of the kind of thinking and experimenting that went on in the master's studio after his second Florentine period can be had from a popular work (at least four versions are extant in Europe) that may have been painted around 1510 by Melzi: the depicted woman (29) has the serenely chaste face of the Virgin of the London cartoon (16) and the exposed breast of a pagan fertility symbol, and the

other details are such that the title is variously given as *Colombine*, or *Flora*, or *Vanity*. (A Russian scholar has argued, very unsuccessfully, that a version in Leningrad is from the hand of Leonardo and that it, not the Louvre painting, is the portrait of Lisa del Giocondo.) All this provides reasonably good grounds for attempting a mythological or allegorical interpretation of the *Mona Lisa*, which was certainly under way, or perhaps finished, at about the same time. But again the difficulty is the absence of a specific clue to the intended meaning — an absence that can be illustrated both by the unsolved case of the visible knots and by the equally unsolved one of the invisible unicorn.

The knots are the looping cloverleaf patterns formed by the endless thread that embroiders the neckline of the dress (30). They are part of the only ornament on the costume, and we can be quite sure that they are not there by accident, that the model did not just happen to be wearing her knot-decorated outfit that day. Similar knots appear in dozens of places in the artist's manuscripts, sometimes as carefully elaborated arrangements and sometimes, perhaps more revealingly, as doodles. They decorate a sleeve in the controversial *Portrait of a Lady* (32), a picture that was probably not painted entirely by Leonardo but was almost certainly done under his inspiration. (The section in which his hand has been detected is, significantly, the dress.) They blossom into intricate rosettes in a series of engravings (31) designed by him and executed, according to plausible guesses, by somebody in his studio. They twine and snake their way through the foliage of the decoration he conceived for the ceiling of the Sala dalle Asse — the "hall of the boards," from the scaffolding that was once there — in the Sforza castle in Milan (33). There is written evidence, too, of their strange importance for him. In a list of his drawings, jotted down perhaps in Milan, he includes *molti disegni di gruppi*, "many designs

30. *Mona Lisa.* Detail

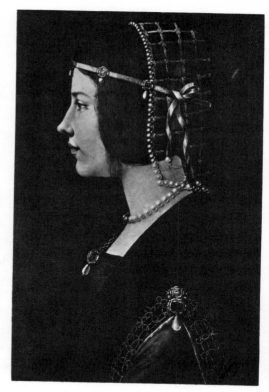

31. *Pattern of Knots*. Leonardo

32. *Portrait of a Lady*. Follower of Leonardo

33. Sala dalle Asse. Detail of decoration. Leonardo

for knots." Vasari mentions both a knot-making addiction and one of the resulting prints:

> He also spent a great deal of time in making a pattern of a series of knots, so arranged that the connecting thread can be traced from one end to the other and the complete design fills a round space. There exists a splendid engraving of one of these fine and intricate designs, with these words in the center: *Leonardus Vinci Academia.*

The number of possible sources for such interlacings is discouragingly immense. Something like them can be found occasionally, decorating a robe, a pedestal, or a tomb, in the work of Verrocchio, Perugino, and Filippino Lippi. They occur in sixteenth-century Venetian pattern books for embroiderers, on fifteenth-century damascened brass or bronze bowls, and as elements in fancy initials designed by a printer in the region of Lake Garda. They can be seen, in portraits painted shortly after Leonardo's death, on costumes worn by Isabella d'Este, Henry VIII, and notably Francis I (89). Looming behind each example are vast and venerable traditions of guilloche ornament — those of the Celts, for instance, and perhaps most relevantly those of Islam, which since the Middle Ages had been moving into Italy on plates, textiles, rugs, coins, arms, and jewelry. We cannot say which design first provoked the addiction of Leonardo, and if we could we might still be in the dark about his reason for putting the knots on the dress of a possibly allegorical personage. It has been suggested that they are secret signatures derived from *vincire*, to lace or to knot, and also that they were originally intended simply as decorative puzzles for basketry and other crafts, in which event there was supposedly a connection between Vinci and *vinco*, osier. Parallels have been found with the attributes of certain Indo-European gods, with a Buddhist

sign of longevity, and with knots used as ancient symbols of the hidden principles of things. Since no Leonardo "academy" can be shown to have existed, it has been thought that the engravings were something like tickets to scientific discussions. Another theory is that the knot-rosette pattern is an abstract map of the cosmos, and as such related to suggestions in Dante and in Neoplatonic doctrine. Still another is that it recalls the inlaid labyrinths found on many medieval church floors, often with an effigy of the architect at the center. Still another takes us back to the labyrinth built by Daedalus for King Minos of Crete, and here we can be reminded that Daedalus, like Leonardo, was interested in flying machines. Much of this freewheeling scholarly speculation is apt to be greeted by most viewers of the *Mona Lisa* with discreet consternation — and yet, once again, we can be sure that the knots are not on the dress by accident.

In the unicorn affair the background is less confused. By the beginning of the sixteenth century the beast was at the peak of its long career as a "fiction that signifies," and it had become a favorite motif for poets, moralists, engravers, painters, and tapestry designers. Leonardo, borrowing from a recently published Italian bestiary, incorporated into his notebooks a version of the basic fable about it, under the unexpected heading *Intemperanza:*

> The unicorn, through its intemperance and not knowing how to control itself, for the love it bears to fair maidens forgets its ferocity and wildness, and laying aside all fear it will go up to a seated damsel and go to sleep in her lap, and thus the hunters take it.

Among his several drawings of the animal are an illustration of the damsel episode (34) and a now almost indecipherable allegory (35) in which fantastic creatures are fighting in front of a figure who is holding a shield that seems to be functioning as a

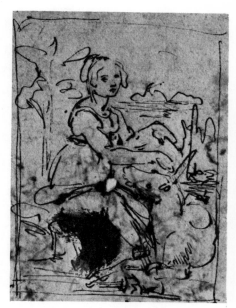

34. *Maiden with a Unicorn.* Leonardo

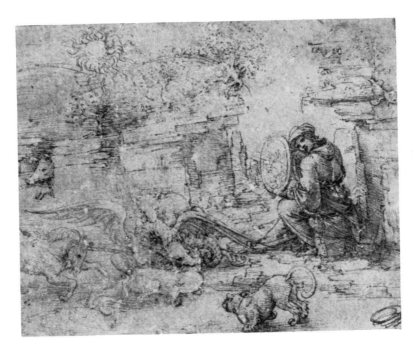

35. *Allegory.*
Leonardo

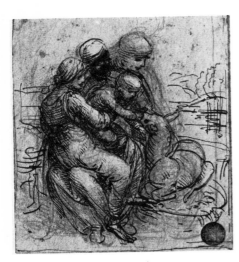

36. Study for *Virgin and Child and St. Anne.* Leonardo

burning glass. There were many other possibilities of visualization, however, for the unicorn was commonly used to signify such various things as courtly love, monastic solitude, sexual purity, and Christ the Lamb, and the story of the maiden and the hunt had been interpreted since medieval times as an allegory of the Annunciation, or more precisely the Incarnation, with Mary in the role of the maiden and the angel Gabriel in that of the hunter. That Leonardo had some of the Christian symbolism floating in his mind is implied by two bits of evidence: a study (36) for the *Virgin and Child and St. Anne* in which the Lamb is simply a hornless species of the unicorn in the drawing with the maiden and the fact that in the notebook bestiary the

unicorn is immediately followed, as if through association, by the lamb as a "most striking example of humility." None of this would be relevant here if it were not for the survival of a work by Raphael (37) that dates back to about 1506 and belongs unmistakably to the Florentine series he painted under the influence of the *Mona Lisa*. From sometime in the latter part of the sixteenth century until the 1920s the accepted title was *St. Catherine of Alexandria*, for the young woman was wearing a mantle and holding the saint's shattered torture wheel. Then, an x-ray examination having revealed extensive repainting by a hand other than Raphael's, a thorough restoration was carried out,

37. *Lady with a Unicorn.*
Raphael

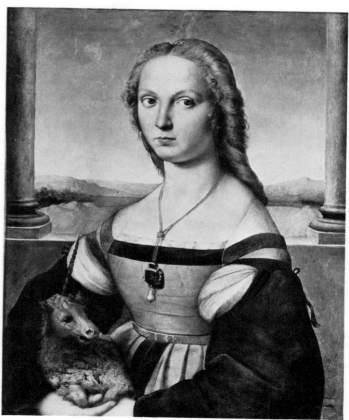

during which the mantle and the wheel disappeared and a gentle unicorn emerged, looking happy and a little bewildered after its long spell in hiding. Was it, as a cautious investigator can assume, just an invention by Raphael? Or was it, as Leonardo's evident interest in the multiple significance of the beast can lead us to imagine, copied by Raphael from an early, lost preparatory study for an allegorical *Mona Lisa?* This kind of speculation about the Louvre picture that might have been is not entirely pointless, for works of art, like people, often look enigmatic merely because they are marked by past lives — and discarded accessories — of which we know nothing.

Another indication, unrelated to unicorns, of what might have been can be discerned in a work which is usually called the *Nude Gioconda* and which has had a rather worldly career of its own. There are several sixteenth-century versions, the most striking and perhaps the oldest of which is a chalk cartoon (38) that may have been executed by one of Leonardo's disciples in Milan, Rome, or France; it represents a naked, nubile, frizzy-headed nymph in the pose of the *Mona Lisa,* and the Leonardesque qualities are such that it is supposed to be a copy of a lost original by the master himself. He could have drawn this original from a naked model as a way of testing the pose he had in mind for his painting, for he is known to have experimented with undraped figures before undertaking such compositions as the *Adoration of the Magi* and the eventually destroyed fragment of the *Battle of Anghiari*, and such experimenting was common in Renaissance studios. But the *Nude Gioconda* in its surviving form looks scarcely at all like a mere testing study, and very much like a definite project for a painting; in fact — although this, of course, is not proof of the intended use of the original — the outlines of the design in the copy are pinpricked for transfer to a panel or canvas, by the usual method of rubbing

powdered charcoal through the holes. The woman could be a Flora, a Pomona, a pastoral heroine, a Virtue, and even a Vice, if it were not for the apparently deliberate exclusion of confirming details. Did Leonardo at one point, anticipating Goya's *Maja Nude* and *Maja Clothed*, plan both a naked and a dressed version of the *Mona Lisa?* Did he have in mind some sort of allegorical contrast? We have no way of knowing.

38. *Nude Gioconda.* Follower of Leonardo

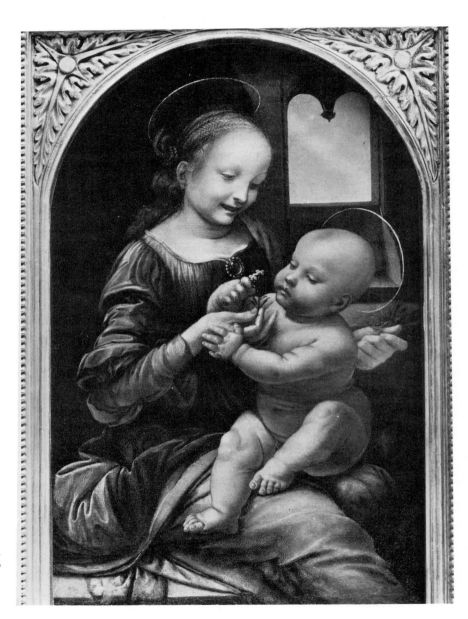

39. *Benois Madonna.*
Leonardo

VI

CONCERNING EXPRESSION

IF THE FIGURE in question is not primarily (the qualifier is best left in place) a likeness of a Lisa or a Costanza, and if she is not finally, whatever she may have been in some earlier version, a recognizable divinity or personification, we are left with only one good choice. It is to suppose that she is a free creation, a *finzione*, who is simply herself, in the way fully rounded characters in plays and novels are simply themselves. This, of course, is what, to a very considerable extent, she has actually become; indeed, in the imaginations of many viewers she ranks with Hamlet, Don Quixote, and perhaps Don Juan as one of the greatest, or at any rate the most successful, fictional characters in Western art. In such imaginations the idea that she might have some connection with a bourgeois smiler born in the Via Maggio in Florence, or with a Petrarchan grande dame screaming defiance from the fortress of Ischia, may be entertaining learned

gossip; but in the end it is about as useful for appreciation as the notion, in a playgoer's mind, that Shakespeare's irresolute prince might have some connection with the Amleth of Danish legendary history. Even less useful is the idea that she might represent the Virgin Mary, or Flora, or possibly Chastity cuddling a missing unicorn, for she is not felt as "representing" anything at all; she exists in the first degree, she is that woman there.

There are reasons for thinking that this effect of a completely convincing but completely independent — and therefore fictional — personage was precisely what Leonardo intended. His manuscripts show that one of the habitual movements of his mind was from the natural, observed in detail with scientific accuracy, to the imaginary or even the paranormal, regarded as a combination of strictly natural details. An extreme example of this movement is the recipe he gives for painting a convincing dragon:

> . . . take for its head that of a mastiff or hound, with the eyes of a cat, the ears of a porcupine, the nose of a greyhound, the brow of a lion, the temples of an old cock, the neck of a water-tortoise.

During his stay in Rome he went so far, according to Vasari, as to assemble a live monster:

> To the back of a very odd-looking lizard that was found by the gardener of the Belvedere he attached with a mixture of quicksilver some wings, made from the scales stripped from other lizards, which quivered as it walked along. Then, after he had given it eyes, horns, and a beard, he tamed the creature . . .

Evidently for the purpose of painting fictional human beings by a similar process of assemblage, he compiled a visual dictionary

of heads, eyes, noses, mouths, chins, throats, necks, and shoulders; he had ten types of nose in profile, his notes say, and eleven types of nose in full face. But a mere juxtaposition of such elements so as to produce, in line with the suggestions of several other Renaissance theorists, an ideal figure was not his aim — or at least it was not his principal aim. In his advice to artists he emphasizes, over and over again, the need for a psychological approach, for a correspondence between an inner life and such external, visible details as a pose, a gesture, a facial expression. He declares that "the good painter must paint . . . man and the ideas in man's mind," and he insists that "a figure is not praiseworthy if there does not appear in it the action that expresses the feeling of its spirit." Acutely aware of the difficulty of rendering "ideas" and "spirit" in an art that lacks words, he refers repeatedly to the example of the deaf and dumb in real life: they understand, he says, "all the actions of the human body better than one who can speak and hear," and they are thus "able to understand the works of painters and recognize the actions of their figures."

Much of his theorizing and exemplifying now seems too systematic; one can see in it the seeds of future European schools of academic, completely external, and often histrionic "expression" on canvas. Much of it, too, was directed exclusively toward the representation of supposedly historical figures in dramatic situations; its most obvious application was to the *Last Supper* (65), for instance, in which the gesticulating Apostles look a little too much like deaf-mutes, and to the *Battle of Anghiari*, in which the fear and fury of the soldiers did not call for subtle artistic means. But the vividly paranormal *St. John the Baptist* (50) is proof that the repertoire of gestures and facial expressions could be used to transform a supposedly historical figure into an independent creation, a deeply Leonardesque character who has

about as much to do with the biblical Forerunner as a dragon has with a lizard. And an anecdotal passage in a notebook discussion of painting and poetry reveals an overweening awareness of the possibility of transforming a female religious figure into an equally independent, and presumably even more realistic and distracting, fictional character:

> It once happened to me that I made a picture representing a sacred subject which was bought by one who loved it and who then wished to remove the symbols of divinity in order that he might kiss her without misgivings. Finally his conscience prevailed over his sighs and lust and he felt constrained to remove the picture from his house. Now let the poet go and try to rouse such desires in men by the description of a beauty which does not portray any living being.

We must be cautious here, for the context is a running Renaissance debate between champions of pictures and defenders of words, and the story is in fact just a variation on one by Pliny about the Aphrodite of Praxiteles. Such phrases as "remove the symbols" and "not portray any living being" are nonetheless suggestive of the creative decisions and growing ambition that could have accompanied the long, frequently interrupted invention of the *Mona Lisa*; and if "sighs" and "lust" seem unconvincingly immoderate we have only to recall the odd desires that have been actually aroused by the draped torso, plump hands, and ambiguous face assembled in the Louvre figure.

Like much else in the assemblage, the three-quarter, waist-up view has, or once had, sacred overtones; it is among other things a development and a secularization of the view of the altarpiece donor in a standard fifteenth-century Flemish diptych or triptych. A praying version, complete with an open gallery, or loggia, and a landscape background, can be seen in Memling's

40. *Benedetto di Tommaso Portinari*. Memling

Benedetto di Tommaso Portinari (40); here the sitter, or kneeler, originally faced an image of his patron saint, Benedict, and the two panels flanked a central one devoted to the Virgin. Roughly the same pose can be found in the work of van Eyck half a century earlier, at which time it was already in use for straight portraits. Leonardo was certainly familiar with such pictures, for Flemish art, partly owing to the banking connections with Bruges established by the Medici and the Portinari, had long been a regular Italian import, and Flemish influence had been perceptible in Italian studios since at least the 1470s. The notebooks contain, however, much independent thinking about the problem of poses. Decorum, expressiveness, and a tucked-in look are called for in a section on history painting:

 Women must be represented in modest attitudes, their legs close together, their arms closely folded, their heads inclined . . .

Elsewhere the accent is on variety of implied movement and mostly on *contrapposto*, the twisting of parts of the body in opposite directions:

> Always make your figures in such a way that the direction of the head is not the same as that of the chest, for nature created for our convenience the neck, which turns easily in several directions when the eye wants to consider diverse places, and the movements of other joints are in part subject to the same purpose. And if you paint a seated figure whose arms have something to do on the sides, make the chest turn on the hips.

What was finally adopted for the *Mona Lisa* was a downward extension of the Flemish-donor scheme and a further modification of it in the direction of the tucked-in look and a mild *contrapposto* effect. Seen as a whole, the figure is a satisfyingly integrated block with no fussy outshoots; she answers to Michelangelo's reported desire for a kind of sculptured form that could be rolled down a hill without breaking anything. Seen in detail, she is a spiraling movement, taut with life and gently deliberate, which can be imagined as having just been set off by the arrival of someone in the loggia from an entrance in front of her and slightly to her left. Her chair, her left arm, and presumably her hips are almost parallel with the wall of the loggia; her trunk is rotated in the recommended way; her head is turned a little more; and her eyes still more, so as to meet the gaze of her visitor, who is also the viewer of the picture. It all looks so easy and natural, and it has been done so many times since, that we are apt to forget how innovative it was at the beginning of the sixteenth century.

The crossed hands, which have become a recognition tag for the entire pose, were similarly an innovation that grew out of traditional practice. Hand gestures had long been a favorite study among Italian painters, and collections of more or less explicit ones had been built up in the motif books of workshops. In addition to those that could be understood directly, with help from a context, as common expressions of affirmation or negation and of such emotions as anger (clenched fist), grief (palm pressed against the breast), and shame (fingers over the eyes), there were many that were intelligible because they were established pictorial conventions. A hand supporting the chin, for example, meant melancholy, and two hands held up with the palms outward meant awareness of something sacred. Especially familiar was a series used in Annunciations: there were the fluttering, pushing hands that signified Mary's initial disquiet over the message brought by Gabriel, the hands held against Her robe that signified, less clearly, Her moment of thoughtfulness, and the extended hand, with the other against Her body, that signified Her perplexity ("How shall this be, seeing I know not a man?"). In short, the age was highly sophisticated about hands, and so was Leonardo: the evidence is in his already mentioned theorizing and the *Last Supper*, and also in such gesture-pictures as the *St. John the Baptist* and the *Virgin of the Rocks* (110). He had moments of revulsion, however, for flutter; in a note that may refer to one of Botticelli's agitated works he says:

> I recently saw an Annunciation in which the angel looked as if he wished to chase Our Lady out of Her room with a movement of such violence that She might have been a hated enemy. And Our Lady seemed as if in despair She was about to throw Herself out of the window. Remember not to make such a mistake as this.

41. *Paradise*. Detail. Nardo di Cione

42. *Annunciation*. Sassetta (?)

Apparently it was in such a moment that he conceived the monumentally quiet hands of the *Mona Lisa*. Iconologically speaking, they can be said to signify either merit or submission, or both at the same time, for they are derived from the crossed hands that have such meanings in traditional Tuscan images of the Virgin and sometimes of the angel Gabriel (41, 42). Sociologically speaking, they can be called a sign that the personage is a decent woman from the educated classes; the documentation for this interpretation is a passage in a Renaissance girl's handbook, *Decor puellarum*, which warns against an overly free, possibly enticing use of manual gesture:

> Whether you are standing still or walking, your right hand must always rest upon your left, in front of you, on the level of your girdle.

Psychologically speaking? Here the difficulties begin. The hands are prominent enough and beautiful enough to imply that the artist, in line with his theory, intended them as external manifestations of an inner something; at the same time they are noncommittal enough to leave the exact nature of that something an open question. They are thus, to a degree that will vary with the sensibility of each viewer, a kind of manual echo of the celebrated puzzling smile.

The smile has been proclaimed original so often and so rightly that we may be in danger of forgetting that, along with the pose and the hands, it was by no means entirely original. Like Shakespeare and Mozart, Leonardo was new less by revolutionary means than by doing better, with refining touches of insight, grace, and humanity, what others had already done. An ostensibly transcendental smile, perhaps of ancient Eastern origin, was a frequent device in Gothic art; it appears — looking Dionysian, beatific, or mindless, according to one's religious disposition —

43. *Angel*. Detail. Reims
Cathedral

44. *Annunciation*. Detail.
Jan van Eyck

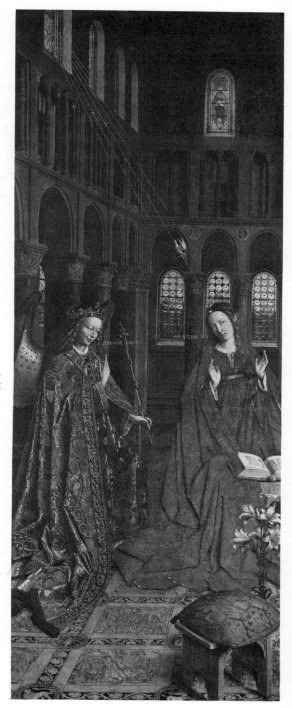

on the familiar angel (43) of Reims Cathedral,
and it would have been known to the young Leo-
nardo in something like its original state through
the work of Tuscan painters, principally Sienese,
who continued the Gothic tradition on into the
period of the Early Renaissance. In the work of
less conservative artists it had evolved from a
half-archaic pasted-on pattern toward more and
more naturalism; by the 1430s, in a van Eyck An-
nunciation, it could light up the face of Gabriel
(44) with the reassuring expression of a boyish
Flemish doctor informing a client that he had a
delightful surprise for her. By the second half of

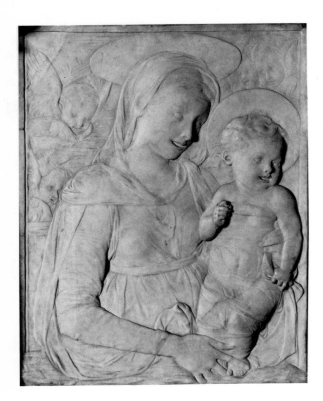

45. *Virgin and Child.*
Desiderio da Settignano

the fifteenth century, particularly in the workshops of Florentine sculptors, the transformation of the transcendental into the psychological, of the old sacred attribute into a purely human one, had been fully accomplished. Desiderio da Settignano — whose art was studied by Leonardo and who was well described by Raphael's father as *il vago Desider si dolce e bello*, the dreamy Desiderio so gentle and beautiful — gave his marble Madonnas (45) the tender gaiety of young Italian mothers rejoicing over their firstborn. Verrocchio — who, it should be emphasized, was the principal mentor of the creator of the *Mona Lisa* — turned the humanizing trend toward introspection; in the proud, difficult, pinched smile of the bust (46) of Giuliano de' Medici (the murdered uncle of Leonardo's patron), and in

the remote, barely sketched smile of the *David* (51), the candid curve favored by the Reims carver and van Eyck became a slightly rueful sign of habitual self-awareness. Thus the historical stage was well set for the arrival of the insinuating talent of Leonardo, and he took full advantage of the fact. Although evidence in the form of works has not survived, it is probable that he began his experiments in Verrocchio's shop as an apprentice modeler, for Vasari says that "in his youth [he] made in clay several heads of women, with smiling faces, of which plaster casts are still being made, as well as some children's heads executed as if by a mature artist." But the *Benois Madonna* (39) shows that by the mid-1470s he was already translating the delicate expressiveness of Florentine sculpture into two dimensions (apparently with Desiderio's low-relief panels serving as a tran-

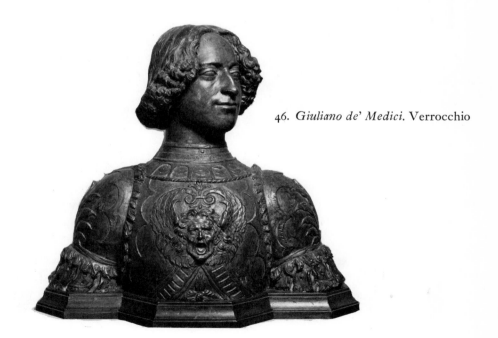

46. *Giuliano de' Medici.* Verrocchio

sition from Verrocchio's freestanding works), and he must have been pleased by the results. In any event, from this point he went on to become unquestionably the most mouth-conscious of the great Renaissance painters and draftsmen, possessed with, or by, a supply of expressions that eventually included, in addition to the elusive smile of the *Mona Lisa*, such various items as a nightmarish canine grin (47), the maternal beam of St. Anne (49), an old-Roman antisimper (48), and the disconcerting Bacchic smile of John the Baptist (50).

In the light of its Early Renaissance and Gothic artistic ancestry, and of its relationship to the smiles in other pictures by Leonardo, the smile of the *Mona Lisa* can be said — like the costume, the pose in the loggia, and the crossed hands — to have vaguely religious connotations. It can also be interpreted, again like the crossed hands, as a sign that the personage is from the educated classes, for smiling has long been thought superior to laughing in Western polite society, and a sixteenth-century woman's manual, Angelo Firenzuola's *Della perfetta bellezza d'una donna*, includes the following among its instructions for looking beautiful and modish:

> Close from time to time the right corner of the mouth, with a sweet and lively movement, and open the left corner, as if in a secret smile . . .

To the sacred and social readings can be added an art critic's sort of analysis: the flicker of the left corner of the mouth can be seen, along with the narrowing of the eyes that accompanies it, as the final element in the movement of the figure and as the point at which the moderate *contrapposto* loses the character of a formal device in order to become an expressive one. After this observation we leave the realm of the quasiobjective for that of the purely subjective. Does the personage look as if she were

47. *Monster*. Leonardo

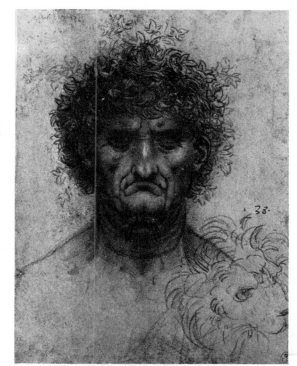

48. *Old Man.*
Leonardo

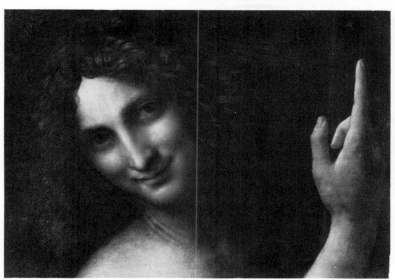

49. Head of St. Anne, detail from
Virgin and Child and St. Anne.
Leonardo

50. *St. John the Baptist.*
Detail. Leonardo

"full of merriment," in Vasari's phrase, because of the musicians and jesters Leonardo supposedly hired for the sittings? Most viewers would probably answer no, although the passage in the notebooks about uncouth sculptors and gentlemanly painters suggests that the picture may in fact have been worked on sometimes to the accompaniment of music and other entertainment. Many viewers might add, to judge from a sampling of reactions, that the smile is irritatingly self-satisfied. Others would describe it as provocative, watchful, or worrisomely appraising, like the faint smile of a stranger encountered in the street on one of our less confident days. Some would go so far as to call it a plain aggression, an unwarranted discharge of the ego aimed at anyone within range. The medical-minded have seen in it the symptomatic rictus of the asthmatic, the bewildered, habitual eagerness of the hard of hearing, and the placid expression of a pregnant housewife, this last hypothesis being allegedly confirmed by the crossed hands and the straight-backed posture. Where should we draw the line between the sixteenth-century "picture" and the Gioconda "myth"? The difficulty is partly that all faint smiles are physically pretty much alike, whether they are smiles that make us happy, smiles that make us blue, smiles that have a tender meaning, or smiles that signify the recent eating of canaries. Each depends for its intelligibility on a limiting context or association; each is intrinsically puzzling. And while there are certainly some contexts in which the smile of the *Mona Lisa* can be legitimately interpreted, none of them can be called limiting.

In spite of the exposed breast cleavage and the pregnancy theory, it has been seriously argued that the personage is actually a young man in woman's clothes. Without going that far, one can agree that there is something masculine in the face and that in this instance there is plenty of context. To begin with,

there is Leonardo's very probable homosexuality. Then there is
his very evident, lifelong obsession with sexually ambiguous fig-
ures; it appears in the drawings, in the angel of the *Virgin of the
Rocks*, in some of the Apostles and the Christ of the *Last Sup-
per*, and in the *St. John the Baptist*; and it continues in the work
of his followers as a stylistic constant — in the *Salvator Mundi*,
for instance. Beyond this personal context there is the fact that
androgynous figures are by no means rare in Italian, particularly
Florentine, art of the fifteenth century and the early sixteenth;
the boyish-girlish angels of Botticelli are examples, and so, to a
lesser degree, are some of Verrocchio's creations, including the
graceful, dreaming, rather flirtatious *David*. Part of the explana-
tion may lie in the reported prevalance of pederasty among
artists, and part of it may be simply that the usual absence of
women in the workshops, where the apprentices acted as ser-
vants, encouraged the use of boys as models. We should bear in
mind, too, the notorious popularity of feminine modes and man-
ners among Renaissance fops; one of the conversationalists in
Castiglione's *Courtier* refers to "soft and womanish" men who
can be easily imagined as transvestite figures in paintings:

> [They] doe not onely courle the haire, and picke the
> browes, but also pampre them selves in everie point like the
> most wanton and dishonest women in the world; and a man
> would thinke them in going, in standing, and in all their
> gestures so tender and faint, that their members were readie
> to flee one from an other, and their wordes they pronounce
> so drawningly, that a man woulde weene they were at that
> instant yeelding up the ghost . . .

Both artists and fops could justify their performances on fash-
ionable intellectual grounds. There were standard arguments, of
the sort Lomazzo gives to Leonardo in the dialogue with Phidias,

in favor of homosexuality. On a more philosophical level there
was the idea that the best image of universal humanity was one
that united the characteristics of both sexes and thus abolished
all discord: Renaissance Neoplatonists were notably fond of the
theory, derived partly from Plato's *Symposium* and partly from
a special interpretation of the biblical "male and female created
he them," that human beings were originally androgynous and
will return to that perfect state when the divided Many are at
last reintegrated in the divine One. An allegorical variation that
switches the theme to divinities exists in English in the form of
the veiled statue of Venus in *The Faerie Queene:*

> The cause why she was covered with a veil,
> Was hard to know, for that her priests the same
> From people's knowledge labour'd to conceal.
> But sooth it was not sure for womanish shame,
> Nor any blemish, which the work might blame;
> But for, they say, she hath both kinds in one,
> Both male and female, both under one name:
> She sire and mother is herself alone,
> Begets and eke conceives, nor needeth other none.

It would be much too much, even in such a generally extrava-
gant field as Giocondology, to suggest that the faintly androgy-
nous personage in the *Mona Lisa* is a precursor of Spenser's
hermaphroditic idol. But that Leonardo, in spite of a bias to-
ward science and Aristotle, was familiar with the kind of Italian
symbolic philosophizing that lay back of the stanza in *The
Faerie Queene* is quite certain: he was acquainted with intellec-
tuals in the Medicean Neoplatonic circle, and the notebooks re-
veal that one of the contemporary authors he read was Marsilio
Ficino, the pope of Renaissance Neoplatonism. Moreover, in
thinking about the picture we should not forget that the painter

was an indefatigable lover of riddles, allegories, mysteries, knots, and monsters.

The high forehead, the lack of eyebrows, the bony eye sockets, the prominent cheeks, the long, straight nose, and the crooked little smile fit together so well that it is hard to believe, even after we have rejected the portrait theory, that they were simply assembled from Leonardo's dictionary of features — that the personage is a sort of dragon lady. More probably there was a face in Florence sometime around 1503 that served as an initial creative shock and an expressive foundation. It is not impossible, of course, that this foundation face really was that of Lisa del Giocondo or Costanza d'Avalos, although the note that "Giovannina has a fantastic face, is at Santa Caterina" makes almost equally possible a face encountered by chance, perhaps in the street. Whoever the original model may have been, she (or he) can scarcely have accompanied the artist to Milan in 1506 and remained constantly available during the final years of work on the picture; and so the way is open for a guessing game concerning the identities of other, more incidental, models. What about somebody in the master's immediate "suite"? Although the loyal disciple Melzi was too young to have posed in 1503, it is not at all difficult to imagine, on the basis of his known features (5), that later on he was sometimes ordered to sit when Leonardo felt like adding a few touches to the nose or the mouth. Salai, partly perhaps because we know him from the drawings only in profile (6), seems entirely unlikely as a model for the painting itself, but not entirely as an incidental one for the *Nude Gioconda* (38): that curly hair and those surprisingly burly arms could conceivably be his, and the aggressive sensuality of the nymph's androgynous face can remind us of the notebook entry on the favorite — thief, liar, obstinate, glutton, *ladro, bugiardo, ostinato, ghiotto*. What about the possibility that

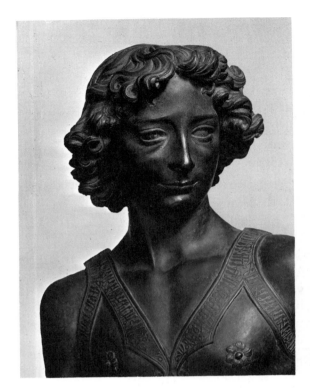

51. *David*. Detail.
Verrocchio

Leonardo, consciously or unconsciously, occasionally projected into the painting an image of himself, transformed by narcissistic memory back into his handsome, beardless young manhood? Piling hypothesis on hypothesis, the guesser who enjoys this notion can compare the *Mona Lisa* with Verrocchio's *David* (51), for which the young Leonardo is said, without proof, to have posed, and with the figure on the far right in the *Adoration of the Magi* (52), which is said, again without proof, to be a self-portrait at the age of about twenty-nine. The guesser can also cite, from a notebook passage about how a painter can give an assembled figure "a pleasing air," a curiously pointed warning against the danger of self-projection:

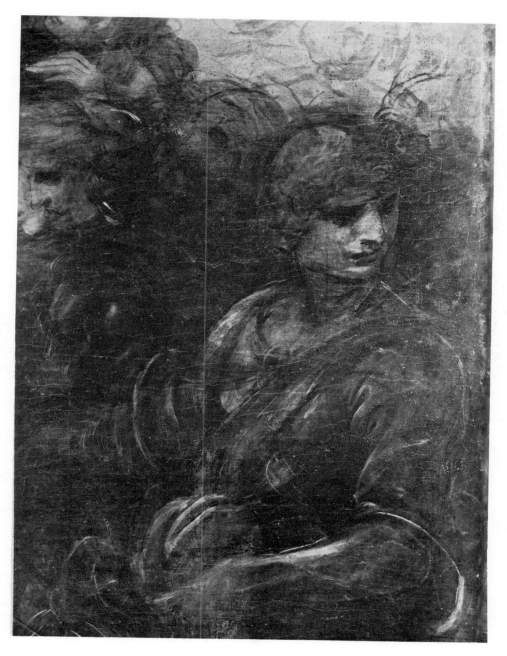

52. Supposed self-portrait, detail from
Adoration of the Magi. Leonardo

Look about you and take the best parts of many beautiful faces, of which the beauty is confirmed rather by public fame than by your own judgment; for you might be mistaken and choose faces which have some resemblance to your own. For it would seem that such resemblances often please us; and if you should be ugly, you would select faces that were not beautiful and you would then make ugly faces, as many painters do. For often a master's shapes resemble himself.

Was the artist thinking of a penchant he had noticed in his own work? Perhaps he was, although it is unlikely that he thought of himself as anything but beautiful. Conceivably, anticipating Flaubert's remark about Madame Bovary, he would have ended the guessing game with a hairy Gioconda smile and *Mona Lisa, c'est moi.*

VII

BEYOND THE LOGGIA

LANDSCAPE WAS NOT a universally admired genre during the Italian Renaissance. Michelangelo included it in his condemnation of Flemish painting as something "without reason" that could appeal only to "young women, monks, and nuns, or certain noble persons who have no ear for true harmony." Botticelli, according to one of Leonardo's notes, thought that the study of natural scenery was a waste of time, "since by merely throwing a sponge soaked in different colors at a wall, a spot is formed wherein a lovely landscape might be discerned." Leonardo, however, disagreed firmly with all such belittling. In his comparison of poetry with painting he refers to "the description of beautiful and delightful places with limpid waters through which the green bed of the stream can be seen, and the play of the waves rolling through meadows and over pebbles, mingling with blades of grass," all of which sounds like a memory of

details in the background of some Florentine pictorial import from Flanders. Elsewhere in his writings, although he does not quite go all the way to the idea of uninhabited field-and-forest mood pictures, he lays a theoretical basis for the sixteenth-century emergence of landscape as an independent branch of painting, and he insists, characteristically, on the freely creative, the fictional, possibilities in the new art:

> If the painter . . . wishes to bring forth sites or deserts, cool and shady places in times of heat or warm spots when it is cold, he fashions them. So if he desires valleys or wishes to discover vast tracts of land from mountain peaks and look at the sea on the distant horizon beyond them, it is in his power . . . In fact, whatever exists in the universe either potentially or actually or in the imagination, he has it first in his mind and then in his hands . . .

His practice suited his theory. His earliest personally dated drawing is a pen-and-ink landscape, apparently put together from elements in the Arno valley; and fictional natural scenery figures prominently in his oils from the time of the first Verrocchio-influenced Madonnas and Annunciations on through the late *Virgin and Child and St. Anne*.

So it was perhaps inevitable, given the evolution of his sensibility toward strangeness, that he should have chosen to provide the figure in the *Mona Lisa* with a background that is every bit as odd, although not so often discussed, as the famous smile. It is a two-storied structure, like one of those double churches in which Gothic builders sometimes indulged their talent for the unexpected: below there is a relatively — or formerly — human landscape, with a bridge that spans a partly dry riverbed and a road that winds to a hidden end through hot, reddish brown rocks; above there is a frosty region with two glaucous lakes, or

sea inlets, and a mountain range whose jagged spires vary from olive green to light blue and finally become almost transparent in the flooding light of the distant horizon. One can be reminded of the Italian Alps and of parts of Tuscany, but there is no point in seeking a real location, for obviously this is an assembled *finzione*, a dragon landscape. It is not so pointless, however, to inquire into the significance of all those naked rocks and of the total lack of plant, animal, and human life, for it is possible to fence in some probable answers by examining contemporary landscape modes and a few of Leonardo's recorded thoughts and visual experiences.

One of the dominant landscape modes of the Early Renaissance was the naturalistic bird's-eye panorama, which seems to have originated mostly in the powerful imagination of Ambrogio Lorenzetti in Siena in the first half of the fourteenth century. It moved into northern Europe by way of miniatures, and there, often in combination with an apparently cliffhanging loggia that provided a plausible reason for the distant view and the lack of a middle distance, it underwent an extraordinary refinement toward detailed realism in the hands of van Eyck (53) and his followers. By the second half of the fifteenth century, sometimes with the high-perched loggia present only by spatial implication, it was influential in Florentine studios, particularly in those of the Pollaiuolo brothers and Baldovinetti (54). It had the charm of a topographical poem and the entertaining factual minutiae of a large, marvelously realistic map; in opposition to the symbolic little paradisiacal garden of late Gothic pictures and tapestries, it can be said to have signified the actual world — the one that was out there waiting to be understood by Renaissance navigators and scientists. As such it must have fascinated the young Leonardo when he first encountered it, perhaps during an exploratory stroll from Verrocchio's place

53. *Madonna of the Chancellor Rollin*. Detail.
Jan van Eyck

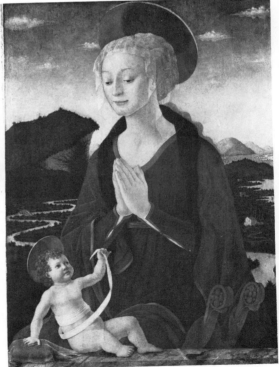

54. *Virgin and Child*.
Alesso Baldovinetti

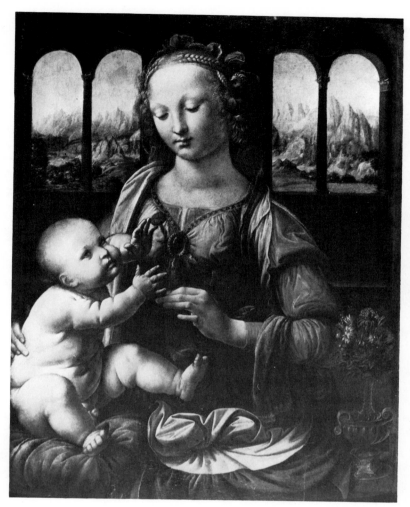

55. *Madonna with the
Carnation*. Leonardo

over to the nearby Pollaiuolo shop. In any event it is already
present, with loggia, in the *Madonna with the Carnation* (55),
which was painted toward the close of his first Florentine
period. (The picture is now in a much-reworked state, but its
condition does not affect the significance of the background.)

Another widely current, although far more ancient, landscape
mode was the nonnaturalistic bare-rock one. Its origins are

56. St. John in the Desert.
Domenico Veneziano

probably to be sought in Hellenistic painting, or even further back into antiquity. It found its way into Byzantine mosaics, icons, and illuminated manuscripts, and then into Gothic art, where it flourished as a pseudonatural element in the pointed style. It was partly just a convention for rough scenery of any sort; Cennino Cennini, whose handbook for painters reflects Florentine practice around the close of the fourteenth century, remarks that "if you want to acquire a good style for mountains, and to have them look natural, get some large stones, rugged, and not cleaned up, and copy them." Often, however, the rocks had the more specific function of symbolizing the hostile zone beyond the wall of the medieval heavenly garden, or of representing the wilderness in which holy men like Moses, Jerome, and John the Baptist (56) spent parts of their lives; and this function, helped by a delight in fantastic forms for their own sake, preserved the unrealistic mode on into the Renaissance

among artists who were perfectly capable of painting realistic mountains. Leonardo reverted to it around 1480 for a picture of Jerome in the desert which was left unfinished, and again a few years later, for less evident reasons, in the *Virgin of the Rocks* (57). He combined it in the background of the *Mona Lisa* with the more recent naturalistic-panorama mode, thus producing a modern, archaic, scientific, and symbolic amalgam that appears to signify, at one level of possible meaning, that the universe out there beyond the loggia, beyond our warm little cliffhanging human enclave, is at once soberly real and crazily inimical.

57. *Virgin of the Rocks.*
Detail. Leonardo

There are other levels of possible meaning, however, for the artist did not easily tire of looking at and thinking about rocks, mountains, and water. On expeditions into the foothills of the Alps from Milan or from Melzi's villa on the Adda he studied outcroppings, stratification, and atmospheric effects; after pondering the presence of marine fossils at high altitudes he concluded that the sea had once covered these regions. Sometimes, according to the notebooks, he let his imagination play with the common Renaissance notion of the microcosm and the macrocosm:

> By the ancients man has been called the world in miniature; and certainly this name is well bestowed, because, inasmuch as man is composed of earth, water, air, and fire, his body resembles that of the earth; and as man has in him bones, the supports and framework of his flesh, the world has its rocks, the supports of the earth; as man has in him a pool of blood in which the lungs rise and fall in breathing, so the body of the earth has its ocean tide which likewise rises and falls every six hours, as if the world breathed; as in that pool of blood veins have their origin, which ramify all over the human body, so likewise the ocean sea fills the body of the earth with infinite springs of water.

A particularly eloquent paragraph, derived from the long discourse attributed to Pythagoras in Book XV of the *Metamorphoses* of Ovid, philosophizes over the remains of a giant fish:

> O time, swift despoiler of all created things, how many kings, how many nations hast thou undone, and how many changes of states and of circumstances have followed since the wondrous forms of this fish perished here in this cavernous and winding recess. Now destroyed by time thou liest patiently in this confined space with bones stripped and bare, serving as a support and prop for the mountain placed above thee.

In a neighboring passage, also borrowed from the *Metamorphoses*, the geologist and paleontologist turns from fossil fish to humanity:

> O time, consumer of all things . . . Helen, when she looked in her mirror, seeing the withered wrinkles made in her face by old age, wept and wondered why she had twice been carried away. O time, consumer of all things!

The melancholy meditations are counteracted by outbursts of delight proper to a scientific imagination:

> O marvelous, O stupendous Necessity — by thy laws thou dost compel every effect to be the direct result of its cause . . .

Fairly often, however, the reader cannot be sure where the scientific imagination leaves off and that of the magus, the dreamer, the ironic riddler, and the reckless prophet begins: some sheets, for example, that contain sketches (58) of mountains similar to those in the far background of the *Mona Lisa* also

58. *Landscape.*
Leonardo

contain a matter-of-fact narrative of a trip taken to the Middle East by the artist-scientist and a careful description of the formation of the Taurus range, all of which is fictional.

Among the prophetic visions are some that concern the end of the world. They may owe something to the millenarianism that was in European minds around 1500, something to Ovid's account of the cruel destruction of mankind by Jupiter and Neptune, and something to childhood memories of disastrous Florentine fires and Arno floods, but the sources are less important than a peculiar, haunting vividness and a natural-supernatural, scientific-paranormal quality that are best described as mature Leonardesque. In one notebook entry the end is envisaged as a series of catastrophes provoked by a mysterious sinking of water into the bowels of the earth; first there will be no more "garlands of leaves" and the fields will "no more be decked with waving corn," then all the animals and the human race will die out, and finally there will be an inevitable, universal conflagration:

> . . . the fertile and fruitful earth will remain deserted, arid, and sterile from the water being shut up in its interior, and from the activity of nature it will continue a little time to increase until, the cold and subtle air being gone, it will be forced to end with the element of fire; and then its surface will be burnt up to cinder and this will be the end of all terrestrial nature.

Fire, however, was not nearly so interesting to Leonardo as water. He devoted a large part of his professional career to studying the flow and swirl of liquids and to elaborating projects, nearly all unrealized, for constructing underground canals in Milan, installing suction pumps and water wheels in suitable locations, draining the Pontine marshes and the swampy area at

Piombino, and diverting the Arno so as to deprive Pisa, the
Florentines' traditional enemy, of its benefits. (This last idea,
adopted by the Florentine government in 1504, got as far as
actual excavation before being dropped as obviously unfeasible.)
So his apocalyptic visions eventually took the form of a deluge,
which is evoked in detailed verbal descriptions and in a series of
drawings which, although dating from different periods, can be
regarded as illustrations for the text. The beginning of the cata-
clysm is visible in a drawing (59) of a mass of panic-stricken
lilliputians blasted by a violent rainstorm of a sort the artist may
have seen during one of his trips into the Alps. In another draw-

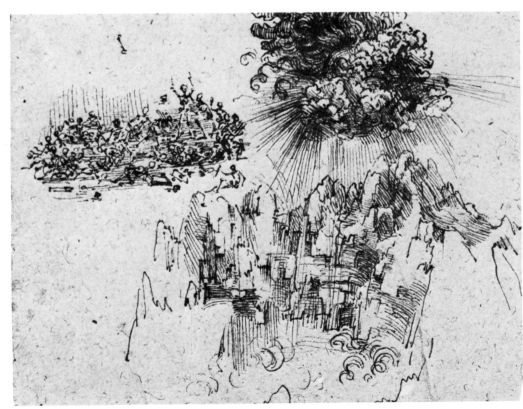

59. *Storm.*
Leonardo

ing (60) the pelting rain and the hurricane winds are accompanied by towering tidal waves. Then, in a written account that is a curious mixture of present and past tenses, the universe goes mad:

> All round may be seen venerable trees, uprooted and stripped by the fury of the winds; and fragments of mountains, already scoured bare by the torrents, falling into those torrents and choking their valleys till the swollen rivers overflow . . . The waters which covered the fields with their waves were in great part strewn with tables, bedsteads, boats, and various other contrivances made from necessity and the fear of death, on which were men and women with their children amid sounds of lamentation and weeping, terrified by the

60. *Flood Under Way.*
Leonardo

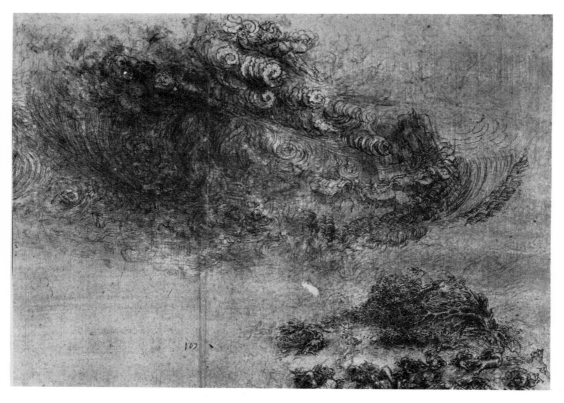

fury of the winds which with their tempestuous violence rolled the waters under and over and about the bodies of the drowned. Nor was there any object lighter than the water which was not covered with a variety of animals . . . And all the waters dashing on their shores seemed to be beating them with the blows of drowned bodies, blows which killed those in whom any life remained.

Finally there is nothing left except a pattern of waves, described as "striking in eddying whirlpools against the different obstacles, and leaping into the air in muddy foam," and depicted in a drawing (61) that might pass for a twentieth-century abstraction.

Although the account of the disaster includes passing refer-

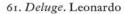

61. *Deluge.* Leonardo

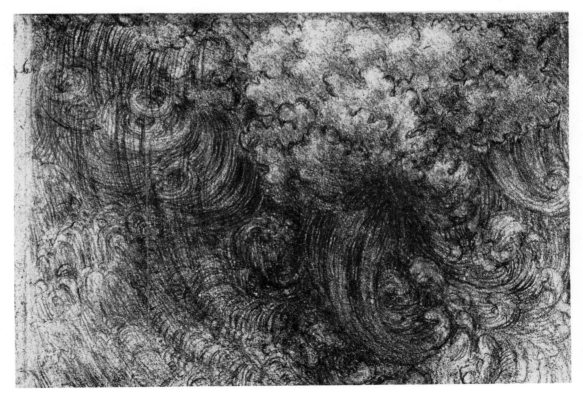

62. *Mona Lisa*. Detail

ences to "the wrath of God," it is on the whole not at all reli-
gious or moralizing in its tone. In fact, it is at times almost
ludicrously scientific, distant, and pictorial, as if the affair were
being observed from another planet by an artist preparing to
execute a painting; one section, for example, dispassionately in-
forms us that "a mountain falling on a town will fling up dust in
the form of clouds, but the color of this dust will differ from
that of the clouds." The implied project for a painting was one
of the many which Leonardo never got around to carrying out;

63. *Mona Lisa*. Detail

perhaps it was one of those before which, in Vasari's words, "he was convinced that his hands, for all their skill, could never perfectly express the subtle and wonderful ideas of his imagination." Both the fiery and the watery visions of the end of things, however, can be reasonably added to the naturalistic-panorama mode, the rock-wilderness symbolism, and the geological philosophizing as part of the network of inspiration that lay behind the invention of the *Mona Lisa* background (62, 63). The bridge and the road, far from implying human activity, merely

reinforce the impression that this is a posthistorical world, long since deprived of every vestige of life. Here are the "deserted, arid, and sterile" valleys left by the last great dry spell, and here also, juxtaposed like the mixed metaphors of a Surrealist poem, are the mountains that were "scoured bare by the torrents." The viewer is confronted by a manifold pattern of associations in which he can imagine that the conflagration or the deluge has done its work and subsided, that the ghost of John the Baptist is wandering among the rocks, and that the fossil of the giant fish is lying patiently in a brown cavern, ready to serve forever as a reminder of time the despoiler.

VIII

CONCERNING TECHNIQUE

ALTHOUGH LEONARDO exhibits in his notebooks a knowledge only of arithmetic, elementary geometry, and simple algebra, his interest in everything involving numbers, proportions, and measurable harmonies was intense; in this respect, as in several others, he was more of a Renaissance Platonist, a believer in abstract ideas, and less of a late medieval, down-to-earth Aristotelian, than certain modern commentators would have us believe. "Let no man," he warns, "who is not a mathematician read the elements of my work." He insists that all "true sciences" are based on experience combined with mathematical reasoning:

> Experience does not feed investigators on dreams, but always proceeds from accurately determined first principles, step by step in true sequences, to the end; as can be seen in the elements of mathematics founded on numbers and measures

called arithmetic and geometry, which deal with discontinuous and continuous quantities with absolute truth. Here no one argues as to whether twice three is more or less than six or whether the angles of a triangle are less than two right angles. Here all argument is destroyed by eternal silence, and these sciences can be enjoyed by their devotees in peace.

Through his friendship in Milan with the mathematician Luca Pacioli, whose influential *Divina Proportione* — a treatise devoted notably to the proportion called the Golden Section — he illustrated, the artist may even have occasionally ventured beyond, or above, the limits of the "true sciences" into the region where Renaissance mathematics became an adjunct of mystical philosophy. Moving in the opposite direction, he took a childlike pleasure in the invention of dozens of geometrical games, and he praised mechanics as "the paradise of the mathematical sciences."

It was in his theorizing about painting, however, that he found what must have been the most satisfactory outlet for his interest, for here he was able to use mathematics as part of his demonstration that his art was really an intellectual, and not just a manual, activity — that it was indeed one of the gentlemanly liberal arts. He spent much time working out supposedly ideal proportions for the members of the human body and even for facial features. An important section of his *Trattato della Pittura*, derived largely from the work of Alberti, Piero della Francesca, and earlier predecessors but including some strikingly original observations, deals with linear perspective; he calls it "a rein and a rudder" for painting, defines it as "a rational demonstration by which experience confirms that every object sends its image to the eye by a pyramid of lines," and rejoices — in a passage borrowed from a medieval writer, John Peckham — over the nobility of the thing:

Among all the studies of natural causes and reasons light chiefly delights the beholders; and among the great features of mathematics the certainty of its demonstrations is what pre-eminently tends to elevate the mind of the investigator. Perspective therefore must be preferred to all the discourses and systems of human learning.

Elsewhere he justifies his reputation as the new Pythagoras, and as a brilliant musician, by maintaining, along with many other Renaissance theorists, that music and painting are sister arts, that the proportions in a picture are analogous to a chord, and that objects of the same size receding in space at regular intervals diminish in harmonic progression.

His thinking about pictorial space also resulted in a theory of aerial perspective — of the changes in color and tone in receding objects provoked by the intervening air. This is the first systematic treatment of the subject since Greek antiquity, although the phenomenon itself was rediscovered by Flemish painters early in the fifteenth century. After remarking that "in an atmosphere of equal density the remotest objects seen through it, as mountains, in consequence of the great quantity of atmosphere between your eye and them, appear blue," and after noting in general the tendency of distant things to lose their colors, he calls for a tie-in with linear perspective that will make the whole system mathematical — and presumably musical:

Take care that the perspective of color does not disagree with the size of your objects, that is to say: that the colors diminish from their natural [vividness] in proportion as the objects at various distances diminish from their natural size.

A final touch to the system is a perspective of *perdimenti*, of the loss of the details of a receding form; according to this a horse, for example, as it gets further and further away will lose pro-

gressively the legs and then the head and neck, until at last the body is just an oval or cylindrical shape in the distance.

Some of the mass of theory seems to have governed the proportions and spatial organization of the *Mona Lisa*. With a little good will, and by carefully choosing the measuring points, one can find here and there in the picture traces of the Golden Section. (Although not really expressible in numbers, it works out to a ratio of around eight to thirteen.) In the same cooperative way one can discover Leonardo's recommended proportions in the face of the personage: the distance from the top of the head to the middle of the eyes, for instance, is about equal to that from the eyes to beneath the chin. Although now obscured by centuries of varnish and dirt, the blue mountains appear to recede into the vaporous distance according to the rules for aerial perspective. The linear variety is suggested by the bases of the loggia columns and by such details as the expertly foreshortened right arm; and it was perhaps more apparent before the panel was trimmed on the sides. The fact, rather unusual for the period, that the horizon is almost at the level of the figure's eyes (and of the viewer's, when the picture is properly hung) is in agreement with a dictum in the notebooks that is also followed in the *Last Supper* and the *Virgin and Child and St. Anne*. But all this is to a surprising degree a matter of approximations and hints; no visitor to the Louvre is likely to see in the *Mona Lisa* an illustration for the *Trattato della Pittura* or a demonstration designed by an artist who was intoxicated by mathematics to the point of believing that perspective "must be preferred to all the discourses and systems of human learning." The visible section of the loggia is not much more implicitly cubical and convincingly three-dimensional than the canopies in many late medieval works, and the complete lack of a middle distance leaves the figure unrelated spatially to the landscape; indeed, to return to

the question of religious overtones, she is easily imaginable as a saint in a mystery play seated in front of a backdrop. The space of the landscape itself, except for the aerial perspective at the top, is astonishingly unsystematic; there are several possible vanishing points, and there is no regular recession to provide clues to the relative sizes of the rocky features. Actually, the whole panorama can be read as simply a combination of distinct landscape bands, brown below and blue above, and the illusion of a vast expanse is due to the superposition of the bands rather than to any serious use of the optical principle of the convergence of receding parallels.

There are at least three probable reasons for this failure to make artistic practice conform to a lovingly elaborated scientific theory. The strictly mathematical linear perspective that was invented in fifteenth-century Italy was an abstraction hard to convert into complex pictures — so much so that, contrary to the impression given by many art-history manuals, it was widely neglected by the painters of the period. In one of his preliminary drawings (64) for the *Adoration of the Magi* Leonardo can be seen getting into trouble with his lines, and even in the spatially uncomplicated *Last Supper* (65) he slipped, for although the perspective is theoretically correct there is no spot in the refectory of Santa Maria delle Grazie from which it can be correctly viewed. Interlocking with the problem of execution was one of an apparently divided temperament; the inquiring scientist and implicit classicist who enjoyed an optical "pyramid of lines" consorted uneasily on many occasions, we can suppose, with the romantic, freely creative artist who wrote the following frequently quoted advice for painters short of ideas:

> . . . when you look at a wall spotted with stains, or with a mixture of stones, if you have to devise some scene, you may

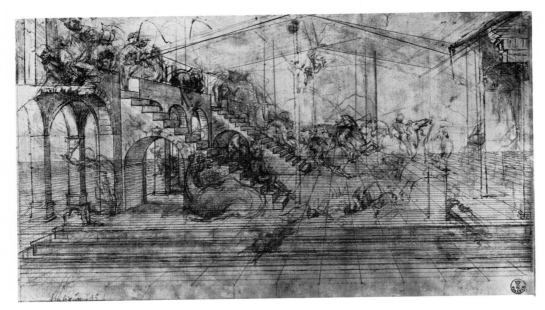

64. Study for
the *Adoration of
the Magi.* Leonardo

65. *Last Supper.*
Leonardo

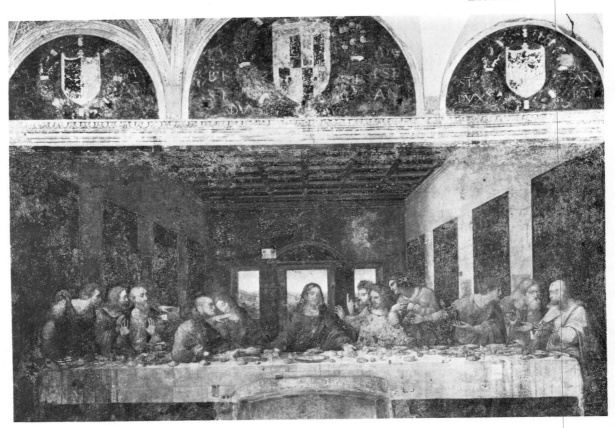

discover a resemblance to various landscapes, beautified with mountains, rivers, rocks, trees, plains, wide valleys and hills in varied arrangement; or, again, you may see battles and figures in action; or strange faces and costumes and an endless variety of objects, which you could reduce to complete and well-drawn forms. And these appear on such walls confusedly, like the sound of bells in whose jangle you may find any name or word you choose to imagine.

Beneath the problems of execution and temperament there may have been one of philosophical outlook, for although Leonardo certainly thought of himself as a realist he seems to have been uncertain about the exact kind of realist he was. In his mathematical moods he was ready to argue that reality was an inflexible structure of laws and harmonies and that painting

> compels the mind of the painter to transform itself into the mind of nature itself and to translate between nature and art, setting out, with nature, the causes of nature's phenomena regulated by nature's laws.

In other moods he put more emphasis on the kind of reality that was represented by the flux of direct sense experience; he insisted that "all our knowledge has its origin in our perceptions" and that "whatever is painted must pass by the eye . . . to the understanding." A synthesis of the mathematical and the sensuous data, of the structure and the flux, was theoretically possible, of course, but his faculty of synthesis was not very strong, and so he was inclined, especially and perhaps regretfully as he grew older, to let his eye decide that the universe was not really the harmonious, slightly boxy place implied by his optical-geometrical studies.

In the physical aspects of technique he had fewer problems. To be sure, during his lifetime and for a long while afterward

he was often called a poor craftsman, largely because of the
deterioration of the paint in the *Last Supper* owing to dampness,
and the unsuccessful experimental medium (perhaps a combina-
tion of wax and oil) used for the *Battle of Anghiari*. But these
were very special cases, and the fact is that the *Mona Lisa* is a
well-made object that has come down through the centuries in
remarkably good condition. The panel, 30.3 inches high and
now in its cropped state 20.9 inches wide, is a single, thin, fine-
grained slab of white poplar, the favorite wood of Italian
painters of the Early Renaissance. (The so-called yellow or
tulip poplar of North America is a quite different article.) It
was probably prepared in the complicated way recommended in
the *Trattato della Pittura:* first was applied a coat composed of
mastic, turpentine, and white lead or lime; two or three coats of
a solution of alcohol and arsenic or mercury chloride were
added, plus a well-rubbed-in layer of boiled linseed oil; these
were followed by a coat of varnish and white lead; the mixture
when thoroughly dry was washed with urine (apparently to
remove any traces of grease); and finally it was pumiced until it
resembled a sheet of ivory. X-ray (66) and other studies in the
laboratories at the Louvre reveal that the pigments for the paint-
ing itself were suspended in a very fluid oil medium and that the
picture was built up, much in the manner of a fifteenth-century
Flemish work, by a succession of thin washes of color, each
contributing a carefully calculated nuance. That things went
slowly can be guessed from an eyewitness account of the paint-
ing of the *Last Supper*, written by the novelettist Matteo
Bandello:

> Many a time I have seen Leonardo go early in the morning
> to work on the platform . . . and there he would stay
> from sunrise till darkness, never laying down the brush, but

66. Mona Lisa. X-ray

continuing to paint without eating or drinking. Then three or four days would pass without his touching the work, yet each day he would spend several hours examining it and criticizing the figures to himself. I have also seen him, when the fancy took him, leave the Corte Vecchia when he was at work on the stupendous horse of clay, and go straight to the Grazie. There, climbing on the platform, he would take a brush and give a few touches to one of the figures: and then suddenly he would leave and go elsewhere.

Although this sort of fitful execution could easily have led to some incoherence in the painted substance, it did not do so in the *Mona Lisa*. The pigments have adhered solidly to the panel except in a crack above the head of the figure and in a few patches, especially in the hands and just above the eyes, where there is some evidence of ancient restoration. There are no signs of reworking by Leonardo himself, and the only noticeable lack of technical continuity, if it can be called that, is in the contrast between the relatively pale face and the warmer-hued hands; this is partly a stylistic trait, to judge from other works by the artist and his followers, and partly, to judge from the accompanying difference in the network of fine cracks, a product of time and chemical reactions, the ochers in the hands having resisted the light-colored undercoat better than the pinkish lakes in the face.

Vasari, ignoring the landscape and relying, it must be remembered, on reports and his imagination, describes the head as a masterpiece of color and realism:

> If one wanted to see how faithfully art can imitate nature, one could readily perceive it from this head; for here Leonardo subtly reproduced every living detail. The eyes had their natural lustre and moistness, and around them were the lashes and all those rosy and pearly tints that demand the

greatest delicacy of execution. The eyebrows were completely natural, growing thickly in one place and lightly in another and following the pores of the skin. The nose was finely painted, with rosy and delicate nostrils as in life. The mouth, joined to the flesh-tints of the face by the red of the lips, appeared to be living flesh rather than paint. On looking closely at the pit of her throat one could swear that the pulses were beating.

How seriously should we take this description? Although defenders of Vasari have suggested that the now conspicuously missing eyebrows were once really there and were wiped off by an overly vigorous cleaning, it is hard to see why the cleaning would have left intact the wispy curls visible on the shoulders, and it is easy to suppose that the first model, following the fashion mentioned by Castiglione in the *Courtier*, plucked her brows. Although the mouth and nose are indeed "finely painted," it seems unlikely that the lips were ever very red and that the nostrils were "rosy." So perhaps it is best to use this obviously set piece of praise as merely a reminder that the picture was once — before the application, almost certainly in the sixteenth century, of a varnish that turned brown — more brightly colored than it is today. The sky and the distant peaks were more blue, and the flesh more flesh colored. The sleeves were probably saffron, the main part of the dress just possibly dark green, and the mantle, or triple veil, just possibly bluish gray.

An imaginary removal of the varnish should not, however, lead to the conclusion, as it almost has in some minds, that the picture was originally a brilliant chromatic exercise, a sort of Renaissance essay in Fauvism. In his notebooks Leonardo shows little interest in color for its own sake, and expresses his contempt for "a certain race of painters who, having studied but

little, must needs take as their standard of beauty mere gold and azure." In fact, it is unlikely that he ever made the modern, and somewhat theoretical, distinction between pure chromatic quality, or hue, and tone value, or relative brightness, since for him light and shade were of supreme importance in painting. Sometimes he seems to favor a straightforward, almost academic approach to the problems involved; here, for instance, is a rule that happens to be followed in the *Mona Lisa:*

> Above all, see that the figures you paint are broadly lighted and from above . . . for you will see that all the people you meet out in the street are lighted from above, and you must know that if you saw your most intimate friend with a light from below you would find it difficult to recognize him.

His advice on "selecting the light which gives most grace to faces" is more Leonardesque and more concerned with emotional content; and we can imagine it, too, as having been followed in the *Mona Lisa:*

> If you should have a courtyard that you can at pleasure cover with a linen awning, that light will be good. Or when you want to take a portrait, do it in dull weather, or as evening falls, making the sitter stand with his back to one of the walls of the courtyard. Note in the streets, as evening falls, the faces of the men and women, and when the weather is dull, what softness and delicacy you may perceive in them.

More important, however, than his use of tone values in broad areas was his use of them in the form of *sfumato:* the technique for making transitions of light and shade, and sometimes of color, nearly imperceptible, so that everything blends, as he says, "without lines or borders, in the manner of smoke." In his scientist role he was inclined to think of *sfumato* as a device for

producing a three-dimensional effect, an illusion of relief, which he called "the first thing in painting," and which is certainly present in the rounded, bulging, sculptural details of the figure in the *Mona Lisa*. But in his artist role he was also ready to think of the device as something for insinuating the presence of a watchful human consciousness behind an evanescent smile and for creating a crepuscular enclave in which such a consciousness could be more at home than in a universe of sharp outlines and glaring geometry.

His interest in the subtle play of light and shade on curved volumes can be linked to his training as a sculptor in Verrocchio's studio, and it is not improbable that some of the *Mona Lisa,* in particular the Greco-Roman drapery, was done with a kind of improvised statue replacing the live model. Several surviving early studies of classical-looking costume (67) were executed in this way, and Vasari describes the process:

67. *Study of Drapery.*
Leonardo

68. *Skull*. Leonardo

Sometimes he made clay models, draping the figures with rags dipped in plaster, and then drawing them painstakingly on fine Rheims cloth or prepared linen. These drawings were done in black and white with the point of the brush . . .

One can imagine, too, that sometimes the head of the live model was replaced by a skull (68), or by the thought of one, for the first years of work on the picture coincide with a period in which Leonardo was devoting much of his time to anatomical studies. In fact, for a while during his stay in Florence between 1503 and 1506 he lived in the hospital of Santa Maria Nuova, where he was given bodies to dissect, and there must have been many days when he went straight from a cadaver to the painting, with his mind's eye still focused on the enduring bony structures that lie beneath fleeting smiles. He was fully aware of the repugnance his dissections aroused in many people:

> And if you should have a love for such things you might be prevented by loathing, and if that did not prevent you, you might be deterred by the fear of living in the night hours in the company of those corpses, quartered and flayed and horrible to see.

But he himself seems not to have been in the least squeamish, for in his conversation with the Cardinal of Aragon at the manor of Cloux he boasted, according to de' Beatis, of having already taken apart "more than thirty bodies, both men and women, of all ages."

His fondness for the *sfumato* technique and his conviction that an illusion of relief was the main thing in painting implied a break with the Florentine tradition that line drawing was fundamental for all the visual arts, and he did not shrink from the implication. "The boundaries of bodies," he writes, "are the

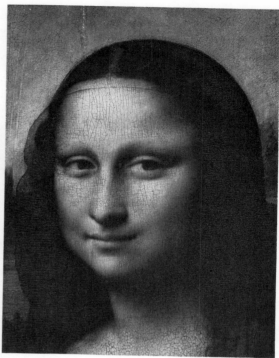

69. *Mona Lisa*. Detail
70. *Mona Lisa*. Detail

least of all things . . . Wherefore, O painter! do not surround your bodies with lines." Much of the *Mona Lisa* follows this rule. The mountains appear to have been merely brushed into their jagged shapes; the boundary of the figure is — or was, before the darkening of the varnish — turned into a tonal transition by the gauze drapery; fingers and facial features emerge from the *sfumato* without apparent lines (69, 70); and laboratory examination has revealed that the pupils of the eyes, unlike those in a figure by Botticelli, for example, are simply layers of transparent color. We can guess that many of the lost studies for the painting were done in black chalk, a tone-producing

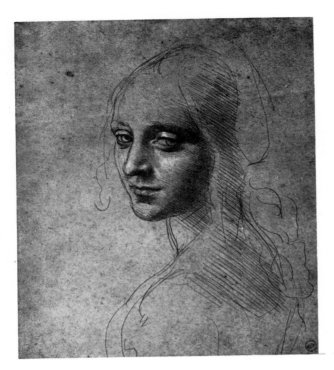

71. *Angel*. Leonardo

medium which Leonardo favored during his late period, or possibly even in pastel, which he is said to have invented. The drawings that were done in pen and ink, or in some other linear medium, must have had more or less definitely outlined forms, of course, but they must also have had many delicately controlled clusters of lines to indicate the zones of light and shade. Such hatchings are frequent in the artist's work: at first they are of the straight slanting kind employed in a fine study (71) for the angel of the Louvre version of the *Virgin of the Rocks*, and after about 1500, as if in answer to a desire for a greater illusion of relief (and perhaps under the influence of Dürer), they are often of the curved bracelet kind used around the model's neck in some studies (72) for the lost *Leda and the Swan*, which was painted while the *Mona Lisa* was under way.

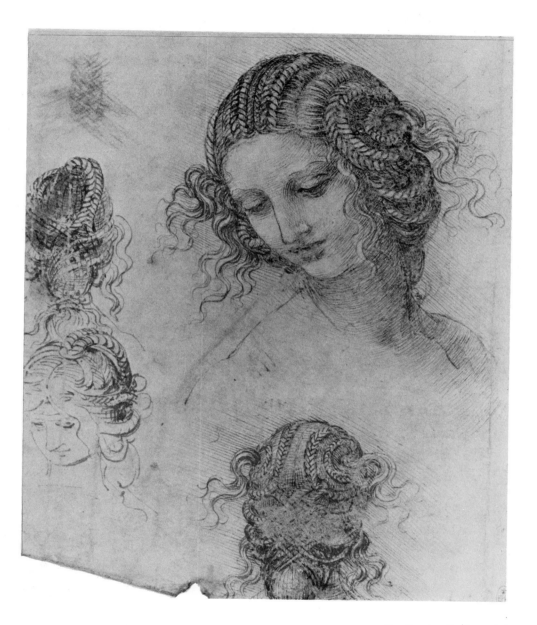

72. Studies for *Leda and the Swan*. Leonardo

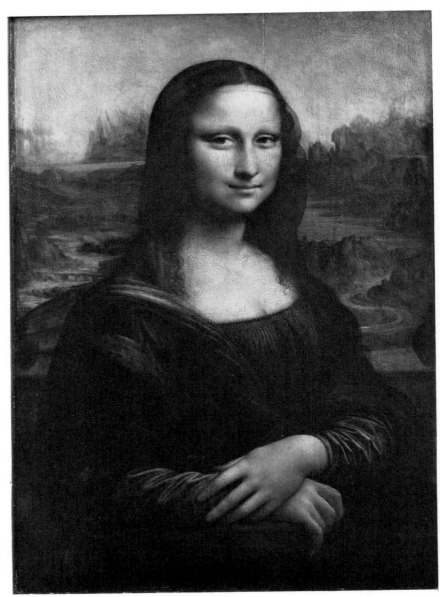

73. "Right-handed" *Mona Lisa*

It has frequently been remarked that Leonardo's drawings look left-handed; the hatching in the above-mentioned study for the angel of the *Virgin of the Rocks,* for example, would probably slant from the right down to the left if the artist had been right-handed. It has also been said, with less assurance, that the *Mona Lisa* itself may be left-handed mirror work, like the handwriting in the manuscripts, and that this may be one of the reasons for the feeling of uneasiness the painting provokes in many viewers — including those who are themselves left-handed, for they are used to living in a right-handed culture. The theory has its points. It can remind us of such strong probabilities as that there is a carryover from left-to-right reading habits to left-to-right picture scanning, that the specialized halves of our brains are extremely addicted to the normal difference between left and right, and that our civilization is loaded with primitive left-right symbolism of which we are only dimly conscious but by which we are constantly affected. Also, the painting is asymmetric enough to make the direction in which it is scanned possibly significant: the halves of the woman's face, like those of real faces, do not quite match, and the halves of the landscape are even less continuous, for the sea horizon on the far right — which incidentally slants a little in the direction of the left-handed hatching — fails to reappear on the other side of the head. The difficulty, however, with the theory is that the psychology of art has not yet got around to understanding and confirming all that it surmises, nor to devising objective tests for reactions to a painting as subtle as the *Mona Lisa.* So about all that can be done is to let sensitive viewers, perhaps preferably right-handed ones, look at a reversed image (73) of the work and come to personal conclusions.

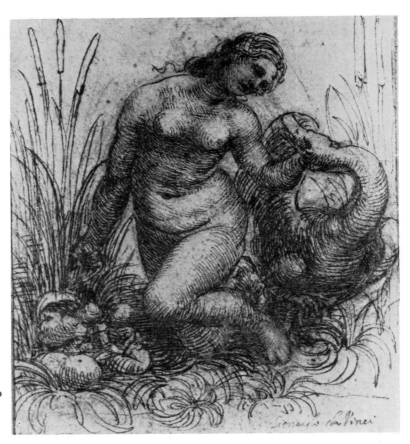

74. *Kneeling Leda*. Leonardo

IX

AN INTERPRETATION

LITERARY CRITICS are in the habit of distilling from the prose, characters, and situations of a piece of fiction an abstraction that can be called "the subject" and can be confidently alleged to be what the work, fable aside, is mainly about; the subject of *Don Quixote*, for instance, is often said to be idealism, appearance, and reality. Applying the method with a proper awareness of the differences between writing and painting, but taking boldness from the fact that Leonardo referred to his art as an invention "which brings philosophy and subtle speculation to the consideration of the nature of all forms," we can say that the *Mona Lisa* is a fiction, a *finzione*, that is mainly about contrast, analogy, and ambiguity. To say this is not, of course, to rule out all other implications, nor to overlook the fascination of the woman in the picture, any more than to speak of the philosophical subject of Cervantes's book is to rule out the satire on chival-

ric romances and to overlook the touching humanity of the hero. Nor should our triple abstraction suggest any lack of enjoyment of concrete pictorial details and artistic qualities, for in fact it can help us to see them — perhaps more of them than we might see with the aid of a conventional aesthetic analysis, and certainly more than with a mere portrait-of-Lisa assumption.

The contrast part of the subject is the most visible. A faintly smiling young woman in an undatable costume is seated on a wooden chair in the moderate light of a loggia perched on the edge of a precipice; below and beyond the loggia, with no spatial transition and in a bright light (before the varnish), there is a panorama of barren rocks, abrupt mountains, and residual water. The loggia is in present, or real, time, like a film shot; we have just entered it, and the woman has just turned her torso, her head, and her eyes to look at us — one, two, three, and then the little movement of the left corner of the mouth. The background, on the other hand, is visibly a record, a relic, of eons of past time. Also, the yielding flesh and rounded forms of the woman's body stand out dramatically against the hard jaggedness, like fruit against cinders; she is alive, whereas the background is emphatically dead. She is possibly pregnant, or at any rate obviously capable of becoming so, whereas no seed will ever grow in that desolate, futureless landscape. If we grant that she has an androgynous look, she becomes a representative of all humanity and of perfect sexuality, while behind her looms a spayed and castrated universe that has long forgotten yin and yang. She represents consciousness, too, as the smile reveals, whereas beyond the loggia the last trace of psychic activity presumably guttered out when the last human being stumbled on the bridge or the road in the airless heat, or was swept by the deluge from the highest mountain.

That this pattern of contrasts, which can be reduced to one

between life and death and one between man and a hostile cosmos, was not due to chance is suggested by evidence from outside the picture. The artist's reverence for life of any kind was such that, like Pythagoras, he may eventually have become a vegetarian; a letter from a mutual friend to Giuliano de' Medici refers in passing to a certain tribe in India "so gentle that they do not feed on anything which has blood, nor will they allow anyone to hurt any living thing, like our Leonardo da Vinci." Vasari speaks of the same characteristic:

> [Horses] gave him great pleasure as indeed did all the animal creation, which he treated with wonderful love and patience. For example, often when he was walking past the places where birds were sold he would pay the price asked, take them from their cages, and let them fly off . . .

The notebooks denounce war, in spite of their author's innovations in weaponry, and condemn, in spite of his tour as a military engineer for Cesare Borgia, the Renaissance tolerance for assassination:

> And you, O Man, who will discern in this work of mine the wonderful works of Nature, if you think it would be a criminal thing to destroy it, reflect how much more criminal it is to take the life of a man: and if this, his external form, appears to thee marvellously constructed, remember that it is nothing as compared with the soul that dwells in that structure; for that, indeed, be it what it may, is a thing divine. Leave it then to dwell in its work at its good will and pleasure . . .

This awareness of the value of life was accompanied by an interest in the mechanism of its creation. Indeed, "interest" is scarcely the word, for although Leonardo as a man apparently

75. *Embryo*. Leonardo

had no heterosexual curiosity, as an inquiring scientist and an ardent philosopher full of "straunge conceits" he was plainly spellbound (and perhaps at the same time repelled, as his remark about the ugliness of sexual intercourse suggests) by the mystery of the production of offspring. He devoted an entire section of his notebooks to embryology, made a sort of x-ray anatomical sketch of human coitus, and produced, after what must have been a particularly trying dissection, what may be the first drawing (75) in history of an unborn infant. His *Leda and the Swan*, which was ruined in the seventeenth century but is known from his preparatory drawings (72) and from early copies (76) by his followers, was probably intended in part as an allegory of the process of generation in the universe. All this tenderness and enthusiasm, however, was balanced by something else. The spectacle of the lubricious swan nuzzling Leda and of Castor, Pollux, Helen, and Clytemnestra emerging from their shells can remind us of the tragic sequels evoked in Yeats's equally antierotic treatment of the myth:

> A shudder in the loins engenders there
> The broken wall, the burning roof and tower
> And Agamemnon dead.

The thinker who loved life and probed its creation also had visions of the end of the world by fire and flood. The painter who imagined Helen of Troy as a swan chick was also the melancholy geologist and fossil hunter who thought of her as a crone before her mirror lamenting the ravages of time. There were moments, according to his notebooks, when he indulged in a mixture of scientific positivism and romantic irony that anticipated the pessimism of certain nineteenth-century philosophers:

> Now you see that the hope and the desire of returning to the first state of chaos is like the moth to the light, and that

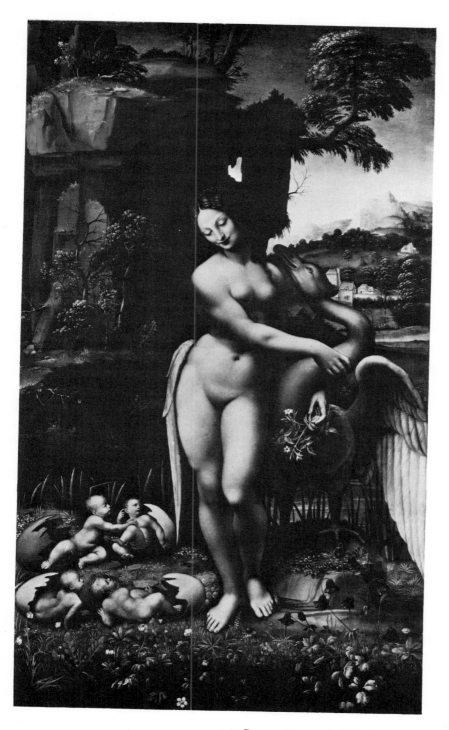

76. Copy of Leonardo's *Leda and the Swan*. Melzi (?)

the man who with constant longing awaits with joy each new springtime, each new summer, each new month and new year — deeming that the things he longs for are ever too late in coming — does not perceive that he is longing for his own destruction. But this desire is the very quintessence, the spirit, of the elements, which finding itself imprisoned with the soul is ever longing to return from the human body to its giver.

If Vasari and Lisa del Giocondo had not triumphed so thoroughly, one might suggest that the *Mona Lisa* could be called simply *Existence and Extinction,* or perhaps *Awareness and Unawareness.*

Such titles would have the defect, however, of excluding the analogy part of the subject of the picture, which is nearly as important, if not as immediately perceptible, as the contrast part. Although Leonardo was modern and scientific in his insistence on experience as the source of knowledge and in his contempt for purely bookish authorities, he was very much of his own century in his tendency to think and feel, or think-feel, in terms of a network of resemblances and resonances. For him the world was a collection of hidden metaphors and similes, a vast, mostly visual poem, available for reading by an initiate, an artist-magus, who knew the references. A lamb (36) resembled a unicorn (34), if one considered the two little beasts with a proper awareness of their full, ramifying, interlocking significances. Leda kneeling (74) before the children fathered by Zeus resembled the Virgin Mary kneeling (77) before a Child fathered in somewhat similar circumstances; the eggs laid by Leda resembled human wombs, which in turn resembled the wombs of other animals — in fact, the uterus in the above-mentioned drawing of a human embryo (75) is that of a cow. The glower of a presumed Roman (48) recalled the glower of a

77. *Kneeling Virgin.*
Leonardo

lion, and the analogy was stressed by means of a sketch in the corner of the same sheet. A roaring lion had exactly the same facial expression as a furiously neighing horse and a yelling man (78); a dog's legs were analogous to those of human beings (79). An important entry in the manuscripts sums up the universal pattern:

78. *Horses, Lion, and Man.* Leonardo

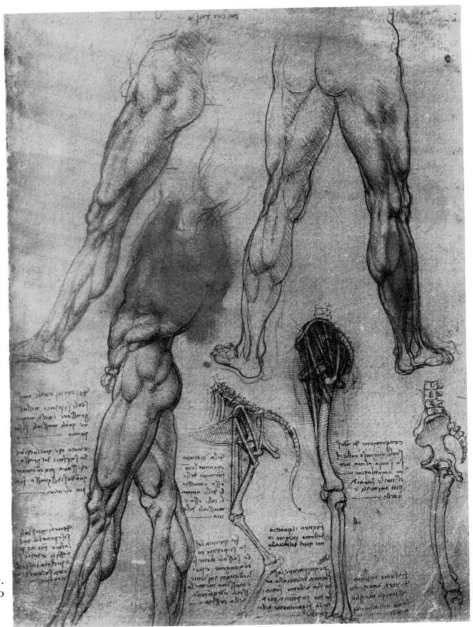

79. *Comparative Anatomy.*
Leonardo

Anaxagoras: Everything proceeds from everything, and everything becomes everything, and everything can be turned into everything else . . .

With this passage and the drawings as authorization, one can interpret the *Mona Lisa* as something quite different from a study in contrast; and there is small danger of letting a twentieth-century analogical imagination go further than Leonardo's would have gone. The bony face of the woman recalls a bare skull (68) from the hospital of Santa Maria Nuova and also the bony face of the ermine in the *Lady with an Ermine* (80), and the animal continues the chain of analogies by resembling irresistibly its owner, Cecilia Gallerani (22). The elusive Gioconda smile reverberates back through a long list of Leonardesque and earlier smiles, and forward into that of John the Baptist (82), which is the smile of both Bacchus and the angel of the Annunciation, and both male and female. The woman's hair descends in liquid waves recalling the final pattern of the deluge (61) and also a drawing (81) in which a Leonardolike magus contem-

80. *Lady with an Ermine.* Detail. Leonardo

81. *Hair and Water.* Leonardo

plates (or seems to, for the sheet was once folded in the middle) swirling water and a note that may reflect his thoughts:

> Observe the motion of the surface of the water which re-sembles that of hair, which has two motions, of which one depends on the weight of the hair, the other on the direction of the curls . . .

There are mirrors and echoes everywhere. The macrocosm is the image of the microcosm. The reddish and blue mountains are the bones of an animate-inanimate organism that has its secret affinity with the skeleton of the woman; they are also — if we have in mind Leonardo's advice to painters short of ideas — like the stains on an ancient wall in Florence, Milan, or Rome sometime early in the 1500s. The distant peaks are even audible, if you have a Leonardesque sensibility and a sharp listening eye, and in that state they are deliciously resemblant, for in their color perspective they are supposedly like musical intervals and through their resonance with leprous walls they are, in the artist's own simile, "like the sound of bells in whose jangle you may find any name or word you choose to imagine."

The ambiguity part of the subject of the picture is already present, of course, in the analogy part, for if "everything can be turned into everything else" everything is highly equivocal. The ambiguity part can be perceived, however, in other ways, and quite easily: the most subject-resistant of viewers, those who find the life-death contrast too crude for acceptance and the multiple analogies too fancy, not to say invisible, will be apt to agree that in any event the *Mona Lisa* is certainly a very unde-cided sort of creation. It is sly about the identity of its strongly individualized personage and at last leaves her in the status of a nameless, and apparently storyless, fictional character, a Piran-dello girl in search of a play. It dresses her in a costume of no

particular time and no particular place; it refuses to provide her with a helpful emblem or accessory, and gives her instead a completely baffling endless-knot ornament. It hints at Christian iconography and at pagan allegory, and then seems to withdraw all such suggestions. It is psychologically and perhaps sexually uncommitted, and seemingly deliberately so; the delicately blurring touches of *sfumato*, for instance, are applied around the eyes and the corners of the mouth in such a way as to leave these key expressive areas without a definable single expression. The space is inconsistent, and the background is divided and unsteady, like the landscape in a dream. Nor is this by any means all, for the painting is self-contradictory not only in its details but also in its message: the ambiguity is both a part of the subject and in a sense the whole of it. The woman and her background raise a familiar problem about the meaning of human life and consciousness in a nonhuman and unconscious universe, and at first the response seems to be that there is no meaning, that the situation is an absurdity. The Pirandello girl winds up in a piece by Samuel Beckett. Then there is a ripple of abracadabra, and suddenly the response, with the assistance of Anaxagoras, of a poetic, metamorphosing imagination, and of some Renaissance pseudoscience, seems to be that everything is acceptable because everything is analogous in the secret understructure of reality. But this, besides being inconsistent with the first response, is little more than a restatement of the problem, for there is not much comfort in being informed that all, our precious selves included, is in all. The felt contrast between the Us and the It, the human and the nonhuman, remains in the mind — as it does, very plainly, in the picture.

Hence the *Mona Lisa*, along with many of the masterpieces in all the arts, must finally be interpreted as simply an eloquent question. To insist on asking for the sense of these images of

existence and extinction, of fruitfulness and sterility, of smiling self-aware humanity and grimly unaware cosmos, is ultimately futile, for the painting, in spite of its insinuating manners, has no intention of giving a definite answer. Like *Hamlet*, a work it resembles in ambiguity, and like real life, it is asking *us*.

Was Leonardo deeply concerned with his unanswered question? He did not have to be, of course; only mediocre artists, it has been said, are completely sincere. He was certainly capable of imagining predicaments that were not his own, and he delighted in puzzles as such. Still, it is not unlikely that into this picture he projected, if only in an indirect fashion, a personal failure to solve common existential and metaphysical problems. He may have been skeptical about a divine order in the universe, for according to Vasari — in a passage suppressed in the revised edition of the life — he "did not adhere to any kind of religion, believing that it was perhaps better to be a philosopher than a Christian." Apparently he had doubts from time to time about the premises of his scientific work, for in one of his notes he remarks mysteriously, as if the ironic, poetic, Hamlet side of his mind were rebuking the naively positivist Horatio side, that "nature is full of infinite causes that do not come within experience." He was forced to admit tacitly that the mathematical system in which he professed to believe did not fit the flux of observed phenomena. Moreover, during the latter part of his career he had to live with disappointments which, while not specifically philosophical in their implications, could well have fostered a what-is-it-all-about feeling. His works were few in comparison with those of his young rivals, Michelangelo and Raphael, and time the despoiler was acting with unusual swiftness. After some fifteen years of labor and hope, the completed colossal clay model of his horse for the Sforza monument in Milan had ended up as a target for French soldiers and had then

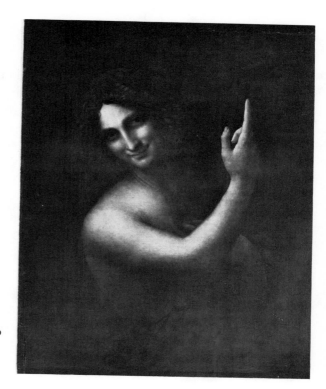

82. *St. John the Baptist*. Leonardo

crumbled away in the rain in a Ferrara courtyard. ~~Before the~~
~~Mona Lisa was finished, the Last Supper was decaying and the~~
~~Battle of Anghiari, his third monumental project, was half a~~
~~ruin.~~ The dearly purchased knowledge he had accumulated in
his notebooks was almost impossible to edit into publishable
form. Too much should not be made of these disappointments,
for he had an immense reputation that could have persuaded him
that his existence had meaning. Nor should too much be made
of his reported lack of religious faith, for in his will he ordered
for himself a splendid Christian funeral, with sixty torchbearers.
But against the evidence of this perhaps merely conventional
document can be placed the implications in the startlingly un-
conventional *St. John the Baptist* (82), painted only a few years

before his death. Here we have what can be considered a last artistic testament, a final effort to deal pictorially with ultimate puzzles comparable to those evoked in the *Mona Lisa;* and the resulting images are a pagan smirk and a finger jabbing the darkness.

X

THE COURTESAN

DURING THE MOVING, learned, and worldwide celebration in ~~1952~~ of Leonardo's five-hundredth birthday a group of French ʾ3 curators took a census of reasonably old versions of the *Mona Lisa*, and came up with no less than sixty-one that were thought worthy of scholarly attention. Almost as surprising as the number was the geographical distribution; interesting things were noticed, for instance, in French provincial collections at Tours, Bourg, Quimper, and Mulhouse, and in such distant spots as Rome, Leningrad, Florence, Baltimore, Bologna, Oslo, Innsbruck, Madrid, Stuttgart, Algiers, and the aristocratic homes of England. Today the list of both works and places would be considerably longer, for the publicity accompanying the exhibition of the painting in Washington, New York, Tokyo, and Moscow has encouraged private collectors and museum directors to look around in their attics and reserves — and often to

summon newspapermen for an allegedly sensational revelation.

Some of the copies are of very uncertain dates, of course, and others are perhaps copies of copies. But many are unquestionably early. One now in the possession of the Louvre, for example (83), includes the columns of Leonardo's intact original, shows signs of having been executed by an Italian, and appears in inventories of the French royal collection dating back at least to the reign of Louis XIV. Versions in the Walters Art Gallery in Baltimore and in the collection of the Vernon family in the United States are among others that show the uncropped condition. Several of these pictures are good enough to have been attributed at one time or another to Leonardo himself — although without winning, it should be firmly added, the assent of any significant number of specialists. Others have been assigned, on persuasive stylistic grounds, to immediate disciples and may have been painted in Milan before 1513, when the original was presumably taken by its creator to Rome. An especially fine one (84), with a clarity and an expressiveness that compensate for the lack of the landscape, is now in the Prado in Madrid; it is perhaps by a sixteenth-century Spanish master who worked for a while in Italy or France.

Along with the more or less faithful early copies and the free "interpretations" must be considered a number of Renaissance pictures that reveal, again more or less, the influence of Leonardo's work. A rather diffused but recognizable Gioconda inspiration can be seen, for instance, in the *Margherita Colleoni* of Bernardino de' Conti, a close Leonardo follower, and in a *Charles d'Amboise* that has been attributed to another, more gifted follower, Giovanni Antonio Boltraffio; and both portraits were painted only a few years after the *Mona Lisa*. The Gioconda smile — admittedly often mixed with reminiscences of other Leonardesque smiles — flickers through the work of a

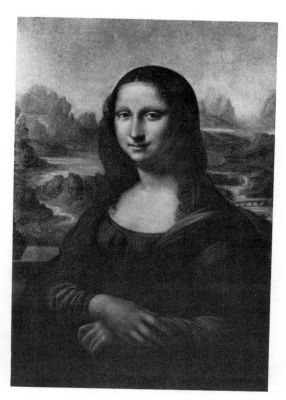

83. Italian copy of the *Mona Lisa*. Anonymous

84. Spanish copy of the *Mona Lisa*. Anonymous

dozen other minor Italian masters of the sixteenth century and also, combined with soft Leonardesque modeling, through that of such major talents as Andrea del Sarto and Correggio. The Gioconda pose, with its easy naturalness, its seeming inevitability, and its strange authority, fascinated Raphael during most of his career. It appears not only in his drawing of 1504 and the *Lady with a Unicorn* but also in his portraits of Maddalena Doni (86) and of the unknown, curiously repressed-looking woman traditionally called *La Muta*, the mute (87), both of which were painted around 1506 or 1507 in Florence; and it reappears with slight modifications some ten years later in his *Baldassare Castiglione* (85), the perfect psychological portrait of the perfect Renaissance courtier, intellectual, and dandy.

85. *Baldassare Castiglione.*
Raphael

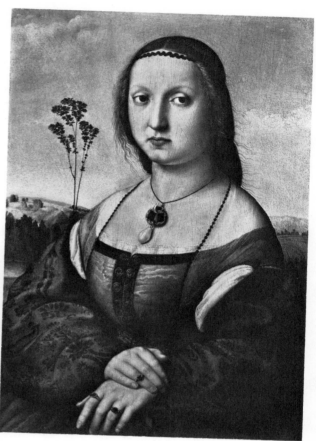

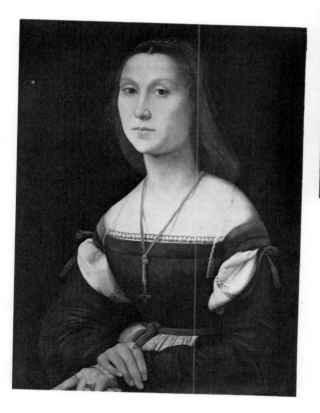

86. *Maddalena Doni*. Raphael

87. *La Muta*. Raphael

Move forward perhaps twenty years beyond the *Castiglione,* and the pose can be discovered making its way into northern Europe as part of the fresh charm of a Flemish Gioconda in her Sunday bonnet (88). In short, the *Mona Lisa* obviously did not take long to emerge from the obscurity surrounding its beginnings (an obscurity that was not, of course, nearly as dense for Leonardo's contemporaries as it is for us). And by adding early critical comment to the number of early copies and derivatives, with due allowance for all that has not survived, we can conclude that the picture went on manifesting its mana at an accelerating rate throughout the first hundred and twenty-five years or so of its existence. In other words, instructed by our knowledge of what happened later, we can sense that here it all began, that during this period the eventually immense, bizarre, proliferating Gioconda myth began seriously to sprout, and we can immediately ask why — from the point of view of people in the sixteenth century and the first part of the seventeenth. Some of the explanation may be that Leonardo's slim output, perhaps thirty finished paintings during his entire career, and his legendary reputation tended to amplify the response to the few things from his hand that could be seen. A similar combination of rarity and reputation certainly helped to create a mythical aura around Giorgione's works, for instance, whereas those of the relatively prolific Titian were merely highly admired. Another factor, especially after the middle of the sixteenth century, was what a modern public-relations man would call excellent, snowballing promotion: the fact that Vasari could rely on hearsay for his long, eloquent description implies that the picture was much talked about in the 1540s, and the success of his book evidently stimulated more and more talk. (He proudly remarks in his edition of 1568 that eighteen years earlier not a single volume of the first edition had been left on the shelves of booksellers.)

The main explanation, however, if we can trust contemporary commentators, is simply that early viewers were startled, dazzled, and obscurely troubled by Leonardo's skill as an illusionist — by the fact that the "courtesan in a gauze veil," as the personage continued to be called in France long after "the Gioconda" was adopted by readers of Vasari, looked magically alive.

Praising a painting for its lifelike quality was an ancient critical habit, of course, which during the Renaissance degenerated into a way of paying ready-made compliments. But in the minds of pioneer admirers and mythicizers of the *Mona Lisa* the commonplaces seem to have suddenly lost their triteness and acquired literal meanings. De' Beatis refers to the picture as "done from the life," *facta di naturale,* and "most perfect." Vasari is

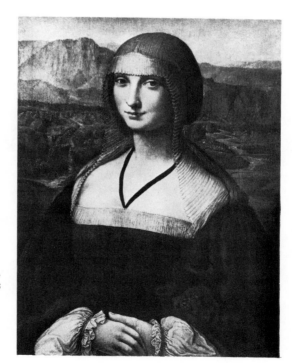

88. *Flemish Gioconda.*
Anonymous

inspired by his informant to marvel ecstatically at "how faithfully art can imitate nature," at the "natural lustre and moistness" of the eyes, at the beating pulse in the pit of the throat, at the "living flesh" of the mouth, and at a general effect "as alive as the original," and the inaccuracies in the account do not weaken its validity as evidence of what was thought about the picture. In 1584 the Florentine writer Raffaelo Borghini continues in the same vein, observing that the work is such "that art can do no more." In 1625 Cassiano dal Pozzo, one of the leading scholarly antiquarians in Rome and a patron of the young Nicolas Poussin, visited the French court and wrote an exact description of the painting that makes Vasari look like a careless schoolgirl but supports the biographer's critical emphasis:

> A life-size portrait, half-length, of a certain Gioconda, in a carved walnut frame. This is the most finished work of the painter that one could see, and lacks only speech, for all else is there. It represents a woman of between twenty-four and twenty-six years old, seen from in front, but not entirely full face, as Greek statues are. It has certain delicate passages around the lips and the eyes that are more exquisite than anyone could hope to achieve. The head is adorned by a very simple veil, but this is painted with great finish. The dress is black, or dark brown, but it has been treated with a varnish which has given it a dismal tone, so that one cannot make it out very well. The hands are extremely beautiful, and, in short, in spite of all the misfortunes that this picture has suffered, the face and the hands are so beautiful that whoever looks at it with admiration is bewitched. Note that his lady, in other respects beautiful, is almost without eyebrows, which the painter has not recorded, as if she did not have them.

The mention of "delicate passages around the lips" is the only allusion to the smile, although Vasari's description of it is proof

that by 1625 it had long been famous. There is no sign of awareness of an allegedly enigmatic personality; the woman is dismissed offhandedly, on the basis of an evident familiarity with the Italian tradition, as merely "a certain Gioconda." Dal Pozzo is mostly impressed by Leonardo's technique, and there is only the romantic word "bewitched" to hint at future developments of the myth.

The early bewitching must have been facilitated by fairly early exhibition. The older Italian copies, Raphael's borrowing of the pose, and the account by de' Beatis of the visit to the manor of Cloux all suggest that Leonardo himself often brought out the painting, or at first a cartoon, for a studio viewing by fellow artists or illustrious guests; and conceivably Francesco Melzi, who was not only a faithful follower but also his master's principal heir in France, continued the custom for a while after Leonardo's death. The main credit, however, for wide sixteenth-century dissemination of the spell of "the courtesan" belongs unquestionably to Francis I (89), whose admiration for her creator was nearly boundless. (He once remarked in Benvenuto Cellini's presence, sometime around 1540, "that he did believe no other man had been born who knew as much as Leonardo, both in sculpture, painting, and architecture, so that he was a very great philosopher.") Exactly how the king acquired the *Mona Lisa* is unknown; according to a persistent legend, which cannot be traced back beyond the middle of the seventeenth century, he purchased it for the huge sum of four thousand gold crowns, and according to a good guess he obtained it, in line with his position as the painter's royal patron, for nothing. In any event, by the mid-1530s he had it with him in his favorite chateau, Fontainebleau, and there he put it in his favorite recreation and cultural center, the Appartement des Bains.

Such apartments, distantly related to the ancient Roman im-

89. *Francis I*. Jean Clouet (?)

perial baths, had been the rage in Italy for about twenty years;
there were elegant ones in several town houses in Rome, and an
amazing one at Mantua in Federigo Gonzaga's Mannerist plea-
sure house, the Palazzo del Tè. Few, however, could have been
comparable in luxury to the one at Fontainebleau. It was a suite
of six rooms, decorated by the recently imported Italian Man-
nerist Francesco Primaticcio and his pupils with a mixture of
mythological murals and svelte stucco nymphs which, according
to contemporary descriptions, was similar to the mixture that has
survived, with restorations and alterations, on the floor above in
the Gallery of Francis I (90). One room was devoted to bath-
ing, two to steaming and sweating, and the remaining three to

dressing, resting, dallying, gaming, talking, and looking at the easel pictures that were hung in the framework of stucco statues. In addition to the *Mona Lisa* there were apparently some twenty or thirty other items from the royal collection, which by this time included works by, among others, Perugino, Raphael, Andrea del Sarto, Fra Bartolommeo, Giulio Romano, and Sebastiano del Piombo. It has been said that the Louvre Museum was born in Francis's bathroom at Fontainebleau, and in fact the place was often permitted to function as a semipublic art gallery, devoted primarily to the official policy of bringing the Italian Renaissance to a France that in many respects was just emerging from the Middle Ages. Painters and engravers were encouraged to come in for copying sessions, student artists were taken on

90. Gallery of Francis I, Fontainebleau

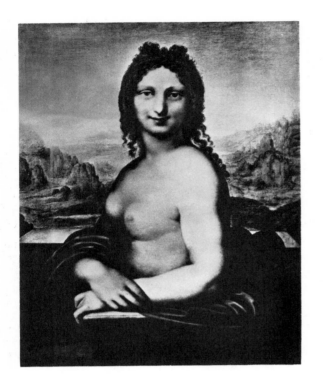

91. *Nude Gioconda.* Anonymous

92. *Nude Gioconda.* Joos van Cleve

93. *Nude Gioconda.* Barthel Bruyn

conducted tours, courtiers were allowed to wander in and out, and important visitors to the chateau were shown around by a special concierge — a sort of curator, one gathers — or by the king himself, who is recorded as having served as gallery guide in 1543 for the ambassador of Henry VIII of England. There can be little doubt that a masterpiece in the Appartement des Bains was seen by a lot of people.

Much of the permanent decoration of the apartment was frankly and cheerfully erotic, and the atmosphere thus created may have partly conditioned the first of many detours in the development of the *Mona Lisa* myth — a sudden multiplication, early in the Fontainebleau period, of versions of the *Nude*

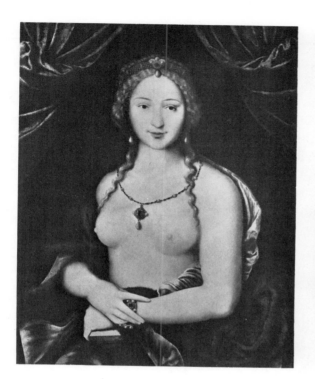 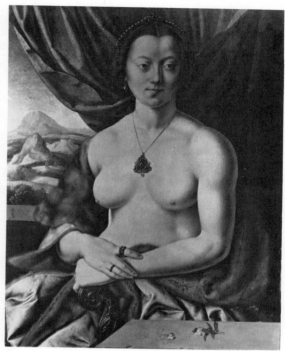

Gioconda. All are evidently somehow related to the lost supposed original by Leonardo or to the supposed studio copy (38), and some are also connected, by the inclusion of a loggia and a mountainous landscape (91), with the surviving painting. The subject appealed especially to painters in northern Europe; the Antwerp master Joos van Cleve, who is thought to have worked at the court of Francis I sometime before 1540, converted the naked personage into a feline Flemish whore (92), and one of his painting contemporaries in Cologne, Barthel Bruyn, provided her with a fur drape, rings, and flowers (93). In France the numerous variants, assisted by overtones from such popular themes as the toilets of Venus and Psyche, contrib-

uted to the emergence of one of the stock images of the School of Fontainebleau: the royal mistress in her tub (94). The effect of all this on appreciation of the *Mona Lisa* can only be guessed, but it seems to have been to give Leonardo's fictional character a reflected nuance of sophisticated sexuality, a nuance she has never quite lost. From the status of a courtesan in the old sense of a lady of the court she apparently moved a bit in many imaginations toward that of a courtesan in the sense, already current in sixteenth-century French, of a high-class prostitute — a hetaera, *une grande cocotte*.

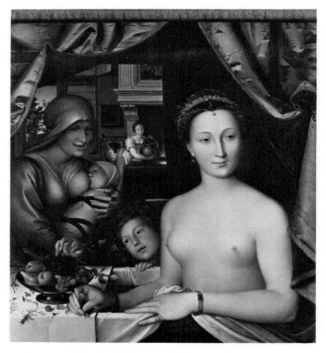

94. *Lady in Her Bath*. François Clouet

XI

FROM PALACE TO MUSEUM

AT THE END of the sixteenth century the easel paintings in the Appartement des Bains were showing signs of the deteriorating effect of humidity, and so they were transferred to a specially conceived Cabinet des Tableaux on the first floor of a part of the chateau that henceforth was usually called the Pavillon des Peintures. (The decoration of the bathroom suite, with copies on canvas replacing many of the original Italian panels, resisted dampness and royal demolitionists until 1697, and then fell victim to the taste of Louis XIV for something more stately.) In 1608 Jean de Hoey, a painter from Utrecht whose qualifications included being a grandson of the much-admired Lucas van Leyden, was appointed keeper of the collection; his officially prescribed duties were to stand guard over "the old pictures" at Fontainebleau and, rather ominously, "to restore those that are damaged, painted in oil on wood or canvas, together with clean-

ing the borders of the fresco pictures in the chambers, halls, galleries, and smaller rooms of the said chateau." When de Hoey died, seven years after his appointment, he was succeeded as keeper by his son Claude; and one or the other may have been guilty, perhaps with extenuating circumstances, of cropping the sides of the *Mona Lisa* and thus removing the columns that are visible in early copies. The thick varnish, however, should probably not be blamed on them, for Cassiano dal Pozzo's reference to it as having given the dress "a dismal tone" indicates that it was already fairly old when he saw it in 1625, and suggests that it may have been applied as protection against moisture during the heyday of the Appartement.

Neither vandalistic cropping nor dismal coats of varnish deterred admiration, which was such that, shortly before dal Pozzo wrote his description, the painting was almost carried off to England to join Charles I's collection (soon to become, with the spectacular purchase in 1627 of the bulk of the Gonzaga collection at Mantua, the largest and finest in Europe). The occasion for the attempted abduction was a visit to Fontainebleau in the spring of 1625 by the Duke of Buckingham, then virtually the ruler of England, who had come over to France from London to promote a war with Spain, flirt with the French queen, and make the final arrangements for the marriage by proxy of Charles I with Henrietta Maria, the youngest sister of Louis XIII. The duke was himself an avid and discerning art collector; he was also a tactless man in whom a meteoric career as a royal favorite had instilled a conviction that he could always have what he wanted; and in this instance what he wanted, he made plain to the French king, was the portrait of the courtesan with the veil. Louis, who was only twenty-four, habitually deferential, and at bottom not much interested in pictures, was on the point of granting the English request when he was dissuaded, dal

Pozzo says, "by the entreaties of several persons who advanced the consideration that His Majesty was sending his most beautiful painting out of the kingdom." Buckingham reacted to these interventions with much "resentment" and "displeasure," and dal Pozzo adds that "one of the people to whom he complained was Rubens of Antwerp," who had just arrived at the French court for the inauguration of his decorative series (now in the Louvre) on the life of Maria de' Medici. Does all this mean that Rubens should be given part of the credit for saving the *Mona Lisa* for France? Probably not, for in 1625 he was Buckingham's portraitist, diplomatic interlocutor, and personal friend. But that he was among the "several persons" who thought that the *Mona Lisa* was the most beautiful painting in the kingdom is not impossible, for he had long admired Leonardo's work in general and had made a spirited copy of the central episode in the *Battle of Anghiari.*

The production of derivatives and variations continued, often perhaps at several removes from the original, like some of the master's own echoing analogies. Thus the fact that in 1641 Agatha Van Schoonhoven, the charmingly plain wife of the burgomaster of Haarlem, was portrayed in the Gioconda pose (95) does not necessarily mean that her painter, Jan Verspronck, had visited Fontainebleau, for by that date the pose, in

95. *Agatha Van Schoonhoven.*
Jan Verspronck

one form or another, could easily have visited Haarlem: Raphael's portrait of Castiglione (85), for instance, had been copied by Rubens early in the century, had been shipped to Amsterdam for a sale in 1639, had been sketched on that occasion by Rembrandt, and had been acquired by a Spanish collector in Holland. (Acquired only temporarily, one should add, for soon the picture was in the collection of Mazarin, whose heirs sold it to Louis XIV in 1661.) Even when the influence was presumably quite direct, its effect could be surprising. Thus, about the time that Agatha was being painted, a French provincial artist who has been identified as a certain Jean Ducayer may indeed have visited Fontainebleau, but certainly without excessive respectfulness, for the surviving result (96) is an interpretation of the *Mona Lisa* in which an embroidered bodice adds a touch of folksiness to the alleged *grande cocotte*. Meanwhile, there were additional nude Giocondas; one painted sometime in the first part of the 1600s shows the model surrounded by flowers (97) and can encourage the feeling that, if all the missing evidence could be found, we would discover that at one stage in its evolution the *Mona Lisa* was a mythological or allegorical work, a cousin of the extant studio *Flora* or *Colombine* (29). By 1642 there were enough nude variations in existence to give point to a protest by Père Dan, the author of a Fontainebleau guidebook, that the clothed version was not only "first in esteem, a marvel of painting," but also a depiction "of a virtuous Italian lady and not of a courtesan, as some people believe." The myth was evidently flourishing.

Well-known professional artists and academic critics were among the admirers. In 1649 Abraham Bosse, celebrated for engravings of French upper-middle-class life and manners, praised the painting because "the light and shade are, so to speak, elasticized, blended, melted, or made to vanish together, and a

96. *Gioconda with Bodice.*
Jean Ducayer (?)

97. *Nude Gioconda.*
Anonymous

great many of the protuberances are very rounded out," all of which was a discerning compliment the *sfumato*-minded and relief-minded Leonardo would certainly have appreciated. Two years later, when the first edition of the *Trattato della Pittura*, in both Italian and French, was published in Paris, it included an engraving of the *Mona Lisa* as the only illustration taken from the master's works. (Dal Pozzo, who edited the manuscript material, persuaded his friend Poussin to draw the rest of the illustrations, which were of a didactic sort.) In 1666 the French

architect and art theorist André Félibien des Avaux, whose imaginary conversations about famous painters were used as a teacher's handbook during most of the reign of Louis XIV, continued the sixteenth-century emphasis on the magic naturalism in the work:

> Truly . . . I have never seen anything more finished or expressive. There is so much grace and so much sweetness in the eyes and the features of the face that it seems alive. And in looking at this portrait one has the impression that this is indeed a woman who takes pleasure in being looked at.

The judgment was not as routine as it may seem, for earlier in the conversation a speaker had complained that Leonardo had sometimes gone "beyond what art can do," had created "figures that are not quite natural," and had "put too much black in the shadows."

By the time Félibien was writing, the *Mona Lisa* had begun to travel again. Sometime in the 1650s it had been transferred, with the bulk of Francis I's Italian collection and with a third-generation de Hoey as keeper, from Fontainebleau to the Louvre, which after a period of neglect was being temporarily favored as a royal residence. By 1695, according to an inventory, and probably for some years before then, the painting was in the Petite Galerie of Louis XIV at the chateau of Versailles. In 1706 it was back in Paris as part of the Cabinet des Tableaux installed in the palace of the Tuileries. Three years later it was in Versailles again, and in 1720 it was still there, in the first salon of the Petite Galerie along with fifteen other masterpieces selected from the now immense royal collection. (Colbert, perhaps Louis XIV's most art-conscious minister, had increased the number of pictures owned by the crown from some two hundred to more than two thousand.) All this shuttling seems not

to have hampered appreciation. In 1717 Leonardo's panoramic background was apparently hovering in the imagination of Watteau, along with the landscapes of Bruegel and other northern artists, when he painted the distant, dreamlike mountains in his *Pilgrimage to the Island of Cythera* (98). In 1720 a look at the supposed Lisa del Giocondo led Jean Baptiste de Monicart, the author of *Versailles immortalisé*, into an enthusiastic mixture of doggerel and weak pronoun reference:

> Il a fait Lise encor femme de Gioconde
> Et Florentin de nation:
> Les contes faits en vers sur lui comme son nom,
> Firent et font toujours un grand bruit par le monde:
> Qu'on croit aussi le plus parfait
> Des ouvrages de ce même homme.

98. *Pilgrimage to the Island of Cythera*
Detail. Antoine Watteau

He did Lisa also wife of Giocondo
And Florentine in nationality:
The tales told in verse about it, like its name,
Have made and continue to make a great stir in the world:
It is also considered the most perfect
Of the works of this same man.

Unfortunately "the tales told in verse," which may have contained some interesting information about the evolution of the Gioconda myth (if the word *lui* is to be read as referring to the picture), have not come down to us.

During the rest of the eighteenth century the *Mona Lisa* appears to have been relatively unnoticed. One reason was a disposition in classicizing circles, especially after about 1750, to regard all naturalistic painting as something inferior to work in the Grand Manner — to work that subordinated the particular in an effort to depict the universal or the ideal. A more important reason, however, was simply that in general the French royal collection was no longer as visible as it had been in the sixteenth and seventeenth centuries, when monarchs like Francis I and Louis XIV had lived in full view of their subjects and had proudly exhibited their treasures to the world. Compared with his predecessors, Louis XV was almost a private citizen in his style of living, and he was inclined to disperse his paintings in such out-of-the-way places as the storerooms of the Direction des Bâtiments, which was the rough equivalent of a modern ministry of fine arts. Eventually the situation became bad enough to provoke a campaign of protest: a pamphlet printed in Paris in 1747 vigorously deplored the impossibility of admiring "the most valuable works of the great European masters in His Majesty's collection, buried in the badly lit little rooms [of the Direction des Bâtiments] into which they are now crowded, hidden in the town of Versailles, unknown to foreigners or of

no interest to them because of their inaccessibility." Partly as a result of the campaign, rotating exhibitions of a selection of the king's pictures were staged, with tremendous success, in the Luxembourg palace in Paris between 1750 and 1779, and plans were laid for transforming the royal collection into a public one and housing it in a museum to be created in the Louvre. But the *Mona Lisa* remained almost hidden; inventories taken in 1760, 1784, and 1788 reveal that it spent much of the second half of the century in one of the "badly lit little rooms" in the Direction des Bâtiments. Although after the fall of the monarchy it became, along with the rest of Louis XVI's pictures, in theory the property of the French nation, it continued for several years to be seen mostly by government people, their friends, and their cleaning women. In 1800 it is listed as hanging in Bonaparte's bedroom in the Tuileries.

Meanwhile the Revolution had interrupted and then accelerated progress on the Louvre project. The new museum was officially opened in 1793, and closed a few months later when the palace was found too dark and decrepit for the proper exhibition of works of art. There was a long period of renovation, in which one of the most active spirits was the painter Hubert Robert, who had participated in the original planning under the old regime and who had a talent for dramatic visualization of the various ideas that were being advanced — in particular those involving overhead lighting from roof windows (99). The building was not fully and permanently open to the general public until 1801, by which time local warehouses were gorged with aesthetic objects confiscated from French aristocrats and religious orders or taken by victorious French armies in Belgium, Holland, Italy, Germany, and Austria. Until Waterloo brought about the return of most of the foreign booty, the Musée Napoléon, as it was called after 1803, was the largest and

99. *Grande Galerie of the Louvre*. Hubert Robert

best art show the world has ever seen, and it was also possibly the largest art school, for certain days were reserved exclusively for copyists. On the days for the general public the appeal was such that, according to police files, the main entrance became the favorite soliciting place for Paris prostitutes.

Madame Lisa, as Bonaparte referred to her, remained in the eventually imperial bedroom until 1804. Then she was carried across the gardens of the Tuileries and installed in the Grande Galerie of the Louvre, in the company of several other survivors from Francis I's bathroom and of a host of newcomers from the galleries of Florence, Rome, Venice, Turin, Milan, Parma, Modena, Cremona, Bologna, Perugia, and waypoints.

XII

FEMME FATALE

DURING THE nineteenth century the Gioconda myth rapidly ripened into an outré lushness, like a giant orchid in damp moonlight. Leonardo's fictional personage became a popular star comparable in drawing power to a Paganini or an idolized opera singer, and at the same time an incarnation of all the most sultry vamps of history. Some of the ingredients for such a success had long been present, of course; one can see them in Vasari's "divine" smiler, in the Fountainebleau "courtesan" and her naked versions, in dal Pozzo's "bewitched" reaction, in Félibien's "woman who takes pleasure in being looked at," and in the painting itself — in its aliveness, ambiguity, and general strangeness. Now, however, the ingredients found exactly the right conditions for growth. The opening of the Louvre Museum made the picture available for viewing by everybody from emperors to shop girls, multiplied the number of painted copies and

engraved reproductions in circulation, and fostered, in this instance as in many others, an anecdotal, bourgeois-democratic sort of appreciation. As the century advanced, other conditions emerged from the climate of Romanticism as a whole and from the climates of such Romantic submovements as Neo-Gothicism, Aestheticism, Decadence, and Symbolism.

The age, even more perhaps than the Renaissance, was one of heroes and hero worship, of belief in the supernatural nature of artistic talent, and of cozy storytelling about the great men of the past. Leonardo, well provided with anecdotes by Vasari, lent himself admirably to the tendency; and Leonardolatry encouraged Giocondolatry. Goethe, early in the century, set the pattern by stressing the "universal genius" of the inventor of the *Mona Lisa*. A generation later Jakob Burckhardt, whose *Cicerone* become a favorite guidebook to Italy for German art students, was praising the painter as "free and sublime," and Baudelaire was including him among the *phares*, the lighthouses, of humanity:

> Léonard de Vinci, miroir profond et sombre
> Où des anges charmants, avec un doux souris
> Tout chargé de mystère, apparaissent à l'ombre
> Des glaciers et des pins qui ferment leur pays.

> Leonardo da Vinci, mirror deep and dark,
> Where fascinating angels, with a gentle smile
> All charged with mystery, appear in the shadow
> Of the glaciers and pines that shut in their country.

In 1818 the supposedly but not actually anti-Romantic Ingres contributed to the cult by illustrating (100) Vasari's legend of how the artist, "conscious of the great honor being done to him," died at the manor of Cloux in the arms of Francis I (who in fact was in the suburbs of Paris that day). In 1845 the now

100. *The Death of Leonardo.* J. A. D. Ingres

forgotten but once popular Aimée Brune-Pagés brought the cult
and the Gioconda myth together in a grand troubadourish can-
vas (101), exhibited at the French official Salon and widely
diffused by an engraving, showing Leonardo painting a rather
peaked and bored Lisa, with Vasari's "singers and musicians or
jesters" on one side of the easel and an admiring young Raphael,

accompanied by the mathematician Luca Pacioli in his Franciscan friar's robe, on the other side. All that was needed for secular sainthood was a suitable relic, and this was supplied by the Paris journalist and novelist Arsène Houssaye, who in 1863 went down to Amboise, did some digging among the scattered skeletons under the site of the demolished church of St. Florentin, and came up with a skull which his intuition told him was Leonardo's, for it was unusually massive and "the handsome brow seemed to be still inhabited by meditation."

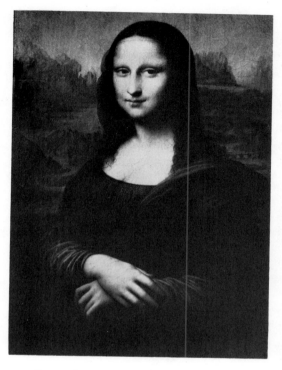

102. Copy of the *Mona Lisa*. Théodore Chassériau

101, opposite. *Leonardo Painting the Mona Lisa.* Aimée Brune-Pages

103. *Woman with a Pearl.* J. B. C. Corot

Although painters as gifted as Chassériau (102) and Corot (103) kept up the tradition of high-quality *Mona Lisa* copies and derivatives, the expansion of the myth was largely the work of literary people. The Marquis de Sade, who may have seen the picture, or a copy, toward the close of his career during one of his moments out of prison, declared — perhaps with ironical overtones proper to his special tastes — that the personage was

full of "seduction and devoted tenderness" and was "the very essence of femininity." Soon the gothic romancers of the period were at work, in a style that can be imagined from a parody written in 1822 by the London painter, critic, and aesthete Thomas Griffiths Wainewright (who later won notoriety by poisoning his sister-in-law, uncle, mother-in-law, and a friend, and thus inspiring stories by both Dickens and Bulwer-Lytton). An innocent maiden is standing in front of a copy of the painting:

> She gazed on the wily eyes of Gioconda, she knew not why. The light of the lamp mingled strangely with the light of dawn: the eyes looked at her altogether painfully, and the corners of the mouth curled slightly upwards . . . Could it be that the imaged lips were indued with the power of evoking like phantoms? For, lo! they move; and the eyes, closing up narrower and narrower, leer amorously at a masculine head which appeared over her shoulder . . .

Such mockery seems to have had no deterrent effect on the next generation of mythicizers — at least not in France. George Sand chose to describe the lover in her *Elle et lui* as thinking of his mistress as "a beautiful sphinx" who implied "treasures of affection, devotion, perhaps sensuality" by means of her habitual silence "and a certain smile, mysterious like that of Mona Lisa, which she had on her lips and in the corner of an eye." In their *Journal* the Goncourt brothers could not refrain from referring to an unconventional woman as being like "one of those courtesans of the sixteenth century, one of those instinctive and dissolute creatures who wear like a magic mask the Gioconda smile full of night." Even the sober Hippolyte Taine, whose mechanistic theory of art would seem to have excluded the more extreme flights of imaginative criticism, described the smile as

"doubting, licentious, Epicurean, deliciously tender, ardent, sad."

A very minor French poet, M. A. Dollfus, tried to solve the whole mystery of the painting by supposing that the sitter had been the artist's passionate, and vaguely jealous, mistress:

> Et comme il achevait son tableau, la Joconde
> Se jeta dans ses bras et lui dit: Quelque beau
> Que soit votre génie, et dût-il, en ce monde,
> Vivre, quand nous serons couchés dans le tombeau;
>
> Je n'en serai pas moins poussière, cendre, argile,
> Mon amour sera mort, l'amour qui fut ma foi.
> Quoi que vous en disiez, il sera plus facile
> De peindre comme vous que d'aimer comme moi!
>
> And as he finished his picture Mona Lisa
> Threw herself into his arms and said: However fine
> Your genius, and if it is destined in this world
> To live when we are lying in the grave,
>
> I shall be nonetheless dust, cinders, clay,
> My love will be dead, the love that was my religion.
> Whatever you may say, it will be easier
> To paint as you do than to love as I do!

Such theories were less common, however, than the notion that the personage had been, and indeed still was, a femme fatale. The art historian Charles Clément, writing shortly after the middle of the century, shook his head over "the thousands of men of all ages and all languages," who having looked at the painting and "listened to the lying words of those perfidious lips, carried to the four corners of the world the poisoned arrows in their hearts." A few years later the great Jules Michelet, in an apostrophe in his *Histoire de France* addressed partly to Leo-

nardo and partly to the picture, almost confessed that he himself
had become a victim of the fatal appeal:

> Art, nature, genius of mystery and of discovery, master of
> the profundity of the world, of the unfathomable abyss of
> the ages, speak, what do you want from me? This painting
> attracts me, calls me, invades me, absorbs me; I go to it in
> spite of myself, as the bird goes to the serpent.

Finally Houssaye, writing as a Parisian sophisticate who knew
about such matters, took it upon himself to warn unwary males
against the lovely trap that confronted them:

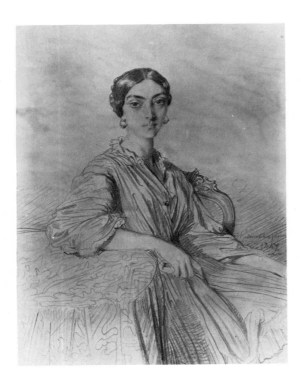

> Mona Lisa of the sweet name, bathed
> in the tawny light of amber . . . do
> not ask who she is, ask rather who she
> is not, this young girl who is so igno-
> rant, as full of grace as the Galatea of
> the poem, and yet a woman, treach-
> erously and deliciously a woman, with
> six thousand years of experience, a
> virgin with an angelic brow who
> knows more than all the knowing
> rakes of Boccaccio!

By this time, it can be remarked incidentally,
even the varnish had been transformed into
part of the myth.

104. *Princess Belgiojoso*. Chassériau

While the rhetoric was flowing, art and life — usually a rather arty sort of life — were being confounded. Extravagantly typical of the trend was the Italian expatriate Princess Cristina di Belgiojoso, who in the late 1830s became a lioness in French intellectual circles that included Liszt, Balzac, George Sand, Musset, and Heine. Her aura as a Romantic figure was brightened by some dabbling in revolutionary politics in Italy, and eventually by the fact that Austrian police found in a cupboard in one of her villas the embalmed corpse of one of her young lovers, who had died of tuberculosis and had been kept close at hand, the princess explained, so that she might conveniently decorate his "tomb" with flowers. From the available evidence she appears to have been generally a little deranged, and specifically more than a little nymphomaniacal. Her defects, however, did not keep her from sowing amorous confusion in Paris for a number of years. According to Balzac she stole Musset from Sand, and Liszt from the Countess d'Agoult, among other exploits; and Sand, in a letter to Liszt in 1835, relays the news that "cousin Heine has turned himself to stone in contemplation at the feet of the Princess Belgiojoso." Moreover, although this does not emerge very clearly from her known portraits (104), a principal reason for her success seems to have been her strikingly Leonardesque behavior and appearance. She reportedly had an irresistible way of interrupting a declaration of love with a fleeting smile *à la Lise*. A contemporary gossip writer, Delphine Gay, noted: "She is beautiful in the fashion of an old painting. Although young, she has a look of being covered with yellow varnish, and she seems to walk surrounded by a frame . . ." Heine wrote later, long after his passion was spent: "I shall never forget that face. It was one of those that seem to belong more to the fantastic realm of poetry than to the rude reality of life, with contours that reminded one of Leonardo da Vinci . . ." Houssaye, perhaps with more insight into

her compulsions, remembered her in his memoirs as "a pure masterpiece of an unsated Gioconda."

By the last third of the century, whether because of a filtering down of influence from the notorious princess or because of a contact with her source in the Louvre, the crooked little smile was fashionable among Paris prostitutes and also among a large number of unprofessional *allumeuses,* or sexual incendiaries, who were described by the Decadent poet Jean Lorrain as "the cut-rate Giocondas of painters' studios and aesthetes' barrooms." By that time, however, avant-garde literary appreciation of the *Mona Lisa* in France was dominated by Théophile Gautier's opinion, which had been published in the magazine *L'Artiste* in 1858 and then, five years later, in the book *Les Dieux et les demi-dieux de la peinture.* Although somewhat prolix in the manner of the period, it is worth quoting at length, for it has remained, Vasari's account aside, one of the two most influential interpretations of the painting ever written:

> The faces of Leonardo seem to come from the upper regions to be reflected in a glass, or rather in a mirror of tarnished steel, where their image remains eternally fixed by a secret similar to that of the daguerreotype. We have seen these faces before, but not upon this earth: in some previous existence perhaps, which they recall to us vaguely. How can we explain otherwise the singular charm, almost magic, which the *Mona Lisa* exercises on even the least enthusiastic natures? Is it her beauty? Many faces by Raphael and other painters are more correct. She is no longer even young; her age must be that loved by Balzac, thirty years; through the subtle modelling we divine the beginnings of fatigue, and life's finger has left its imprint on the peachlike cheek. Her costume, because of the darkening of the pigments, has become almost that of a widow; a crêpe veil falls with the hair along her face; but the expression, wise, deep, velvety, full of promise, attracts you irresistibly and intoxicates you, while the

sinuous, serpentine mouth, turned up at the corners, in the violet shadows, mocks you with so much gentleness, grace, and superiority, that you feel suddenly intimidated, like a schoolboy before a duchess. The head with its violet shadows, seen as through black gauze, arrests one's dreams as one leans on the museum railing before her, haunts one's memory like a symphonic theme. Beneath the form *expressed*, one feels a thought that is vague, infinite, *inexpressible*, like a musical idea. One is moved, troubled, images *already seen* pass before one's eyes, voices whose note seems familiar whisper languorous secrets in one's ears; repressed desires, hopes that drive one to despair stir painfully in the shadow shot with sunbeams; and you discover that your melancholy arises from the fact that Mona Lisa three hundred years ago greeted your avowal of love with this same mocking smile which she retains even today on her lips.

Here we are certainly a long way from the simple astonishment of the sixteenth century at Leonardo's skill. This is the world of Poe's tales, of Baudelaire's substitution of one sensation for another, and of Wagnerians listening with their heads in their hands. Daydreaming, musical analogies, and an appeal to a half-serious theory of metempsychosis have been substituted for critical analysis. Yet we cannot be sure that Leonardo would have been displeased by such an uncontrolled acceptance of the reality of his *finzione*. "Now," he might have repeated, "let the poet go and try to rouse such desires in men."

The other most influential account of the picture is, of course, Walter Pater's great organ peal, which was published in the British *Fortnightly Review* in 1869 and reprinted in 1873 in the book *The Renaissance*, along with such famous essays as the one on the poetry of Michelangelo and the one that set forth the credo of the new aesthetes: "To burn always with this hard, gemlike flame . . ." England at the moment was lagging in work on the *Mona Lisa* myth; even the Pre-Raphaelites, who

had the right sort of sensibility, had seen in the painting only what they called "dreamy beauty," and in a list of their favorite immortals they had ranked Leonardo only at the level of Browning. Pater, however, soon remedied matters:

> *La Gioconda* is, in the truest sense, Leonardo's masterpiece . . . The presence that rose thus so strangely beside the waters is expressive of what in the ways of a thousand years men had come to desire. Hers is the head upon which all "the ends of the world are come," and the eyelids are a little weary. It is a beauty wrought out from within upon the flesh, the deposit, little cell by cell, of strange thoughts and fantastic reveries and exquisite passions. Set it for a moment beside one of those white Greek goddesses or beautiful women of antiquity, and how would they be troubled by this beauty, into which the soul with all its maladies has passed! All the thoughts and experience of the world have etched and moulded there, in that which they have of power to refine and make expressive the outward form, the animalism of Greece, the lust of Rome, the mysticism of the middle age with its spiritual ambition and imaginative loves, the return of the Pagan world, the sins of the Borgias. She is older than the rocks among which she sits; like the vampire, she has been dead many times, and learned the secrets of the grave; and has been a diver in deep seas, and keeps their fallen day about her; and trafficked for strange webs with Eastern merchants; and, as Leda, was the mother of Helen of Troy, and, as Saint Anne, the mother of Mary; and this has been to her but as the sound of lyres and flutes, and lives only in the delicacy with which it has moulded the changing lineaments, and tinged the eyelids and the hands. The fancy of a perpetual life, sweeping together ten thousand experiences, is an old one; and modern philosophy has conceived the idea of humanity as wrought upon by, and summing up in itself, all modes of thought and life. Certainly Lady Lisa might stand as the embodiment of the old fancy, the symbol of the modern idea.

There is much here that is plainly borrowed, and much that is

far from relevant. As early as 1864 Swinburne, who was familiar with the work of Gautier and other French critics, had commented on the "fair strange faces" of Leonardo's women, "full of dim doubt and faint scorn," and on their ability to "allure and perplex the thoughts and eyes of men." Sinful Borgias, lustful Romans, delightfully pagan Greeks, mystical medieval saints and lovers, fatal women who had enjoyed many incarnations down through history, and vampires who knew the secrets of the grave were a part of stock Romanticism, used and reused in novels, poems, pictures, and operas. It should also be remarked that, unlike Gautier leaning on the railing in the Grande Galerie of the Louvre, Pater was remote from firsthand experience of the spell of the *Mona Lisa*. Indeed, he may have been partly inspired by another picture: he mentions Dürer's *Melancholia* (105) in his essay, and it has been pointed out that a good deal

105. *Melancholia I.* Albrecht Dürer

106. *Maitreya*. Detail.
Chinese, about 470

107. *Kouros*. Detail.
Greek, about
540 B.C.

of what he says — the references to the presence "that rose thus so strangely beside the waters," to the "weary" eyelids, to the "etched" thoughts, and to "the rocks among which she sits" — fits the German engraving rather better than Leonardo's painting. But when all the borrowings and the irrelevancies have been noted, and when all the deflating remarks about Oxford aestheticism have been properly registered, one can easily feel that they do not much matter, for the fact remains that in this jeweled, carefully cadenced, absurdly splendid piece of prose the Gioconda myth was crystallized into an unforgettable form.

Houssaye's knowing virgin "with six thousand years of experience," Gautier's "voices whose note seems familiar," and Pater's "fancy of a perpetual life" had as a visual counterpart an extension of the painting's original pattern of analogies further

108. *Kore*. Detail. Greek, about 520 B.C.

109. *Sphinx*. Greek, about 530 B.C.

and further into time and space. The supposed Lisa del Giocondo of the Via Maggio was metamorphosed into a cousin of smiling Buddhist saints, Archaic Greek youths and maidens, and notably the inscrutable, cruel sphinx of antiquity (106–109); and Leonardo's rocky panorama was made to resonate with the noble vistas created by ancient Chinese painters. The tendency was encouraged by what Pater calls "the idea of humanity as wrought upon by, and summing up in itself, all modes of thought and life," by the general expansion of sensibility that preceded the advent of modern art, and by the influence of verbal clichés that classified almost any puzzlingly inexplicit facial expression as "oriental" or "sphinxlike." Many, however, of the resemblances that were discovered can be called real, or at least as real as such things ever are in art; and they can therefore

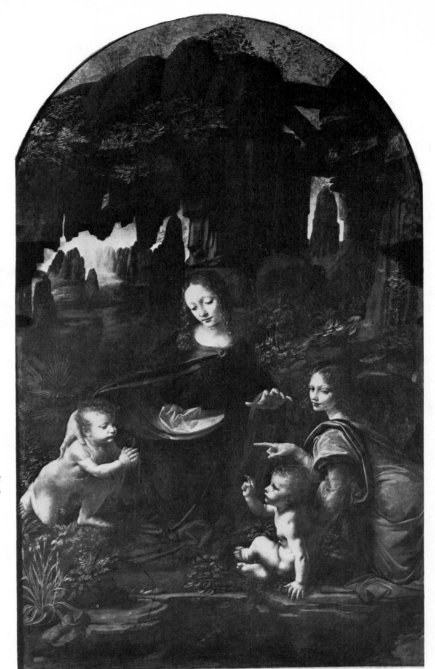

110. *Virgin of the Rocks*
(Louvre version). Leonardo

still invite theorizing. It has been suggested, not very convincingly, that some cheerfully grinning Etruscan funeral bronze, turned up for the boy Leonardo's viewing by a fifteenth-century peasant's plough in the Arno valley, may be the missing link between the Gioconda smile and the somewhat similar ones of Archaic Greek statues the painter could never have seen. With more evidence at hand, we can imagine a direct influence from a sphinx (109) on both the Gioconda smile and the Gioconda pose, for sphinxes are fairly common in Italian Renaissance art and one of the compound creatures may have inspired the curious crouch, impossible for a human being, of the pointing angel in the *Virgin of the Rocks* (110). More generally, historians can cite a persistence of many conventions down through the ages from the ancient world, Asia included, to the revival of pagan art in the Florence of the fifteenth and sixteenth centuries — a persistence subject to constant variation, and for that very reason apt to produce at a given moment a throwback to an early form. But probably the best, and at any rate the most interesting, explanation is simply that Leonardo had something in common, in terms of aims and sometimes of methods, with certain artists who were remote from him historically and geographically. Like the sculptors who carved the smiles on Greek sphinxes and kouroi, he was striving to penetrate the double mystery of the cosmos and of consciousness, and at the same time to create an illusion of reality. Although, contrary to the guesses of some enthusiastic modern analogizers, he almost certainly never saw a Sung or Ming painting, his somewhat Chinese feeling for distant mountains (111), for landscape as both a fact and a symbol, and for the wideness of the world led him in the *Mona Lisa* to reject converging lines and adopt a strikingly Chinese combination of aerial perspective with shifting viewpoints and parallel bands of scenery. His *sfumato* is comparable

111. *Buddhist Temple in the Hills.*
Detail. Li Ch'eng

to the tonal technique of Chinese ink painting, his wall-stain notion is remindful of Zen blots, and his idea of the microcosm and the macrocosm, although thoroughly Western, is in exact agreement with part of the old Chinese outlook. "Rocky formations," the eleventh-century master Kuo Hsi told disciples, "are the bones of the universe . . . Water is the blood of the universe."

In the hothouse of European fin-de-siècle literature, inhabited by androgynous Narcissuses, sadistic Salomes, and innocently evil Mélisandes, Leonardo's personage was perfectly at home. Mallarmé urged all modern artists to study the "painfully renascent" Gioconda smile in order to learn "the sense of the mystery of which Mona Lisa knew only the fatal sensation." D'Annunzio found the smile "glorious, cruel," and the mouth as a whole "a dolorous flower." The Paris poet, painter, and occultist Joséphin Péladan, who preferred to be known by his self-assumed "Babylonian" name, Le Sâr Mérodack, gave to one of the characters in his book *Le Vice suprême* a love poem addressed to a "perverted sphinx" who was also a "sister" of Mona Lisa:

Fidèle à ton vice monstrueux, Ô Fille du Vinci, Muse
Dépravante de l'esthétique du mal, ton sourire peut s'effacer sur la
 toile,
Il est facsimilé dans mon coeur . . .

Faithful to your monstrous vice, O Daughter of Vinci,
Depraving Muse of the aesthetic of evil, your smile may fade away
 on the canvas,
Its facsimile is in my heart . . .

In Vienna Hugo von Hofmannsthal sang of "the enigmatical, bitter-sweet mouth" and the "dream-heavy eyelids." The Ital-

ian aesthete Angelo Conti was one of the few writers to link the smile to the background:

> It is a movement, a light, which passes from the woman's lips and eyes into the winding rivers of the landscape, broadening and invading . . .

In England Michael Field (the pseudonym of Katharine Harris Bradley and Edith Emma Cooper) introduced a variation by noticing a hand:

> Historic, side-long, implicating eyes;
> A smile of velvet's lustre on the cheek;
> Calm lips the smile leads upward; hand that lies
> Glowing and soft, the patience in its rest
> Of cruelty that waits and doth not seek
> For prey . . .

Edward Dowden, with Keatsian fervor, appealed to the "sphinx of Italy" for a showdown that would end the puzzlement:

> Make thyself known, Sibyl, or let despair
> Of knowing thee be absolute: I wait
> Hour-long and waste a soul. What word of fate
> Hides 'twixt the lips which smile and still forbear?
> Secret perfection! Mystery too fair!
> Tangle the sense no more, lest I should hate
> The delicate tyranny . . .

In 1902 both Leonardolatry and Giocondolatry reached a peak — a very respectable one — with the publication in Russia of Dimitri Merezhkovsky's learned and sensitive *Romance of Leonardo da Vinci*. By that date the celebrated Florentine femme fatale and her portraitist could be thought of as "two

mirrors which, reflecting themselves in one another, were deepening to infinity":

> And, as though lulled by the music, walled off from actual life by the silence — radiant, a stranger to everything save the will of the master — Mona Lisa gazed straight into his eyes with a smile that was filled with mystery, like still waters, perfectly clear, but so deep that no matter how much the gaze plunged within it, no matter how it probed, it could not see the bottom — she was smiling upon him with his own smile.

XIII

CONCERNING PHANTASMS

THAT THE PAINTER had occasionally entertained monsters in his
unconscious could have been supposed from a casual examina-
tion of his drawings and writings (112), and that he had been
unusual in his sexual appetites must have been suspected, with a
thrill, by many of the sophisticated literary Decadents and Sym-
bolists of London, Paris, and Rome. But the majority of Leo-
nardo scholars in the late nineteenth century were engrossed in
problems of attribution, dating, and stylistic evolution raised by
previously neglected Leonardesque works (the *St. Jerome*, the
two *Annunciations*, the *Madonna Litta*, the *Lady with an
Ermine*, the *Madonna with the Carnation*, and the second ver-
sion of the *Virgin of the Rocks* all entered European museums
between 1860 and 1890); other experts were concentrating on
the philosophical and scientific contents of the notebooks, long
excerpts from which were published in the 1880s; and contem-

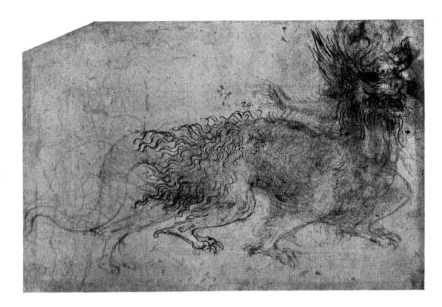

112. *Dragon.*
Leonardo

porary mythicizers of the *Mona Lisa* were on the whole too
fascinated by the sphinx to have much time for a possible
Oedipus. Not until 1910, when Sigmund Freud brought out a
little book entitled *Eine Kindheitserinnerung des Leonardo da
Vinci* ("A Childhood Reminiscence of Leonardo da Vinci"),
was there anything like a scientific, although in this instance
extremely controversial, attempt to extract psychological con-
clusions from the richly available clues.

Freud was obviously aware of the sacred nature of the terrain
onto which he was venturing, and he did his best, with prudent
remarks in the first edition of his essay and with extensive foot-
notes in subsequent French as well as German editions, to be
conciliatory. He granted, or pretended to grant, that what he
was writing might be criticized as little more than "a psychoana-
lytic novel." He insisted on the essential nobility of Leonardo's
personality and paintings, and confessed to having "succumbed
to the attraction of this great and mysterious man." On the one

hand he apparently accepted the Romantic feeling that the Gioconda smile was uniquely spellbinding, and on the other hand he admitted that scholars might find something similar in the work of Verrocchio and of ancient Greek sculptors. The strategic purpose of most of these concessions, however, can scarcely have gone unperceived, for in fact the book was an ingenious elaboration and illustration of the Freudian assumption that a work of art, like a dream, could be a symbolic transformation, or a psychic displacement, of sexual yearnings and frustrations that in an undisguised form could not have passed the artist's inner censor. The strangeness of Leonardo was diagnosed in part as a case of "passive" homosexuality, and more than one reader, attracted by Freud's disarming title, must have been dismayed by the discovery that the "reminiscence" in question had nothing to do with an idyllic childhood in sunlit Tuscany. Instead it turned out to be a wild, dark bird-memory, or bird-phantasm, preserved by Leonardo in a manuscript passage that reads as follows — in an English translation, be it noted, of the German version current in Vienna before 1910:

> It seems that I was always destined to be so deeply concerned with vultures; for I recall as one of my earliest memories that while I was in my cradle a vulture came down to me, and opened my mouth with its tail, and struck me many times with its tail within my lips.

Freud had come across the passage by chance and — alerted, it seems, by some experience in the treatment of a neurotic patient who rather resembled Leonardo, minus the genius — had decided that it was a record, not of a real reminiscence, but of "a phantasy" formed later and transferred back into childhood. His book was an exploration of the buried significance of the supposed phantasy, conducted by the already established psycho-

analytic method of moving from secret association to secret association back into the infancy of a troubled personality.

A vulture, he remembered, was the ancient Egyptian hieroglyph for the word "mother," and the Egyptian goddess Mut — a name incidentally analogous to the German word for mother, *Mutter* — was represented with the head of a vulture. Furthermore, the Egyptians, Greeks, and Romans had believed that a vulture was invariably a female and was impregnated by the wind, and the belief had been picked up by early Christians as proof that there was a natural parallel for the way the Virgin Mary had conceived Jesus with the aid of the Holy Ghost. The origins of Leonardo's vulture phantasy, Freud concluded, were therefore quite evident: the bird was a symbolic transformation of the mother of the bastard artist:

> He once happened to read in one of the Fathers [of the Church] or in a book on natural history the statement that all vultures were females and could reproduce their kind without any assistance from a male: and at that point a memory sprang to his mind, which was transformed into the phantasy we have been discussing, but which meant to signify that he also had been such a vulture-child — he had had a mother, but no father. With this memory was associated, in the only way in which impressions of so great an age can find expression, an echo of the pleasure he had had at his mother's breast.

The transformation was "valuable and important" to the mature painter, so the argument ran, partly because "in this way he was able to identify himself with the child Christ." Moreover, in the details of the pretended reminiscence there was a gratifying erotic content:

> A tail, *coda,* is one of the most familiar symbols and substitutive expressions for the male organ, in Italian no less than

in other languages; the situation in the phantasy, of a vulture opening the child's mouth and beating about inside it vigorously with its tail, corresponds to the idea of an act of *fellatio*, a sexual act in which the penis is put into the mouth of the person involved. It is strange that this phantasy is so completely passive in character . . .

Getting ideas as he went along, Freud supposed further that the child must have spent the first three or perhaps five years of his life "not by the side of his father and stepmother, but with his poor, forsaken, real mother, so that he had time to feel the absence of his father." During this period he began to brood over "the great question of where babies come from" and thus "at a tender age became a researcher." When he was eventually taken into the home of his father it was too late to change the consequences of these early formative years, and hence throughout his career as an artist and scientist he "investigated instead of loving."

The Gioconda smile? Freud reached it through some more analysis of the vulture passage:

> In words which only too plainly recall a description of a sexual act . . . Leonardo stresses the intensity of the erotic relations between mother and child. From this linking of his mother's (the vulture's) activity with the prominence of the mouth zone it is not difficult to guess that a second memory is contained in the phantasy. This may be translated: "My mother pressed innumerable passionate kisses on my mouth."

The analysis was followed, perhaps in deference to the feelings of Romantic readers, by a suggestion that was at first more poetical than clinical:

> It may very well have been that Leonardo was fascinated by Mona Lisa's smile for the reason that it awoke something in

him which had for long lain dormant in his mind — probably an old memory.

Two paragraphs later the suggestion was reinforced by a reference to Vasari's story of how in his youth Leonardo made in clay several heads of smiling women and some children's heads. "Thus we learn," Freud wrote,

> that he began his artistic career by portraying two kinds of objects; and these cannot fail to remind us of the two kinds of sexual objects that we have inferred from the analysis of his vulture-phantasy. If the beautiful children's heads were reproductions of his own person as it was in his childhood, the smiling women are nothing other than repetitions of his mother Caterina, and we begin to suspect the possibility that it was his mother who possessed the mysterious smile — the smile that he had lost and that fascinated him so much when he found it again in the Florentine lady.

A few pages further on the suspicion yielded to Freudian certainty, with the unwed Caterina changed into a less attractive figure:

> So, like all unsatisfied mothers, she took her little son in place of her husband, and by the too early maturing of his erotism robbed him of a part of his masculinity . . . When, in the prime of life, Leonardo once more encountered the smile of bliss and rapture which had once played on his mother's lips as she fondled him, he had for long been under the dominance of an inhibition which forbade him ever again to desire such caresses from the lips of women. But he had become a painter, and therefore he strove to reproduce the smile with his brush . . .

The whole argument was apparently strengthened when, three years after the publication of the first edition of the book, an

113. "Vulture" in the *Virgin and Child and St. Anne*

eager disciple named Oskar Pfister found in the robe of Mary in the *Virgin and Child and St. Anne* what he felt certain was a vulture in an "unconscious picture-puzzle" form (113), with the tail leading to the mouth of the Child and "hence to that of Leonardo himself." Freud seems to have been taken aback a little by the alleged image, but finally accepted it as a "remarkable" discovery. "The key," he concluded, "to all of Leonardo's accomplishments and misfortunes lies hidden in the infantile phantasy about the vulture."

Art historians have thoroughly, witheringly, disagreed with this conclusion. They have pointed out that the bird Leonardo had in mind, a *nibbio* in Italian, was actually a European variety of the rapacious kite and not at all, as the faulty German translation led Freud to believe, a vulture, and that therefore one can

114. *Wings for a Flying Machine.* Leonardo

115. *Flying Machine with an Operator.* Leonardo

dismiss in a single sweep the entire pattern of supposed associations — the Egyptian hieroglyph, the goddess Mut, the exclusively female sex, the impregnation by wind, the parallel with the Virgin Mary — leading from the bird to Caterina and the infant Leonardo and on to the Gioconda smile. Moreover, the same scholars argue, the context of the notebook passage strongly suggests that the painter was interested in the kite simply because it seemed to him a possible model for a flying machine (114, 115). Even the tail-in-the-mouth detail can be explained without recourse to sexual symbolism, for the Italian Renaissance was familiar with ancient stories of inspired geniuses whose future achievements were announced when birds or bees alighted on their infant mouths. As for Caterina and her "smile of bliss and rapture," the obvious and unromantic truth is that we do not have the faintest idea of what she looked like. Nor do we have any firm evidence at all that she kept her infant son with her for a number of crucial years and in her ungratified vulturous state "robbed him of a part of his masculinity" — in plainer words, castrated him psychologically and set him on the path of a lonely homosexual looking for a lost maternal smile. On the contrary, the surviving documents imply pretty clearly that he spent his early infancy in his father and grandfather's house, where he was probably born, and that Caterina left almost immediately to live on a neighboring farm with her rapidly acquired peasant husband.

In short, Freud was guilty both of ignorance of the data in the case and of the sin, not uncommon among psychoanalysts, of reasoning uneconomically. Yet the possibility remains that he was right in his intuition while wrong in his elaboration of it. An interest in flying machines and an awareness of stories of gifted infants whose mouths were touched by birds do not seem adequate as explanations for the kite memory, or pseudomem-

ory, the obsessive nature of which is plainly indicated by the fact that it is the sole childhood reminiscence in the manuscripts. Also, one does not have to be a professional Freudian to notice that Leonardo frequently indulged in what, given a slight acquaint with his life and personality, can be interpreted as symbolization or psychic displacement of hidden concerns. He portrayed the Christ Child (116), over and over again, with a gravity and a tenderness that go far beyond the conventional Renaissance treatment and imply a personal involvement in the subject. There are Oedipal birds in his notebook bestiary:

116. *Virgin and Child with St. Anne and St. John*. Detail. Leonardo

> Pigeons are a symbol of ingratitude . . . the young one drives the father out and takes the hen and makes her his own.

There are kites that are by no means merely efficient flying machines:

> We read of the kite that, when it sees its young ones growing too big in the nest, out of envy it pecks their sides, and keeps them without food.

There are beavers, under the melancholy and ironical heading *pace*, peace, that castrate themselves:

> We read of the beaver that when it is pursued, knowing that it is for the virtue [contained] in its medicinal testicles and not being able to escape, it stops; and to be at peace with its pursuers, it bites off its testicles with its sharp teeth, and leaves them to its enemies.

There were once drawings of strange sexual assemblages, two of which were seen and described by Lomazzo in 1584:

> One of them, which was a most beautiful youth, was shown

with the penis on the forehead and without nose, another face being on the back of the head, with the penis below the chin and with the ears attached to the testicle; these two-heads-in-one had faun's ears. The other monster had the penis just above the nose and the eyes by the side of the nose, the rest showing again a most beautiful youth.

A copy by Melzi (117) of a drawing that was perhaps part of the same series shows a faunlike creature with female breasts and with huge testicles hanging under its chin. It can be regarded, of course, simply as the studio joke it undoubtedly was, and also as one more example of Leonardo's interest in a dragonish sort of creative biology. Similarly the bestiary entries about perverse

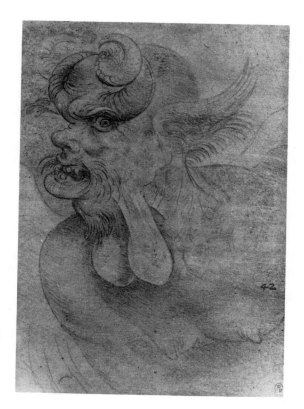

117. *Monster.* Copy by Melzi of Leonardo drawing

birds and the self-castrating beaver can be regarded simply as amusing little moralities extracted from a popular fifteenth-century collection. But such easy dismissals leave open the question of why Caterina's bastard homosexual son chose to draw this particular kind of joke and to copy down in his mirror handwriting these particular moralities.

Confronted by a related question concerning the *Mona Lisa*, depth psychologists of various schools continued to dig in the field opened up by the father of their discipline; and their efforts can be conveniently mentioned here — before returning to a more or less chronological account of the Gioconda myth. Some of the analysts concentrated on Oedipus, others on Narcissus, and others on the almost equally imaginary Caterina. Followers of Carl Jung saw in the picture a particularly noble projection of the anima, the female element in human males; Lisa del Giocondo thus became, for reasons not entirely clear, a serene sister of Athena, Sapientia, and the passionate Shulamite in the Song of Solomon, supposed anima figures that in the Jungian system symbolize transcendent, holy wisdom and therefore occupy a rank higher even than that of the Virgin Mary. The more nearly orthodox Freudian interpretations, long since divested of the embarrassing vulture, evolved into a complexity which, in 1967 in the thinking of the art theorist Anton Ehrenzweig, included both magus and painter, with a sphinx for good measure:

> The scientist unconsciously connives in his castration by the devouring mother, who represents the externalized gnawing superego . . . He unconsciously equates her with a castrated man like himself and assimilates her oral sadism and insatiable curiosity. This identification makes him a seer and scientist. The first object of his curiosity is the devouring mother herself, the smiling sphinx whose secret he fails

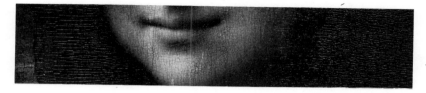

118. *Mona Lisa*. Detail

to unravel. Her smile threatening and promising mutilation becomes the mystery he never tires of exploring. The lure of Mona Lisa's smile might rest on the same promise and threat. Freud explains it as the blissful smile of the breast-fed infant . . . It may still be legitimate to speculate that Leonardo's mother had smothered her child with excessive love and so intensified his oral wishes and fears. Not without reason Mona Lisa's smile is called sphinxlike. I have called the sphinx the supreme symbol of the mother's oral aggression . . .

Freud might have been displeased with the distortion of the emphasis in his original intuition. But in view of the precedent he had set he could scarcely have objected to Ehrenzweig's unstated premise that the *Mona Lisa* was more a symptom than a picture.

119. Salon Carré, Louvre,
August 22, 1911

XIV

JOURNEY TO ITALY

DURING THE MONTHS when the first edition of Freud's book was stimulating European vanguard thinkers a change in traditional French methods of picture display was creating reflections of a different sort and providing Paris newspapers with entertaining squibs. The curators of the Louvre, disturbed by some recent vandalism, had put a few of their more valuable oil paintings, the *Mona Lisa* among them, under glass, and the innovation had provoked a lively guerrilla war of protest from habitués of the museum. The new panes were denounced as vulgar shopwindows, black mirrors, and in general an affront to Gallic good sense. The Montmartre novelist Roland Dorgelès, one of the leaders of the campaign, descended to the Louvre one morning and indignantly shaved with the aid of his reflection in a Rembrandt self-portrait. In July 1910 a humorist writing in *Le Cri de Paris* went so far as to maintain solemnly that the *Mona Lisa*

had been spirited away to the collection of a New York million-aire by clever thieves who, aware that the glass would make their crime almost imperceptible, had replaced Leonardo's original with a copy executed by an old lady from London. The director of national museums, Théophile Homolle, continued to refuse to remove the offending glass; needled by a journalist about the "theft," he laughed and remarked that "you might just as well pretend that one could steal the towers of the cathedral of Notre Dame." So the agitation dragged on sporadically into the following summer, when it gave the painter Louis Béroud what he thought was a profitable idea. He had enjoyed some popular success with a series of pictures using rooms in the Louvre as settings; now he decided to do one showing a pretty Parisian arranging her hair in front of the new Gioconda "mirror."

In the company of a friend and with the intention of making some preliminary sketches, Béroud went to the museum early on the morning of Tuesday, August 22, 1911 — a morning he would remember in sharp detail for the rest of his life. There was nobody in the Grande Galerie except three Americans and a group of French schoolchildren shepherded by their teacher. In the Salon Carré (119), to which the *Mona Lisa* had been moved some years before, there was not even a guard. In fact, there was not even the *Mona Lisa;* on the wall it usually occupied, between Correggio's *Mystical Marriage of St. Catherine* and Titian's *Allegory of Alfonso d'Avalos,* there were only the four iron pegs to which it had been attached. Béroud called the section chief of the guards, who suggested that the painting was probably for the moment down in the photography annex. Béroud waited until midmorning, observing philosophically that "when women are not with their lovers they are apt to be with their photographers." He then called the section chief

again, who checked with the photographers and found that they had not seen the painting that day. A rapid search of the building by the section chief, the captain of the guards, and the museum paymaster was without result. Homolle being on vacation, the paymaster summoned the curator of Egyptian antiquities, who after a personal search telephoned the Paris prefect of police, who called La Sûreté, the national criminal investigation department. Shortly after noon sixty special policemen invested the Louvre, ushered out the visitors one by one, and began a new search. In one of the little spiral stairways that lead into the Cour Visconti, a courtyard on the Seine side of the palace, they found the much-discussed pane of glass and the empty frame, a handsome ancient one donated two years earlier by the wealthy Countess de Béarn. At four in the afternoon the hunt was abandoned. The local *procureur de la République*, or district attorney, arrived with an examining magistrate. The truth had to be faced: the *Mona Lisa* had been stolen.

The news pushed into the background such relatively minor matters as social unrest in England, a general railway strike in France, and the condition of the playwright Edmond Rostand, who had just been injured in an automobile accident. In Paris the editors of *Le Matin* caught the first public reaction exactly by using the single word *Inimaginable!* as their streamer headline. Within a few days several theories concerning the identity and motive of the thief were widely current. He was a maniac, it was said, obsessed by the Gioconda smile. Or perhaps he was merely an eccentric artist who had wished to attract attention with a prank, or perhaps somebody who had wanted to give the museum guards a lesson, and hence the painting would soon be back in the Salon Carré. French patriots insinuated that he was a German agent and that the theft was simply the first in a demoralizing series that would end with the loss of France's col-

onies. German patriots returned the accusation, suggesting that the whole affair was a trick of the French government designed to distract public opinion while pickpockets from Paris were filching the Congo. In artistic circles the feeling was mostly one of incurable desolation; the painter Maurice Denis spoke of "the death of a friend, an old friend." When the Louvre was re-opened to the public, after remaining closed for a week to facilitate investigation, thousands of Parisians filed through the Salon Carré to stare at the vacant place on the wall, before which an anonymous mourner had deposited a mass of flowers. One could not have had stronger proof of the power of the Gioconda myth — of the myth unalloyed, for many of the wall viewers, an inquiring reporter discovered, had never seen the picture.

Rewards were posted for the recovery of what was now recognized as an important part of the French patrimony, in spite of its Italian origins. The association Les Amis du Louvre was ready to pay twenty-five thousand francs, and the magazine *L'Illustration* was willing to go up to forty thousand, with no questions asked. In a front-page editorial *Le Matin* offered five thousand francs "to the occultists, clairvoyants, palmists, and so on who, by means derived from the Beyond, will bring about the return." Everyone agreed that back of the disaster there was an enormous, long-festering scandal of official negligence. Fifty members of the Chamber of Deputies demanded instant explanations from the government; the minister of public instruction, who was partly responsible for the protection of the national art collection, rushed back from his summer holiday to confer with Premier Joseph Caillaux and the minister of justice. Homolle, who was not allowed to forget that remark about the *Mona Lisa* being as immune to theft as the towers of Notre Dame, was finally forced to resign from his post of museum director.

There were rumors that the theft story had been invented in order to cover up the fact that the painting had been damaged by careless handling, and there were horror tales about how badly the whole system of surveillance was organized. In the daily *Intransigeant* Guillaume Apollinaire, who was beginning to be known for his poetry and his vigorous essays in defense of modern art, wrote — with what in a few days would look like deliberate irony — that the Louvre was guarded "worse than a Spanish museum."

Meanwhile the police and the examining magistrate, handicapped at first by their belief that the crime was a joke, were trying to piece together what had happened during the hours immediately preceding Béroud's discovery. A mason at work in the Louvre remembered that he had seen the *Mona Lisa* around seven o'clock on the morning of August 21 and that about an hour later, walking through the Salon Carré again with his helpers, he had noticed that the picture was no longer there. "Well, well," he had said, "they're afraid somebody's going to pinch it." A checkup revealed that the regular guard assigned to the Salon Carré had stayed home on August 21; it was a Monday, then the weekly closing day for the museum, and one of his children was having measles. His supposed replacement admitted having spent some time, perhaps around eight o'clock, smoking a cigarette in the toilet. The porter in the Cour Visconti was said to have been seen dozing that morning, with his red parasol fixed in front of him to shade his eyes from the early rays of the sun. In sum, it seemed probable that the thief, who may have spent Sunday night hiding in the building, had clipped the painting from its four wall pegs shortly before eight o'clock on the twenty-first, darted with it down into the spiral stairway, removed the bulky frame and glass, and then, while the porter was napping, slipped with his prize out through the courtyard

onto the neighboring Seine quay. Why had nobody been alarmed by that empty spot on the wall until Tuesday morning? The answer seemed to be that the notion that somebody might steal the *Mona Lisa* had been unthinkable. Who could the thief have been? Beyond the fact that he was evidently a person familiar with the insides of the Louvre, everything was foggy. The celebrated fingerprint expert Alphonse Bertillon was called in; he was successful in obtaining a clear thumb mark from the empty frame but was unable to match the pattern with any of the seven hundred thousand in his files. Workmen who knew how the pictures in the Salon Carré were wired to the wall were questioned without result. A plumber who had seen a stranger in a white smock lurking in the building spent hours examining faces, again without result. Soon the magistrate was reduced to listening hopelessly to the testimony of almost anyone. There were voluble children who were sure they had seen the criminal on the street; there was a baggage handler at the Gare d'Orsay who had seen a bearded individual take the train for Bordeaux with a flat, rectangular object under his arm; there was an aged woman who that Monday morning had seen a German eating peanuts in front of the Louvre with a shifty look, *un air sournois.*

On September 7 French detectives made their first — and their only, as things developed — arrest in the case. To the surprise of everyone and the delight of the sensation-seeking press, the suspect was Apollinaire (120). Although he could not be linked directly to the theft, he had been exposed as a friend and occasional employer, for dishwashing and secretarial work, of an engaging Belgian literary vagabond named Géry Piéret, who it seemed had been making fools of the guards at the Louvre for a good while. On Monday, August 21, perhaps significantly, Piéret had disappeared from Apollinaire's apartment near the

120. *Guillaume Appolinaire.* Jean Metzinger

Pont Mirabeau, and a week later he had turned up in the offices of the *Paris-Journal* with a "Phoenician" statuette (later identified as Iberian) which he said, after obtaining a promise not to betray him to the police, he had stolen from the museum. The editors of the paper, pleased to have more evidence of a scandalous situation, had paid two hundred and fifty francs for the stolen object and before returning it to the Louvre had published an article in which the thief described his several misdeeds:

> I had already appropriated three Phoenician statuettes and masks which I had given to friends. Then I had left for Belgium and California, and had remained away for four years. On my return, last May 7, I again visited "my" Phoenician collection. There were only twenty or twenty-five statuettes left, whereas there had been about forty at the moment of my departure. Furious at having imitators, I picked up a feminine bust and slid it in against my belly. It was bulky . . . I vowed not to return to the Louvre without cowboy pants and extendible suspenders.

With his fee Piéret had left immediately for a tour of southern France and possibly Germany, confessing gleefully along the way. From one town he had written to the Paris police announcing that he was responsible for the theft of the *Mona Lisa* but that "it was a commissioned job." From another he had demanded a ransom of a hundred and fifty thousand gold francs for the return of the picture. From a third he had sent a mysterious classified advertisement which the *Paris-Journal* had run on its front page: "The *Mona Lisa*. B. S. Agreed. Let us wait." The police department had investigated and had found that there was more than leg-pulling in the affair; Piéret had sold or given two of his stolen statuettes to Picasso and another to Apollinaire, and had reportedly once said to friends: "I'm off to

the Louvre. Do you want anything?" So Picasso had been brought in for questioning, and Apollinaire, who seemed to have been a protector of the thief, had been thrown into the grim Paris prison of La Santé. He remained there long enough to be described by La Sûreté as "the chief of an international gang that has come to France to rifle our museums," and to be denounced by French chauvinists as a *métèque,* a wop (he was Polish and Italian by birth). He also had time to be moved to write some characteristic verses:

> Avant d'entrer dans ma cellule
> Il a fallu me mettre nu
> Et quelle voix sinistre ulule
> Guillaume qu'es-tu devenu
>
> Le Lazare entrant dans la tombe
> Au lieu d'en sortir comme il fit
> Adieu adieu chantante ronde
> O mes années ô jeunes filles.
>
> Before entering my cell
> I had to strip myself naked
> And what sinister voice ululates
> Guillaume what have you become
>
> Lazarus entering the tomb
> Instead of leaving it as he did
> Farewell farewell melodious round
> Ô my years O young maidens.

On September 12 he was released, the judge having decided, under the influence of an explanatory letter from a contrite Piéret and of growing harassment from indignant French men of letters, that there were no grounds for a formal accusation.

As the weeks and then the months went by without a sign of

the whereabouts of the painting, anger and grief were largely replaced by humor, faddism, and hucksterism. Because of the many copies that were arousing immediately disappointed hopes, Montmartre cabaret entertainers sang *Non, ce n'est pas toi, ce n'est pas ton vi-sa-ge* (No, it isn't you, it isn't your fa-a-ce), with the melody borrowed from Gounod's *Faust*. The *Cri de Paris* renewed its gag of the summer of 1910 and insisted that what had been stolen was after all merely the version painted by the old lady from London. Postcards represented Lisa as leaving Paris in a fiacre driven by Leonardo, as jilting the under secretary for the fine arts, as strolling near Westminster Bridge, or simply as thumbing her nose at France. There were Gioconda radiator caps for motorists, a Gioconda waltz, and a Gioconda patterned tussore silk that was referred to, with a pun on *tu sors*, you leave, as *le tussor du Louvre*. A German film producer rushed into production a farce in which bumpkins mistook a vacationing housewife for the missing celebrity and forcibly shipped her to the museum. In 1912 in the traditional Paris mid-Lent parade Leonardo's *finzione* was honored with a special float showing her taking off in an airplane (121); at Nice she was

121. Gioconda float in Paris mid-Lent parade, 1912

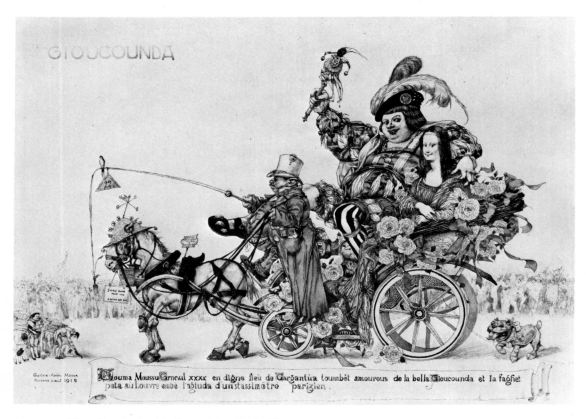

GIOUCOUNDA

Gu-bve-Abile Mossa
Niceiou pinxil 1912

Bouma Moussu Carneval xxxx en digne fieu de Gargantüa toumbèt amourous de la bella Gioucounda et la faĝĝiet
pela au Louvre embé l'aĝiuda d'un stassimetre parizien.

122. *King Carnival with Mona Lisa.* G. A. Mossa

imagined as snuggling up to the Rabelaisian figure of King Carnival (122). Music hall and theatrical stars, among them Mistinguett (123), were photographed in the Gioconda pose. The mourning continued, of course, for a while here and there. In November, 1912, after the directors of the Louvre had filled, not inappropriately, the vacant space on the wall with Raphael's *Castiglione,* the art historian Robert de la Sizeranne wrote in the *Revue des Deux Mondes:*

. . . one feels indeed a certain malaise on seeing in the

middle of the Salon Carré in the place of the familiar smile — the most feminine of all smiles — this man with his ample beard, with his skull tightly wrapped and haloed by an immense black biretta or turned-up toque, who looks out at you calmly with his big blue eyes. One knew very well that the Gioconda would not be seen again, but it seemed that the place she had occupied for such a long time was a little hallowed, and that a man ought not to settle himself there in a comfortable and self-important way. Perhaps the curators of the Louvre would have done better if they had left the place empty — in imitation of Burne-Jones, who in his famous mosaic *Christ Surrounded by Angels*, in the American church of St. Paul in Rome, left empty the place of the greatest figure, on the right hand of God, in expectation of the day when *He* would return.

This faintly hopeful lament was about the last of its kind, however, for gradually even the most stubborn of optimists ceased to believe that some day *she* would return.

Then, just when it seemed that the world was learning to live without the Gioconda smile and that the greatest art theft in history might be remembered as simply the last and biggest jest of the Belle Époque, a wonderful dénouement got under way. In the autumn of 1913, a little more than two years after the disappearance of the picture, a Florentine antique dealer named Alfredo Geri, whose fashionable clientele included such people as Eleanora Duse, inserted an advertisement in several Italian newspapers saying that he intended to organize an exhibition and that he was "a buyer at good prices of art objects of every sort." On November 29 he received a letter that gave as a return address a postal box in the Place de la République in Paris; the writer, who used idiomatic Italian and called himself Leonardo Vincenzo, said that he had the *Mona Lisa* in his possession and that he wanted to sell it to Geri in order to restore to Italy a

123. Mistinguett as Mona Lisa

work "stolen by Napoleon." Geri, supposing that he was dealing with one of the many naively hopeful owners of copies of Leonardo's picture, replied that he handled only originals and that for the moment he could not come to Paris to look at anything, but that he was ready to pay any sum that was wanted for the real *Mona Lisa*. On December 10, in his sales rooms in the Via Borgognissanti in Florence, he was visited by a mustachioed Italian of about thirty, cleanly dressed in clothes that revealed a working man. The stranger waited until some customers had left, and then quietly announced that he was Leonardo Vincenzo, that he had just arrived from Paris, that he had the *Mona Lisa* with him in his room in the Tripoli-Italia Hotel in the Via Panzani, and that he wanted half a million lire for the painting, plus a firm understanding that it would be hung in the Uffizi and never returned to France. Geri, who by then was beginning to shed his skepticism, hastily agreed to the price and the condition, but said that he had to have the approval of the director of the Uffizi, Giovanni Poggi, who would naturally want to examine the painting before reaching a decision. Vincenzo thereupon suggested a meeting in his hotel room the next day, and departed with apparently not the slightest suspicion that he had set a trap for himself. Geri alerted the police, who immediately surrounded and infiltrated the Tripoli-Italia; he also called Poggi, who mobilized the museum's staff of Renaissance specialists.

In the hotel room the next day Vincenzo was waiting for them, still mysteriously and serenely confident. He pulled out from beneath a chest of drawers a small, unpainted wooden trunk, a sort of seaman's locker, opened it, and carefully removed a pair of old shoes, a shirt, and some woolen underwear. Then came the moment Geri would recall as the most exciting in his life:

After taking out these not very appetizing objects [Vincenzo] lifted up the false bottom of the trunk, under which we saw the picture . . . As soon as it appeared we had an impression that it was indeed the authentic work of Leonardo da Vinci. The smile of Mona Lisa was again alive in Florence. We were filled with a strong emotion. Vincenzo looked at us with a kind of fixed stare, smiling complacently, as if he had painted it himself.

Poggi recognized the number and seal of the Louvre on the back of the panel. He said that some comparison at the Uffizi with other works by Leonardo would be necessary; he assured Vincenzo that if everything turned out as expected "your fortune is made." Then, in one of the great cool actions of history, he picked up the painting and, followed by Geri and Vincenzo, walked out with it. At the museum the first impression was confirmed by an inch-by-inch inspection with the aid of photographs, taken shortly before the theft, that showed the details of the network of fine cracks. There could be no doubt; the *Mona Lisa* had been found at last. Moreover, to the satisfaction of Italians and many other people, it had been found in its native city, probably not more than a few hundred yards from the spot where it had been conceived four centuries earlier. Romantic mythicizers could not have asked for a more poetic end to the adventure.

Vincenzo, seemingly relieved to be rid of his secret, and quite obviously simple to an abnormal degree, talked readily to the police (124). His real name was Vincenzo Peruggia. He was born in 1881 at Dumenza, a small locality in northern Italy near Como. He was vaguely a house painter, and he was almost without formal education beyond reading and writing. He insisted repeatedly on his patriotism. He had gone to Paris in 1908 and had worked briefly at the Louvre before moving on to other

124. Vincenzo Peruggia

temporary jobs; he had noticed the large number of Italian paintings in the French national collection and, assuming that they had been stolen by Napoleon, had sworn to himself that one day he would take some of them back to Italy. Early on the morning of August 21, 1911, he had gone to the museum, where he was still known as a workman to some of the guards, had found the Salon Carré deserted, and had left with the *Mona Lisa* hidden under his house-painter's smock. That was about the full story of his crime, for he had had no accomplices and no precise plans for disposing of the picture. Until his departure for Florence he had kept it in his prisonlike cell in a rundown Paris rooming house, where he had lived the lonely life of a nearly penniless bachelor immigrant. Why had he picked the *Mona Lisa* as the first of the works in the Louvre he intended to return to Italy? Because, he said, it had seemed to him the most beautiful, *perchè mi sembrava la più bella.*

The news went out from the Uffizi like the shock waves of an explosion (125). In the Italian parliament a debate that had

degenerated into fistfighting was instantly transformed into handshaking. The French government cabled its congratulations and gratitude to the Italian prime minister. Student painters at the Villa Medici, the seat of the French Academy in Rome, celebrated with champagne. Newspapers everywhere devoted their front pages to the sensation, eventually with huge photographic layouts showing Geri, Poggi, Peruggia, and the little trunk with the false bottom. In Florence the Tripoli-Italia became the Gioconda Hotel; in Paris the entertainers who had sung *ce n'est pas ton visage* two years before were soon singing:

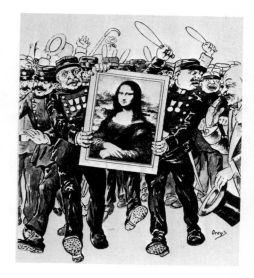

> Elle va nous revenir en trombe
> Elle va re-sourire pour la France.

> She's going to return to us like a whirlwind,
> She's going to smile again for France.

Premonitions of a war that was in fact only a few months away were countered with another song:

> C'est moi que j'suis la Joconde
> Attendez que le vernis tombe
> Attendez la fin du monde
> Je sourirai sous les bombes.

> It's me, I'm the Gioconda
> Wait for the varnish to fall
> Wait for the end of the world
> I'll smile under the bombs.

125. The Return of Mona Lisa.
Orens

People who had stared at the vacant spot in the Salon Carré in 1911 gathered to stare at the façade of the Paris rooming house, at 5 rue de l'Hôpital-Saint-Louis, where Peruggia had lived with his treasure.

The return was a royal progress. The painting was exhibited
at the Uffizi until December 19, then in Rome (126) at the
Palazzo Farnese, the Galleria Borghese, and the Villa Medici,
and finally for two days in Milan, where sixty thousand half-
hysterical Italians surged through the Brera museum for a last
glimpse. Riding in a special compartment of the Milan-Paris
express and escorted by a squadron of politicians, museum offi-
cials, artists, and policemen, the precious panel touched French
soil on December 30, amid what a journalist called "indescribable
rejoicing." On its arrival in Paris it was subjected to a new
examination by experts, so thorough that Colette, at the moment
a columnist for *Le Matin*, felt moved to complain. "They pick
at her," she wrote, "uncover her, discover her; they want to love
her for something other than her beauty . . ." A special three-
day show was staged at the École des Beaux-Arts for the benefit
of Italian charities, and then, at ten o'clock on the morning of

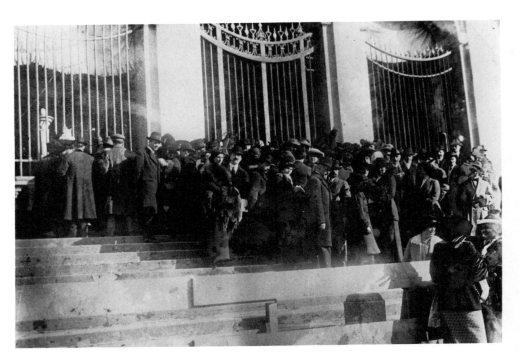

126. *Mona Lisa* viewers
in Rome in 1913

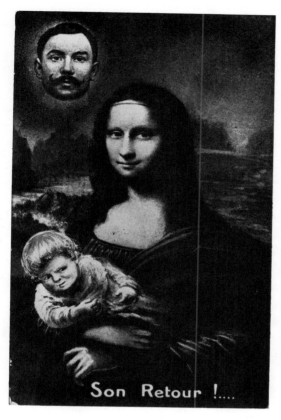

Son Retour !....

127. "Her Return!" Postcard, 1914

souhait de Bonheur
pour 1914

La Joconde
Reçoit de nouveau
tous les jours sauf les
Lundi
musée du Louvre Paris

128. French New Year's
greeting card, 1914

Sunday, January 4, 1914, the painting was ceremoniously restored to its place in the Salon Carré. Among the new postcards on sale in the neighborhood of the Louvre were one showing Lisa and Peruggia with a baby as a result of their escapade (127) and one announcing that madame would again receive visitors every day except Monday (128).

Peruggia was tried at Florence in June. His story that he had acted from lofty patriotic motives was spoiled somewhat by his having demanded half a million lire for his gesture and by the

revelation that he was not quite the ordinary workman he had seemed: French records showed that he had been arrested in 1908 for attempted theft and that in 1909 he had been given eight days in prison for violence and carrying a weapon. Public opinion, however, was in his favor, and so was the testimony of alienists, who had examined him carefully and had concluded that he was only partly responsible for his actions. His lawyer pointed out that the picture had been returned in excellent condition and suggested that anyway the crime had not been exactly heinous, for it had given thousands of Italians a chance to admire the Gioconda smile and had shown the French how badly their works of art were guarded. A sentence of a year and fifteen days was pronounced and then reduced to seven and a half months, which meant that the accused, who had been in jail since December, could be freed almost immediately. Geri, everything considered, was treated much less justly. He received the reward of twenty-five thousand francs offered by Les Amis du Louvre, and nothing else except a rosette for his lapel and a letter from Paris informing him that he had been honored with the title of Officier de l'Instruction Publique. He sued the French government, basing his case on the Gallic custom that gave the finder of a lost object a recompense equal to at least 10 percent of the value of the object. After a long struggle in French courts his claim was rejected, partly because he had allegedly done nothing but his duty and partly, it seems, because no one knew how to calculate 10 percent of the inestimable.

For several years after the return of the painting eccentrics everywhere in Europe kept surfacing with attempts to appropriate some of Peruggia's celebrity. An antique dealer in Holland announced that the recovered work was merely a copy which had been proposed to him for sale in 1913. An Italian immigrant in Paris, described as a student in a school of practical spiritual-

ism, "confessed" that he and his brother had helped Peruggia with the little trunk. A British "accomplice" in the theft pretended that he had executed six copies of the picture: five, he said, were sold to American collectors and the sixth was what Peruggia had palmed off on Geri, Poggi, and the directors of the Louvre. One of the most persistent of the pretenders was Gabriele d'Annunzio, who had spent part of the period from 1911 through 1913 at Arcachon, in the Landes region of southwestern France, and who seems to have gradually persuaded even himself that he had somehow masterminded the crime from his provincial residence. He began his feigning by dropping some broad hints during an interview with a French reporter:

> Why not admit that a man — a poet, an artist — can lose his heart to a dead woman? One can certainly lose one's heart to a painting. I know a man who fell in love with the *Mona Lisa*. He is the one who had it stolen.

By 1920 he was no longer merely hinting. "I remember," he wrote,

> when the sublime stealer of the *Mona Lisa* brought the panel, wrapped in an old horse blanket, to me in my retreat in the Landes. I remember that I finally began to detest the languid Gioconda hands, constrained as I was to have them under my eyes, sometimes for an entire day, during the metaphysical speculations proposed by the thief.

In conversations with friends he frequently alluded, apparently seriously, to his part in the theft, and in 1923 he declared that, "as many people know," he had returned the painting to the Louvre because of his "satiety and disgust" with it.

129. *Thirty Are
Better Than One.*
Andy Warhol

XV

GIOCONDOCLASTS AND GIOCONDOPHILES

THE MOCKERY provoked in some quarters by the theft of the *Mona Lisa* was not entirely new. Early in the nineteenth century there had been Wainewright and his fun with "the wily eyes of Gioconda." Around 1880, a few years after the success of Pater's description of the "diver in deep seas," George du Maurier had satirized the English Aesthetic Movement with a cartoon character in *Punch* whom he called Mrs. Joconda Cimabue Brown. The publicity the painting received between 1911 and 1913 had the effect, however, of stiffening the resistance to the myth, and soon there were signs that d'Annunzio was not alone in feeling what he called "satiety and disgust." In 1914 the French painter Othon Friesz, who had been one of the leading Fauves of the previous decade and was still a prominent modernist, told the daily *Gil Blas* that he was unimpressed by the return of Lisa:

For a long while her artifical and dreary smile had ceased to attract me . . . I left her in the company of her shamming public, with whom she could profit from her usurped reputation. I have never been guilty of a similar discourtesy toward the smallest pear painted by Chardin.

In 1915 the Italian poet, novelist, and art critic Ardengo Soffici, who was a supporter of Futurism, wrote in the diary he called his shipboard journal:

> In the tram-omnibus. I see written on a wall in large white letters against a blue background: "Gioconda. Italian Purgative Water." Further down there is the stupid face of Mona Lisa. At last something like good art criticism is getting under way even in Italy.

Such comments could be discounted, of course, as simply standard avant-garde provocation, for the French Fauves had long since announced that tone-value painting made them ill, and the Italian Futurists, in their manifesto of 1909, had proclaimed their conviction that a roaring motorcar was more beautiful than the *Victory of Samothrace*. In 1916, however, admirers of Leonardo were shaken by an attack from an entirely unexpected and hard-to-discount direction. Bernhard Berenson, whose reputation as an aesthetician and an expert judge of Italian Renaissance painting was then at its peak, and who some years earlier had informed his enthusiastic, if perhaps a little mystified, followers that the *Mona Lisa* was possibly the world's finest example of "tactile values," now suddenly joined the ranks of the enemy. In a long confession, entitled "Leonardo da Vinci, an Attempt at a Revaluation," he explained that for years he had been deluded by the magic of Pater's description, that one day he had actually looked at the painting, and that then "an enchanted adept" had died in him:

What I really saw in the figure of Mona Lisa was the estranging image of a woman beyond the reach of my sympathies or the ken of my interests, distastefully unlike the women I had hitherto known or dreamt of, a foreigner with a look I could not fathom, watchful, sly, secure, with a smile of anticipated satisfaction and a pervading air of hostile superiority.

He had felt guilty about his apostasy until "one evening of a summer day in the high Alps," when a rumor of the theft had reached him. At first he had supposed that the story was a practical joke:

> To my amazement I nevertheless found myself saying softly: "If only it were true!" And when the news was confirmed I heaved a sigh of relief . . . She had simply become an incubus, and I was glad to be rid of her.

After some disillusioned thinking about such tricks as *contrapposto* and *sfumato* he had come to the conclusion that perhaps Leonardo had been "only the greatest of cranks."

In the mood of general irreverence that followed World War I the picture and the myth became fair game to whole sectors of society. There were popular-level humorists who continued to exploit the immense familiarity produced by newspaper accounts of the theft. There were liberated young women who were anti-Romantic on principle, and fashionable intellectuals who were ready to be ironical about almost anything that their Victorian or Second-Empire grandfathers had loved. To the Dadaists the painting was a cultural fetish of the bourgeoisie and a prime symbol of the spurious values, smugness, and meretricious Art-with-a-capital-A which their nihilistic buffoonery was supposed to destroy. To Marcel Duchamp, who had been Dada long before Dada, Lisa seems to have been a personal bugaboo, and in 1919

130. *Negative Gioconda*

he struck back at her with a reproduction which he captioned
L.H.O.O.Q. and to which he added a mustache and a beard
(131); what hurt in this now historic gesture was not so much
the "corrected ready-made" itself as the obscene caption (to be
read *elle a chaud au cul,* she has a hot ass), which reduced to
latrine wit the highfalutin eroticism of the Gautier-Pater school.
In 1922 Aldous Huxley, in his short story "The Gioconda Smile"
(which became a London play the following year), subjected
to a similar deflation the stock sphinxlike heroine of Romantic
fiction — and of Romantic bedrooms, in the performances of the
Princess Belgiojoso and her like. The Giocondoclastic note was
struck at the beginning of the tale, in which a smiling, urbane,
supercilious Mr. Hutton was introduced in the act of calling on
Miss Janet Spence, his tedious, obtuse, aesthetically pretentious
mistress:

> Miss Spence was smiling too: her Gioconda smile, he had
> once called it in a moment of half-ironical flattery. Miss
> Spence had taken the compliment seriously, and always tried
> to live up to the Leonardo standard . . . What a queer
> face she had! That small mouth pursed forward by the
> Gioconda expression into a little snout with a round hole in
> the middle as though for whistling — it was like a penholder
> seen from the front.

Not till the end did readers discover that the real joke was that
Miss Spence was indeed, to Mr. Hutton's cost, a fatal woman.
In smart connoisseur circles the disenchantment of Berenson
became a vogue; the elitist feeling of initiation that had once been
got from praising the *Mona Lisa* could now be had from dis-
praising it, preferably with a knowing use of technical terms. In
1929 Percy Dearmer, a British lecturer on art, exhibited the new
attitude, almost to the point of caricature, in an article in the
Contemporary Review:

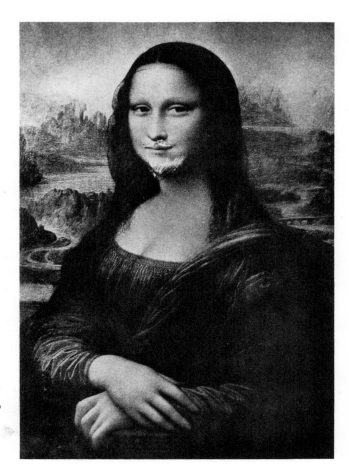

131. *L.H.O.O.Q.* Marcel Duchamp

Perhaps the visitors to the Louvre who are escorted round the Salon Carré by the representative of a tourist agency do really believe that Mona Lisa has "learned the secrets of the grave, and has been a diver in deep seas"; but the rest of us know that [Leonardo] was just experimenting in dimples with his beloved chiaroscuro, and we remember that the un-fathomable smile about which everybody has written so ecstatically was probably evoked on the face of a rather stupid woman by the efforts of the artist to drag her out of her lethargy.

The reaction was not invariably snobbish, however, nor always directed against the painting itself and the allegedly mediocre intelligence of Lisa del Giocondo. Paul Valéry objected to the vagueness of the myth and to what he thought were mistaken assumptions about the nature of Leonardo's mind and talent:

> I do not think I can give a more amusing example of common attitudes toward painting than the celebrity of the Gioconda smile, to which the adjective *mysterious* seems to be irrevocably attached. This wrinkle in a countenance has been fated to give rise to the kind of writing about art that is supposedly justified, in all literatures, by such a title as "impressions." It has been buried under piles of words and rendered invisible by paragraphs that begin by calling it "troubling" and wind up with a generally vague description of a soul. It deserves a less intoxicating kind of study. Leonardo did not make use of imprecise observations and random signs.

Unfortunately Valéry never got around to writing the sober study of the famous "wrinkle" he seemed to have promised.

Among modern artists — those who had not, like Duchamp and the Dadaists, ostensibly rejected art — the tendency was to ignore the *Mona Lisa* as something irrelevant to their concerns. Exceptions to the rule were a few of the Surrealists, who were on the lookout for shocking juxtapositions or self-advertisement (132), and very notably Fernand Léger. In 1924 the latter, who at the moment was combining an interest in abstraction with his basic machine aesthetic, denounced Leonardo's entire approach to painting as a pernicious heresy:

> The Italian Renaissance — the *Mona Lisa*, the sixteenth century — is regarded by the whole world as a zenith, a summit, an ideal to be attained; the École des Beaux-Arts is based completely on slavish imitation of this period. *This*

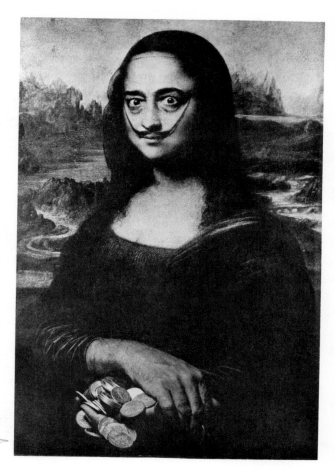

132. *Dali as Mona Lisa*. Philippe Halsman

is the most colossal error that could be committed. The
sixteenth century was a time of almost total decadence in
every area of plastic interest. It was the period of the
mistake of *imitating*, of copying servilely the subject, in con-
trast with the preceding so-called Primitive period, which
became great and immortal precisely because it invented its
forms and means.

Six years later he painted his *Gioconda with Keys* (133), in
which he inserted a small copy of the *Mona Lisa*. Had he

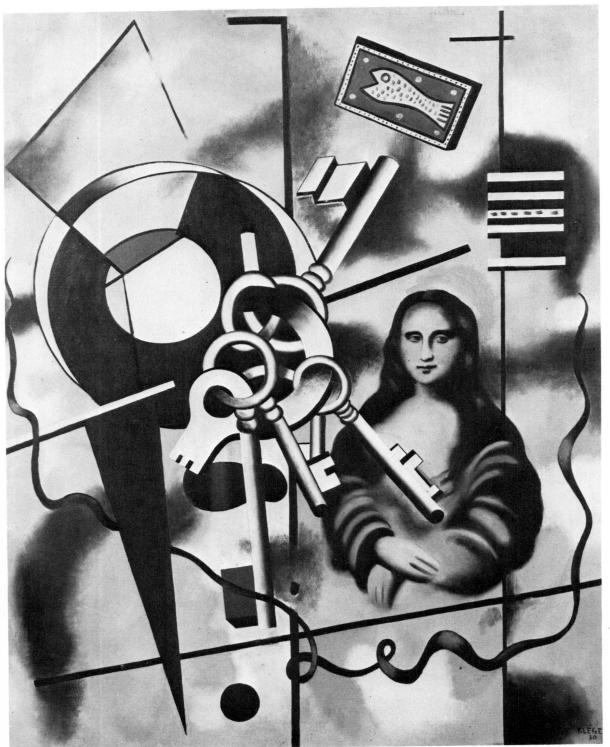

133. *Gioconda
with Keys.*
Fernand Léger

changed his mind about the Italian Renaissance? No, he explained to a friend, he had begun his picture with the bunch of keys and had then left his studio to look for an object that would provide a strong contrast:

> I had walked only a few steps, when what did I see in a shopwindow? A *Mona Lisa* postcard! I understood immediately. She was what I needed . . . Then I added a can of sardines. That made a very sharp contrast.

He went on to assert that to him Leonardo's picture was "an object like any other object."

It would be an overstatement to say that all the irony, scorn, japery, repentance, and revaluation did not leave any dents in the myth. Since the 1920s many picture viewers in Europe and America have been a little wary about expressing their admiration for the *Mona Lisa*, and poets have been too prudent to sing of their passion for the perverse sphinx. But on the whole the damage, given the scale of the attacks, was remarkably slight. In Germany in 1915 the composer Max von Schillings and his librettist, Beatrice Dovsky, had produced an opera in which Lisa, once again the eternal femme fatale, had murdered jealous old Francesco del Giocondo in revenge for his having killed one of her former lovers; and in 1923 public interest in the work was still strong enough to warrant a performance at the New York Metropolitan. In 1927 the British poet and biographer Rachel Taylor, in a style that used Freud to update Gautier and Pater, was still keeping the myth going; for her Leonardo had become a homosexual Narcissus, and his lovely sitter a woman aching with sexual disappointment:

> He painted Madonna Lisa with the comprehension, not of love, but of secret cruelty. It amused him to knead his dream into her beautiful flesh . . . Not hers the predestined face,

the face that might have lured [him] to mysterious love and supersubtle embrace . . . Women, as a rule, regard her a little uneasily, for they are dimly aware of her simple riddle — that she is enchanting but disenchanted, with the disenchantment of every woman who has found love's consummation destroy the rare pattern of her illusion.

In 1931 another German film on Peruggia's crime, *Der Raub der Mona Lisa*, was produced with considerable success. Four years later Yeats broke up Pater's description into lines of poetry and published it as the first selection in *The Oxford Book of Modern Verse*. At the level of scholarship admirers of the painting remained — and still remain — numerous, in spite of Berenson's talk about "an incubus" and Dearmer's scorn for "experimenting in dimples." Kenneth Clark, in 1939, was not at all reticent about praising "the submarine goddess of the Louvre," about acknowledging that inevitably an English viewer of the picture still had "Pater's immortal passage ringing in his ears," and about saying flatly that to write as Valéry had about a mere "wrinkle in a countenance" was simply

to misunderstand Leonardo, for the Mona Lisa's smile is the supreme example of that complex inner life, caught and fixed in durable material, which Leonardo in all his notes on the subject claims as one of the chief aims of art.

At the level of the general public the demythicizers were, and have continued to be, practically without influence. From 1919 to 1939 a fanatic came to the Louvre every day to contemplate Lisa, often until the guards gently reminded him that it was closing time. During the optimistic weeks of the French Popular Front of 1936 Léger, who in addition to being a ferocious Giocondoclast was a staunch Marxist, persuaded the fine-arts administrator to open the doors of the museum after five o'clock

for the benefit of factory employees — and then watched with chagrin what happened:

> He opened them in the evening, and the workers came. But there you are, they saw only one picture. They had to line up in front of the *Mona Lisa*, for it was the star, as in the movies. Consequently the results were nil.

During World War II the painting, along with other works from the Louvre, was kept outside Paris as a precaution against bomb damage, but it was not in the least forgotten by its existing and potential adorers. Art historian Germain Bazin, at the time the curator of the museum depot, recalled later that in the Nazi debacle of 1944 he saw "German soldiers in full flight stop and pound on the door . . . and ask as an ultimate, supreme favor that we let them see the *Mona Lisa* before they left."

A reason for the ineffectiveness of the attacks can be found in their frequent ambiguity. To speak, as Berenson did, of an "estranging image," a "foreigner," and a "sly" woman "with a smile of anticipated satisfaction" was merely to add to the nineteenth-century version of the myth some hints of personal sexual fantasies; to desecrate the alleged cultural fetish as Duchamp did was plainly to acknowledge its power — to the point of attempting what any amateur anthropologist could have recognized as a kind of exorcism. Huxley's ineffable Miss Spence did, after all, turn into a smiling trap for the clever Mr. Hutton. Léger's several references to the picture, in both words and paint, suggest a good deal of fascination beneath the proclaimed high-principled dislike; indeed, his *Gioconda with Keys*, when looked at without his possibly disingenuous explanation, can easily imply homage: it contrasts the present and the past by quoting Leonardo's work, in much the same way that a modern poem may quote a line from Dante, or a modern concerto a

134. *In Tears*. Paul Wunderlich

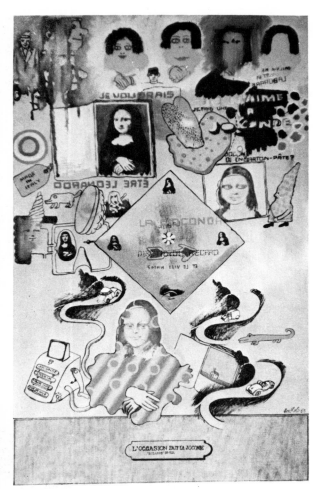

135. *The Occasion Makes the Gioconda*. René Bertholo

phrase from Bach. Not every Giocondoclast, of course, was a secret Giocondophile; there were people who were genuinely fed up with Romantic exaggeration. But there was evidently a lot of love-hate around.

There was also an inclination, well exemplified in the *Gioconda with Keys*, to add something amusing to the long series of *Mona Lisa* derivatives and variations that had begun in the

136. *Great American Nude No. 31.*
Tom Wesselmann

137. *Gymnastic Gioconda.*
Urbaniec Maciej

Golda Lisa

138. *Stalin as Mona Lisa*
Marinus

139. *Golda Meir as Mona Lisa.*
David Geva

140. *Mona Owl.* Chris Marker

sixteenth century with Raphael's Florentine portraits and the first *Nude Gioconda* (38). Since World War II the inclination seems to have become stronger and more varied, and today one can envisage the time when what may be labeled the Gioconda Caprice will be recognized as a distinct pictorial genre (129, 130, 134, 136–140, 144). In many of the recent examples there are traces of disrespectful intentions, which can be partly attributed to the persistent influence of Duchamp's antiart stance. But there are other things worth noticing. Sometimes Leonardo's painting is less a target than a weapon for satirizing something or somebody else, often a politician. Running through the better Pop derivatives is a characteristic taste for kitsch, shaggy-dog humor, and what was called camp in the American 1960s, coupled with assumptions that the *Mona Lisa* itself has become a Pop image, that the Gioconda myth resembles the content of modern advertising, and that therefore the painting is utilizable on the same terms as Marilyn Monroe or soup cans. Elsewhere Léger's inserted-copy trick may recur. Sometimes there are serious scientific intentions: an evocative, Cubist-looking *Squared Gioconda* (141) was produced with optical equipment in 1973 during experiments directed at finding out how people remember faces. Often, too, there is an interest in the creative possibilities in modern technology: computer versions are beginning to appear, and the handsome striped and abstract Giocondas (142, 143) of Shigeo Fukuda are the results of playing with printing methods. Behind everything there is the apparently deep-rooted human desire, common in all periods, to try one's hand at transforming a familiar theme; from this point of view the work in the history of the arts that is most comparable to the *Mona Lisa* is the celebrated, and mysteriously simple, Iberian tune called "La Folía," on which dozens of composers have written sets of variations since the fifteenth century.

141. *Squared Gioconda*

142. *Striped Gioconda*. Shigeo Fukuda

143. *Abstract Gioconda.*
Shigeo Fukuda

More evidence of continued appeal can be seen in modern commercial, or partly commercial, exploitation of the painting. The business has always existed, of course, to a degree; most of the first copies and derivatives were probably executed for clients, and the early engraved reproductions were certainly done for the market. The big sales campaign, however, got

under way in 1911, at the time of the theft, and since then it has expanded steadily. By the 1970s a sufficiently fervent woman Giocondophile, if she happened to be also a sufficiently determined shopper, could have arrived at the Louvre equipped with Mona Lisa nylon underwear and stockings, a Lisa T-shirt, a Mona sweater, a Mona Lisa scarf, a Gioconda compact, and some Joconde hairpins. Her pilgrimage to the source accomplished, she could have bought some postcards, a Joconde jigsaw puzzle, and a color reproduction — perhaps one of the large fancy ones glued to canvas and framed. Outside the museum she could have added a Mona Lisa plate, a Lisa dishtowel, a Mona Lisa wastebasket, a Mona Lisa pencil game, a package of Joconde cotton for removing make-up, a depilatory for bare-legged Giocondas, and a recording of a French popular song that used "Mona Lisa, Mona Lisa" as a klaxoning refrain. Then off to the Mona Lisa Restaurant or the Café de la Joconde, both on the Paris Right Bank, to meet her Giocondophile husband, who can be imagined as wearing his Italian handpainted Gioconda necktie and smoking an American cigarette advertised with the help of the *Mona Lisa*. Their dinner might have included a chianti described as grown in the Gioconda vineyard ("Why is this lady smiling? You'd smile too if . . ."), a Gioconda cheese from Pavia, and some Joconde oranges imported from Spain. Then the husband could have smoked one of his Dutch Mona Lisa cigars, or perhaps one of the brand he had seen advertised in London, again with the help of the *Mona Lisa* ("Some things you can fake, others you can't . . ."). At home the couple could have turned on the high-fidelity equipment they had bought because of scare publicity against supposedly less efficient reproducers ("What would the *Mona Lisa* be like if you could see only half of it?"). Then some magazine reading, during which they could have learned that Mona

laughin' on the inside, cause

it's your birthday instead of mine !

144. *Lisa Reacting*

Lisa has given her name to a prize cow and at least fifteen racehorses. The evening could have closed with a glass of Gioconda, the *acqua purgativa italiana*.

Still more proof, if more is wanted, of the failure of Berenson, Duchamp, and their anti-Lisa allies can be found in the success of the painting on its foreign tours. In 1963 during seven weeks in the United States, first at the Washington, D.C., National Gallery of Art (145) and then at the New York Metropolitan Museum of Art, the work attracted an estimated one million six hundred thousand viewers. In 1974 during three months, first at the Tokyo National Museum and then at the Pushkin

Museum in Moscow, the total was more than two million. These trips were occasions for vehement protests in France; it was pointed out that Leonardo's fragile panel and eggshell-thin paint were extremely sensitive to shock and to changes in temperature or humidity, that publicity attracts destructive maniacs, that there was already too much peddling of art, and that serious viewers could very well take the trouble to come to Paris to see the picture — after all, Cairo did not send the Pyramids on tour. The objections were particularly justified by the exhibition in Japan, which turned into a vast, grotesque parody of manners and morals in the fine-art sector of Western society: twenty-

145. Viewers in Washington in 1963

146. *Mona Lisa* shop in Tokyo

147. *Mona Lisa* viewers in Tokyo in 1974

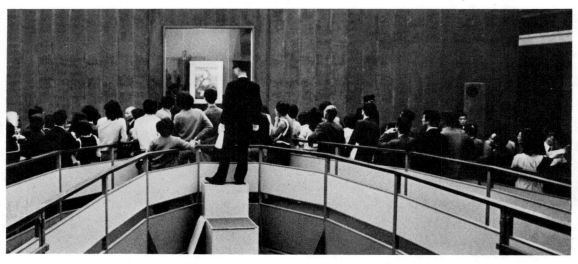

seven Tokyo bars and shops changed their names to Mona Lisa, a chain of cabarets organized a Mona Lisa Festival, a nightclub staged the world's first Mona Lisa Nude Revue, a department store put on a "smiling season" sales drive, a flood of reproductions on almost everything (146) enticed buyers, a fashion model underwent plastic surgery in order to acquire the Gioconda smile, a telephone number brought the taped "voice" of Mona Lisa, and the country's largest trade union put up posters (148) in which a nonsmiling Lisa, her market basket on her arm, joined the campaign against rising prices — all this while attendants at the National Museum hustled the crowds past the painting at a speed that gave each person a glimpse of about ten seconds (147). Yet the results of the junkets cannot be dismissed as completely deplorable. Millions of Americans, Japanese, and Russians saw the picture itself for the first time, and the reactions of many revealed that beneath the cynical exploitation there was an area of dreams, aspiration, reverence, and affection. In Moscow several viewers left poems in front of the panel, as if it were an icon; and when the show closed a woman in the provinces sent three rubles to the organizers, with a request that they buy roses for Lisa before she took the plane for Paris.

148. Tokyo poster

149. *Mona Lisa*. Detail

XVI

ANOTHER QUESTION

THERE CAN BE no proper conclusion to a discussion of the *Mona Lisa*, for both the picture and the myth have long since demonstrated their inexhaustibleness. But since the present discussion opened with a question it can perhaps appropriately close, or be suspended, with another question — the inevitable one. How should we explain the myth?

Fragments of answers can be dug out of such already mentioned external factors as exhibition facilities, dominant artistic criteria, shared cultural attitudes, and fashions in sensibility. Things might have been different if Francis I had not built his bathroom, if Vasari had not written his book, if the sixteenth and seventeenth centuries had not been thrilled by virtuosity and illusionism, if the Louvre Museum had not been created, if Romantic and Decadent aesthetes had not made a cult of perverse and cruel seductresses, if the dying nineteenth century had

not been neurotic, if art had not become a substitute for fading religion, if the aristocracy and then the bourgeoisie and then the working classes had not attached a status value to paintings, and if the European theatrical, concert, and operatic world had not encouraged an enormous public appetite for the kind of star the French call a sacred monster. The effect of momentum should also be remembered: as in all sorts of stardom and best selling, the success of the *Mona Lisa* reached at a certain indeterminable point — somewhere in the middle of the nineteenth century — what can be called a cultural orbiting speed, and after that it had little need for fresh impetus.

Other fragments of answers can be had from a mere glance at the painting. Leonardo's use of the *sfumato* technique, for example, was of an importance that can scarcely be overestimated, since shadowy pictures are obviously more apt to be thought mysterious than sharply defined, brightly colored ones, and since the Romantic era, as its immediate acceptance of photography revealed, took a special delight in the contemplation of tone values. Such nineteenth-century phrases as Baudelaire's "mirror deep and dark," Gautier's "mirror of tarnished steel," and Houssaye's "tawny light of amber" show that the dirty varnish also counted heavily — a fact tacitly acknowledged by the Louvre, which has steadfastly refused to clean the picture and thus run the risk of wiping off part of the myth.

Beyond such somewhat prosaic explanations there are more poetic ones that merit consideration. Leonardo, it can be said, really was a wizard: he combined optics with legerdemain, actuality with artifice, matter with spirit, and the natural with the supernatural in a manner that fits fairly precisely what we mean by "magic." He was also, it can be argued, the first of the mythicizers of his work. He imparted to his fictional personage something of what gave the goddesses of classical antiquity their

authority over imaginations, plus something of a human arche-
type; he transformed Lisa, or Costanza, or whoever his first
model was, into an Aphrodite and an Eve, into a representative
of both the Greco-Roman and the Judeo-Christian strains in
Western civilization. This sort of explanation has attracted
critics from Pater forward, and in 1963, during the exhibition
ceremonies in Washington, it led André Malraux into a charac-
teristically sweeping and eloquent theory:

> The antiquity revived by the Italians [of the Renaissance]
> offered an idealization of forms. But the people of the an-
> cient statues, being a people without seeing eyes, were a
> people without soul. A regard, a soul, a spirituality — these
> were in Christian art, and Leonardo first used the celebrated
> smile for the face of the Virgin Mary. By using it to trans-
> figure a nonsacred face he gave to the soul of woman the
> idealization that Greece had given to her features. The
> mortal creature with the divine regard triumphed over the
> sightless goddesses. She is the first expression of what
> Goethe would call the Eternal Feminine.

Although as sober art history this is open to several objections,
as dramatized insight and a kind of mythmaking about the
mythmaking it has its points.

The trouble, of course, with all these explanations, useful as
they are, is that they fail to explain sufficiently why what hap-
pened should have happened to this particular painting. There
were other masterpieces in the Appartement des Bains at Fon-
tainebleau, other femmes fatales lurking in European public
collections, other fetishes for the rising middle classes, other
combinations of varnished *sfumato* with sex and psychology,
and other mixtures of Renaissance paganism with Christian
sensibility. What made the mythicizers fasten on Leonardo's
fiction with such exclusive persistence?

The answer must be that the *Mona Lisa* was more open to interpretation than any of its possible competitors, and this brings us around again to its "subject." The work posed problems in an irresistible way, and refused to provide clues to definite solutions. It stimulated analogizing. It was intensely ambiguous, and hence insinuatingly multivalent. Although vividly figurative, and in some respects as specifically naturalistic as a film sequence, it had, as Gautier noticed, much of the unspecifically suggestive power of a piece of abstract music. It was a battery waiting to be charged. In sum, it was, and still is, one of the supreme examples in Western art of sheer availability for meaning, of the general, uncommitted sign that invites the viewer-reader to discover for himself, perhaps invent, exactly what is signified. Recognizing it as such does not, to be sure, make legitimate all the panting vampires, deep-sea divers, and castrating mothers that have been imagined, nor authorize our treating the painting today as simply a lovely invitation to uncontrolled speculation. There are limits to the openness for interpretation; otherwise there would be no point in trying to distinguish between "the picture" and "the myth." But it can be granted that the limits are exceptionally wide — wide enough to warrant concluding that the myth was from the beginning a potentiality in the picture.

List of Illustrations

Bibliography

Notes

Index

ILLUSTRATIONS

9. *Church*. Leonardo. c. 1489. Ink. Full sheet, 23 x 16 cm. Paris, Institut de France.

10. *Flowers*. Leonardo. c. 1483. Ink over metal point. 18.3 x 20.3 cm. Venice, Accademia.

11. *Heart*. Leonardo. 1513. Ink. Full sheet, 41 x 28 cm. Windsor, Royal Library.

12. *Horseman*. Leonardo. c. 1490. Silver point. 14.8 x 18.5 cm. Windsor, Royal Library.

13. *Crossbow*. Leonardo. c. 1486. Ink. 20 x 27 cm. Milan, Ambrosiana.

14. *Virgin and Child and St. Anne*. Leonardo. c. 1510. Oil. 168.5 x 130 cm. Paris, Louvre.

15. *Florentine Portrait*. Raphael. c. 1504. Ink. 22.3 x 15.9 cm. Paris, Louvre.

16. *Virgin and Child with St. Anne and St. John*. Leonardo. c. 1498. Charcoal. 139 x 101 cm. London, National Gallery.

17. *Florence*. Sixteenth century. Anonymous engraving.

18. *Milan*. Seventeenth century. Anonymous engraving.

19. *Rome*. 1549. Anonymous engraving.

20. *Isabella d'Este*. Leonardo. c. 1502. Black chalk, charcoal, and pastel. 63 x 46 cm. Paris, Louvre.

21. *Ginevra Benci*. Leonardo. c. 1475. Oil. 42 x 37 cm. Washington, D.C., National Gallery of Art.

22. *Lady with an Ermine*. Leonardo. c. 1485. Oil. 53.4 x 39.3 cm. Cracow, Czartoryski Muzeum.

23. *Musician*. Leonardo. c. 1490. Oil. 43 x 31 cm. Milan, Ambrosiana.

24. *La Belle Ferronière*. Leonardo. c. 1497. Oil. 63 x 45 cm. Paris, Louvre.

25. Angel, detail from *Virgin of the Rocks*. Leonardo. c. 1483. Oil. Paris, Louvre.

26. *Salvator Mundi*. Follower of Leonardo. 1504 (?). Oil. 48 x 38 cm. Nancy, Musée des Beaux-Arts.

27. *Annunciation*. Antonella da Messina. 1475. Oil. 35 x 34 cm. Palermo, Galleria Nazionale.

28. *Tornabuoni Allegory*. Detail. Sandro Botticelli. c. 1483. Fresco. Paris, Louvre.

29. *Colombine*. Francesco Melzi (?). c. 1510. Oil. 76 x 63 cm. Blois, Musée d'Art Ancien.

30. *Mona Lisa*. Detail of the dress.

31. *Pattern of Knots*. Leonardo. c. 1498. Engraving. London, British Museum.

76. Copy of Leonardo's *Leda and the Swan*. Francesco Melzi (?). Early 16th century. Oil. 132 x 78 cm. Florence, Palazzo Vecchio.
77. *Kneeling Virgin*. Detail of studies for a Nativity. Leonardo. c. 1483. Ink over lead point. Full sheet, 19.5 x 16.2 cm. New York, Metropolitan Museum of Art.
78. *Horses, Lion, and Man*. Leonardo. c. 1504. Ink. Full sheet, 19.6 x 30.8 cm. Windsor, Royal Library.
79. *Comparative Anatomy*. Leonardo. c. 1504. Ink over red chalk. Full sheet, 28.5 x 20.5 cm. Windsor, Royal Library.
80. *Lady with an Ermine*. Detail. Leonardo.
81. *Hair and Water*. Leonardo. c. 1510. Ink. 15.2 x 21.3 cm. Windsor, Royal Library.
82. *St. John the Baptist*. Leonardo. c. 1513–16. Oil. 69 x 57 cm. Paris, Louvre.
83. Italian copy of the *Mona Lisa*. Anonymous. 16th century. Oil. 82.5 x 64.5 cm. Paris, Louvre.
84. Spanish copy of the *Mona Lisa*. Anonymous. 16th century. Oil. 76 x 57 cm. Madrid, Prado.
85. *Baldassare Castiglione*. Raphael. 1516. Oil. 82 x 67 cm. Paris, Louvre.
86. *Maddalena Doni*. Raphael. 1506. Oil. 63 x 45 cm. Florence, Palazzo Pitti.
87. *La Muta*. Raphael. 1507. Oil. 64 x 48 cm. Urbino, Galleria Nazionale delle Marche.
88. Flemish *Gioconda*. Anonymous. 16th century. Oil. Present location unknown.
89. *Francis I*. Jean Clouet (?). After 1525. Oil. 96 x 74 cm. Paris, Louvre.
90. Gallery of Francis I. Château of Fontainebleau.
91. *Nude Gioconda*. Anonymous. 16th century. Oil. Leningrad, Hermitage.
92. *Nude Gioconda*. Joos van Cleve. c. 1535. Oil. 95 x 72 cm. Munich, private collection.
93. *Nude Gioconda*. Barthel Bruyn. Before 1555. Oil. 71 x 54 cm. Nuremberg, Germanisches Nationalmuseum.
94. *Lady in Her Bath*. François Clouet. c. 1570. Oil. 92.1 x 81.3 cm. Washington, D.C., National Gallery of Art.
95. *Agatha Van Schoonhoven*. Jan Verspronck. 1641. Oil. 81 x 68 cm. Paris, Louvre.
96. *Gioconda with Bodice*. Jean Ducayer (?). Early 17th century. Oil. 35 x 27.5 cm. Tours, Musée des Beaux-Arts.

97. *Nude Gioconda.* Anonymous. Early 17th century. Oil. 78 x 60 cm. Bergamo, Accademia Carrara.
98. *Pilgrimage to the Island of Cythera.* Detail. Antoine Watteau. 1717. Oil. Paris, Louvre.
99. *Grande Galerie of the Louvre.* Hubert Robert. 1796. Oil. 46 x 55 cm. Paris, Louvre.
100. *The Death of Leonardo.* J. A. B. Ingres. 1818. Oil. 40 x 50.5 cm. Paris, Petit Palais.
101. *Leonardo Painting the Mona Lisa.* Aimee Brune-Pagés. 1845. Engraved by Charles Lemoine from the oil original. Paris, Bibliothèque Nationale.
102. Copy of the *Mona Lisa.* Théodore Chassériau. c. 1840. Oil. 78 x 53 cm. Formerly Paris, Chéramy collection.
103. *Woman with a Pearl.* J. B. C. Corot. 1868. Oil. 70 x 55 cm. Paris, Louvre.
104. *Princess Belgiojoso.* Chassériau. 1847. Pencil. 30 x 22.8 cm. Paris, Petit Palais.
105. *Melancholia I.* Albrecht Dürer. 1514. Engraving. 24 x 18.8 cm. Paris, Bibliothèque Nationale.
106. *Maitreya.* Detail. Chinese, Northern Wei Dynasty. c. 470. Sandstone. Full height, 130 cm. New York, Metropolitan Museum of Art.
107. *Kouros.* Detail. Greek. c. 540 B.C. Marble. Athens, National Museum.
108. *Kore.* Detail. Greek. c. 520 B.C. Marble. Full height, 55.5 cm. Athens, Acropolis Museum.
109. *Sphinx.* Greek. c. 530 B.C. Marble. Height with plinth, 142 cm. New York, Metropolitan Museum of Art.
110. *Virgin of the Rocks.* Leonardo. c. 1483. Oil. 199 x 122 cm. Paris, Louvre.
111. *Buddhist Temple in the Hills.* Detail. Li Ch'eng. c. 960. Ink. Kansas City, Mo., Nelson Gallery, Atkins Museum of Fine Arts.
112. *Dragon.* Leonardo. c. 1505. Ink and black chalk. 18.8 x 27 cm. Windsor, Royal Library.
113. "Vulture" in the *Virgin and Child and St. Anne.*
114. *Wings for a Flying Machine.* Leonardo. c. 1488. Ink. 23 x 16.4 cm. Paris, Institut de France.
115. *Flying Machine with an Operator.* Leonardo. c. 1488. Ink. 23 x 16 cm. Paris, Institut de France.

Acknowledgments. Thanks are due to the institutions and private collectors listed above for permission to reproduce works in their possession. In the few instances where data are lacking the author will do his best to make proper acknowledgment when supplied with the necessary information. Credit is due to the following sources of photographs: Arts Graphiques de la Cité, Paris, for the color frontispiece and numbers 14, 24, 25, 28, 30, 49, 50, 53, 54, 62, 63, 69, 70, 73, 85, 89, 92, 93, 98, 99, 103, 113, 114, 115, 118, 130, and 149; Alinari-Giraudon, Paris, for 33, 41, 51, 52, and 108; Alinari-Viollet, Paris, for 107; Anderson-Giraudon, Paris, for 3, 5, 23, 34, 36, 64, 71, 84, and 86; Anderson-Viollet, Paris, for 32 and 76; André Morain, Paris, for 135; Archives Photographiques, Paris, for 9, 74, and 104; Bruckman-Giraudon, Paris, for 91; Bulloz, Paris, for 15, 20, 38, 39, 43, 55, 87, and 100; A. C. Cooper, London, for 12, 47, 72, and 117; Doisneau-Rapho, Paris, for 1 (four photographs); France-Match, Paris, for 146 and 147; John R. Freeman, London, for 2, 7, 13, 17, 19, 31, 58, and 68; Giraudon, Paris, for 8, 27, 67, 96, 101, and 133; Laboratoire de Recherche des Musées de France, Paris, for 66; Lauros-Giraudon, Paris, for 29, 37, 65, 82, 90, 110, and 122; Metropolitan Museum of Art, New York, for 42, 77, 106, and 109; National Gallery, London, for 16, 57, and 116; National Gallery of Art, Washington, D.C., for 21, 44, 46, 56, and 94; Nelson Gallery, Atkins Museum of Fine Arts, Kansas City, Mo., for 111; Paris-Match, Paris, for 145; Philadelphia Museum of Art, for 45; Service de Documentation Photographique de la Réunion des Musées Nationaux, Paris, for 26, 35, 83, and 95; Shunk-Kender, Paris, for 129; H. Roger Viollet, Paris, for 10, 18, 40, 105, 120, 121, 124, 125, 126, and 128; Witt Library, Courtauld Institute, London, for 4, 6, 11, 48, 59, 60, 61, 75, 78, 79, 81, and 112. Works from the British Museum and the National Gallery, London, are reproduced by courtesy of the trustees of these institutions.

BIBLIOGRAPHY

1. Adhémar, H. *Portraits français*. Paris, 1950.
2. Adhémar, J. "The Collection of Paintings of François ler." In *Gazette des Beaux-Arts*, 30, 1946, pp. 5–16.
3. Alazard, J. *Le portrait florentin de Botticelli à Bronzino*. Paris, 1951.
4. Anonimo Gaddiano. In *Codice Magliabecchiano*, ed. C. Frey. Berlin, 1892.
5. Argan, G. C. *Renaissance*. Paris, 1968.
6. Barrès, M. *Visite à Léonard de Vinci (Trois Stations de psychothérapie)*. Paris, 1891.
7. Baxandall, M. *Painting and Experience in Fifteenth Century Italy*. Oxford, 1972.
8. Bazin, G. *The Louvre*. London, 1966.
———. *Le Temps des musées*. Paris, 1967.
9. Bérence, F. *Léonard de Vinci*. Paris, 1965.
10. Berenson, B. *The Italian Painters of the Renaissance*. London, 1930.
———. "Leonardo da Vinci, an Attempt at a Revaluation." In *The Study and Criticism of Italian Art*, Third Series. London, 1916.
11. Bertram, A. *Florentine Sculpture*. New York, 1969.

12. Billy, A. *Apollinaire*. Paris, 1956.
13. Blanc, C., and Mantz, P. *Histoire des peintres de toutes les écoles. École florentine*. Paris, 1879.
14. Blum, A. "Léonard de Vinci graveur." In *Gazette des Beaux-Arts*, August–September 1932, pp. 89 ff.
15. Blunt, A. *Artistic Theory in Italy, 1450–1600*. Oxford, 1962.
16. Boas, G. "The Mona Lisa in the History of Taste." In *Journal of the History of Ideas*, vol. I, No. 2, 1940, pp. 207–24.
17. Bonne, J. C. "Le travail d'un fantasme." In *Critique*, August–September 1973, pp. 725–53.
18. Brion, M., and others. *Léonard de Vinci*. Paris, 1959.
19. Butsch, A. F. *Handbook of Renaissance Ornament*. New York, 1969.
20. Castiglione, B. *The Book of the Courtier*. New York, 1928.
21. Chastel, A. *Art et Humanisme à Florence au temps de Laurent le Magnifique*. Paris, 1961.
———. *Léonard de Vinci. La peinture*. Edited texts. Paris, 1964.
22. Christie, A. *Pattern Design*. New York, 1969.
23. Clark, K. *Leonardo da Vinci*. Harmondsworth, 1967.
———. "Mona Lisa." In *The Burlington Magazine*, March 1973, pp. 144–50.
24. Clément, C. *Michelangelo, Leonardo da Vinci, and Raphael*. Paris, 1861.
25. Coppier, A. C. "La Joconde est-elle le portrait de Monna Lisa?" In *Les Arts*, January 1914, pp. 1–9.
26. Cox-Rearick, J., and Béguin, S. *La Collection de François Ier*. Exhibition catalogue. Paris, 1972.
27. Croce, B. "Canzoniere d'amore per Costanza d'Avalos duchessa di Francavilla." In *Aneddoti di varia letteratura*, vol. I, pp. 125–30. Naples, 1942.
28. Dan, P. *Le Trésor des Merveilles de la Maison Royale de Fontainebleau*. Paris, 1642.
29. Dearmer, P. "Leonardo da Vinci, a Criticism." In *Contemporary Reveiw*, vol. 135, 1929, pp. 217 ff.
30. Eissler, K. *Leonardo da Vinci: Psychoanalytic Notes on the Enigma*. New York, 1961.
31. Eyre, J. R. *Monograph on Leonardo da Vinci's Mona Lisa*. London, 1915.
32. Félibien, A. *Entretiens sur les vies et sur les ouvrages des plus excellens peintres anciens et modernes*. Trevoux, 1725.

33. Florisoone, M., and Béguin, S. *Hommage à Léonard de Vinci.* Exhibition catalogue. Paris, 1952.

34. Francastel, P. "La perspective de Léonard de Vinci et l'expérience scientifique du XVIe siècle." In *Leonard de Vinci et l'expérience scientifique.* Paris, 1953.

35. Freedberg, S. J. *Painting of the High Renaissance in Rome and Florence.* Cambridge, Mass., 1961.

36. Freud, S. *Leonardo da Vinci and a Memory of His Childhood.* Trans. by A. Tyson. In vol. XI of *The Standard Edition of the Complete Psychological Works.* London, 1957.

37. Gaunt, W. *The Aesthetic Adventure.* Harmondsworth, 1957.

38. Gautier, T. *Les Dieux et les demi-dieux de la peinture.* Paris, 1863.

39. Goldscheider, L. *Leonardo da Vinci.* London, 1943.

40. Gombrich, E. H. "Renaissance Artistic Theory and the Development of Landscape Painting." In *Gazette des Beaux-Arts,* July 1953, pp. 336–60.

41. Gould, C. "Leonardo da Vinci's Notes on the Color of Rivers and Mountains." In *The Burlington Magazine,* September 1947, pp. 239 ff.

42. Griffiths, J. G. "Leonardo and the Latin Poets." In *Classica et mediaevalia,* XVI, 1955, pp. 268 ff.

43. Hastier, L. *Piquantes aventures de grandes dames.* Paris, 1959.

44. Heaton, C. W. *Leonardo da Vinci and His Works.* New York, 1874.

45. Herbet, F. *Le Château de Fontainebleau.* Paris, 1937.

46. Heydenreich, L. *Leonardo da Vinci.* New York, 1954.

47. Hours, M. "La Peinture de Léonard vue au laboratoire." In *L'Amour de l'art,* Nos. 67–68–69, Paris, 1953.

48. Houssaye, A. *Confessions.* Paris, 1885.
————. *Histoire de Léonard de Vinci.* Paris, 1869.

49. Huxley, A. "The Gioconda Smile." In *Mortal Coils.* London, 1922.

50. Huyghe, R. *Dialogue avec le visible.* Paris, 1955.
————. *La Joconde.* Fribourg, 1974.

51. Isnard, G. "La Joconde et les 'Joconde'." In *Le Jardin des Arts,* April 1957, pp. 357–64.

52. Jung, C., and others. *Man and His Symbols.* London, 1964.

53. Klein, R. "La pensée figurée de la Renaissance." In *Diogène,* No. 32, 1960, pp. 134 ff.

54. Kris, E. *Psychoanalytic Explorations in Art.* New York, 1964.

55. Laclotte, M. *Musée du Louvre, Peintures.* Paris, 1970.

56. Léger, F. *Fonctions de la peinture.* Paris, 1965.

57. Levey, M. *Early Renaissance.* Harmondsworth, 1967.

58. Lomazzo, G. P. *Trattato dell'arte della pittura.* Milan, 1584.

59. Löschburg, W. *Der Raub der Mona Lisa.* Berlin, 1966.

60. McCurdy, E. *The Mind of Leonardo da Vinci.* London, 1928.
———. *The Notebooks of Leonardo da Vinci.* London, 1938.

61. McMahon, A. *Leonardo da Vinci: Treatise on Painting.* Edited texts. Princeton, 1956.

62. Mairot, Mme. *Le Fond de la Joconde et l'esthétique de Léonard de Vinci.* Besançon, 1933.

63. Malraux, A. *Les Voix du silence.* Paris, 1951.

64. Manson, A. "Le vol de la Joconde." In *Le roman vrai de la IIIe République,* vol. 3. Paris, 1957.

65. Margat, J., and others. *Bizarre* magazine, special issue, May 1959.

66. Merezhkovsky, D. *The Romance of Leonardo da Vinci.* New York, 1928.

67. Monti, R. *Leonardo da Vinci.* Florence, 1967.

68. Murray, L. *The High Renaissance.* London, 1967.

69. Murray, P. and L. *The Art of the Renaissance.* London, 1963.

70. Nicolle, J. *Léonard de Vinci.* Paris, 1970.

71. O'Malley, C., ed., *Leonardo's Legacy.* Los Angeles, 1969.

72. Ottino della Chiesa, A. *Tout l'oeuvre peint de Léonard de Vinci.* Introduction by A. Chastel. Paris, 1968.

73. Pater, W. *The Renaissance.* Introduction by K. Clark. London, 1961.

74. Pedretti, C. *Leonardo.* London, 1973.

75. Péladan, S. "La Joconde, histoire d'un tableau." In *Les Arts,* January 1912, pp. 1–7.

76. Pia, P. *Apollinaire par lui-même.* Paris, 1969.

77. Plochmann, G., ed., *The Resources of Leonardo da Vinci.* Carbondale, Ill., 1953.

78. Popham, A. E. *The Drawings of Leonardo da Vinci.* London, 1946.

79. Porter, L. P. "The Meaning of the *Mona Lisa.*" In *Woman's Home Companion,* April 1914, pp. 54 ff.

80. Pozzo, C. dal. *Diary,* 1625. In E. Müntz and E. Molinier, *Le Château de Fontainebleau au XVIIe siècle,* Paris, 1886, pp. 5 ff.

81. Praz, M. *The Romantic Agony.* New York, 1970.

82. Pulitzer, H. *Where is the Mona Lisa?* London, 1967.

83. Reinach, S. "La Tristesse de Monna Lisa." In *Bulletin des Musées*, vol. II. Paris, 1909.
84. Richet, M. *Fernand Léger*. Exhibition catalogue. Paris, 1971.
85. Richter, J. P. *The Literary Works of Leonardo da Vinci*. London, 1939.
86. Roger-Milès, L. *Léonard de Vinci et les Jocondes*. Paris, 1923.
87. Rudel, J. "Le Métier du peintre." In *L'Amour de l'art*, Nos. 67–68–69, 1953, pp. 35–45.
88. Schapiro, M. "Leonardo and Freud: an Art-Historical Study." In *Journal of the History of Ideas*, April 1956, pp. 147–78.
89. Schneider, R. "L'Insoluble problème de la Joconde." In *Études italiennes*, No. 4, 1923, pp. 196–208.
90. Sérullaz, M. *La Joconde*. Paris, 1947.
91. Shearman, J. "Leonardo's Color and Chiaroscuro." In *Zeitschrift für Kunstgeschichte*, No. 1, 1962, pp. 13–47.
———. *Mannerism*. Harmondsworth, 1967.
92. Stauffer, D. "Monna Melancholia." In *The Sewanee Review*, XL, 1932, pp. 89 ff.
93. Stendhal. *Vie de Léonard de Vinci*. Paris, 1950.
94. Stites, R. "A Criticism of Freud's Leonardo." In *College Art Journal*, vol. VII, 4, 1948, pp. 257–67.
95. Suyeux, J. *Jeux Joconde*. Paris, 1969.
96. Taylor, R. A. *Leonardo the Florentine*. New York, 1928.
97. Tolnay, C. de. "Remarques sur la Joconde." In *Revue des Arts*, II, 1952, pp. 18–26.
98. Valentiner, W. "Leonardo as Verrocchio's Co-worker." In *The Art Bulletin*, March 1930, pp. 43 ff.
99. Valéry, P. *Introduction à la méthode de Léonard de Vinci*. Paris, 1919.
100. Vasari, G. *Lives of the Artists*. Trans. by G. Bull. Harmondsworth, 1965.
101. Venturi, A. "Leonardo da Vinci." In *Enciclopedia Italiana*.
102. Wallace, R. *The World of Leonardo*. With Time-Life editors. New York, 1966.
103. Wind, E. *Pagan Mysteries in the Renaissance*. Harmondsworth, 1967.
104. Wölfflin, H. *Classic Art*. Trans. by P. and L. Murray. London, 1952.

NOTES

When an entry is completely abbreviated, the first part refers to a page in this book and a passage, identified by an italicized key word or phrase. The second part of the entry, with the "B" number, refers to a page in an item in the bibliography. Thus "P. 51 *for two days,* p. 266 B. 100" means that the account of Leonardo's show cited on page 51 of this book will be found on page 266 of Vasari's *Lives,* which is No. 100 in the bibliography. A section number—S. 1339, for example—instead of a page number is often given in referring to B. 85, which is Richter's *Literary Works of Leonardo da Vinci.*

CHAPTER I. A QUESTION (PAGES 1–5)

P. 1 *divine,* p. 267 B. 100.

P. 2 *Rousseau,* see his Metropolitan Museum pamphlet of 1963.

CHAPTER II. THE NEW PYTHAGORAS (PAGES 7–25)

P. 8 *In the normal,* p. 255 B. 100.

P. 8 *I don't think,* p. 340 n. B. 85, vol. II.

P. 8 *The sublime,* p. 9 B. 72.

P. 9 *Anonimo,* p. 9 B. 72.

P. 9 *good figure,* p. 115 B. 4.

P. 9 *In carbon,* p. 502 first B. 21.

P. 10 *truly suggested,* p. 503 first B. 21.

P. 12 *the arbiter,* p. 3 B. 85, vol. I.

P. 12 *my dearest,* S. 1356 B. 85.

P. 13 *He owned,* p. 257 B. 100.

P. 13 *his suite,* p. 160 B. 9.

P. 14 *fillers of privies,* S. 1179 B. 85.

P. 14 *my father,* S. 1372 B. 85 (Ser Piero was actually seventy-seven when he died).

P. 15 *copulation,* p. 108 B. 70.

P. 16 *usual scandals,* S. 1357 B. 85.

P. 16 *thief, liar,* S. 1458 B. 85.

P. 17 *florins for Salai,* S. 1525, S. 1528, and S. 1535 in B. 85.

P. 17 *attractive youth,* p. 265 B. 100.

P. 18 *whom in life I loved,* p. 141 B. 74.

P. 20 *half your own,* S. 494 B. 85.

P. 20 *forme di tutti,* p. 105 B. 85, vol. I.

P. 21 *Concave mirrors,* S. 1421 B. 85.

P. 22 *Giovannina,* S. 1404 B. 85.

P. 22 *news of things,* S. 1354 B. 85.

P. 22 *wild ox,* S. 1251 B. 85 (a braccio was about two feet).

P. 23 *Unable to resist,* S. 1339 B. 85.

P. 24 chiefest painters, p. 131, B. 20.

P. 24 *mathematical experiments,* p. 108 first B. 23.

P. 24 *Tell me,* p. 147 first B. 23.

P. 24 *We ought not,* S. 1190 B. 85.

P. 24 *had offended God,* p. 270 B. 100.

CHAPTER III. SOME DATES (PAGES 27–38)

P. 29 *charcoal cartoon:* see p. 104 first B. 23 and p. 103 B. 74 on the possibility of a later date.

P. 30 *still unfinished*, p. 266 B. 100.

P. 30 *certain Florentine lady*, p. 24 B. 33 and p. 157 first B. 23.

P. 34 *boldly defended*, p. 111 B. 11.

CHAPTER IV. A CERTAIN LADY (PAGES 39–53)

P. 39 *For Francesco*, p. 266 B. 100.

P. 41 *une courtizene*, p. 136 B. 74 and p. 194 B. 9.

P. 43: on Costanza and Irpino, see B. 27 and B. 101.

P. 45 *a Neapolitan*, p. 107 B. 72.

P. 46 *Gualanda*, p. 137 B. 74.

P. 50 *Giorgione*, p. 274 B. 100.

P. 51 *unspecific requests*, p. 44 seconds B. 91.

P. 51 *for two days*, p. 266 B. 100.

P. 52 *oh musician*, p. 34 B. 85 vol. I.

P. 52 *The marble dust*, p. 83 first B. 23.

P. 52 *If you despise*, S. 652 B. 85.

CHAPTER V. DIVINITIES, KNOTS, AND UNICORNS (PAGES 55–67)

P. 57 *a lady saint*, p. 134 B. 74.

P. 58 *smiling Pomona*, p. 135 B. 74.

P. 60 *molti disegni*, S. 680 B. 85.

P. 62 *He also spent*, p. 257 B. 100.

P. 63 *The unicorn*, S. 1232 B. 85.

CHAPTER VI. CONCERNING EXPRESSION (PAGES 69–88)

P. 70 *take for its head*, S. 585 B. 85.

P. 70 *To the back*, p. 269 B. 100.

P. 71 *the good painter*, p. 34 B. 15.

P. 71 *a figure is not*, p. 10 B. 35.

P. 71 *deaf and dumb*, p. 59 B. 85 vol. I.

P. 72 *It once happened*, p. 59 B. 85 vol. I.

P. 74 *Women must*, S. 583 B. 85.

P. 74 *Always make*, p. 162 second B. 21.

P. 75 *I recently saw*, p. 78 first B. 23.

P. 76 *Decor puellarum*, p. 70 B. 7.

P. 78 *il vago Desider*, p. 85 B. 11.

P. 79 *in his youth*, p. 256 B. 100.

P. 80 *Close from time*, p. 21 B. 33.

P. 83 *soft and womanish*, p. 39 B. 20.

P. 84 *statue of Venus*, cited and discussed on p. 211 B. 103.

P. 88 *Look about you*, S. 587 B. 85.

CHAPTER VII. BEYOND THE LOGGIA (PAGES 89–104)

P. 89 *throwing a sponge*, p. 85 B. 85 vol. I.

P. 89 *the description*, p. 59 B. 85 vol. I.

P. 90 *If the painter*, p. 343 B. 40.

P. 96 *By the ancients*, S. 929 B. 85.

P. 96 *O time, swift*, S. 1217 B. 85.

P. 97 *O time, consumer*, S. 1163 B. 85.

P. 97 *O marvelous*, S. 22 B. 85.

P. 98 *the fertile*, S. 1218 B. 85.

P. 100 *All round*, S. 608 B. 85.

P. 101 *striking in eddying*, S. 609 B. 85.

P. 102 *a mountain*, S. 610 B. 85.

P. 103 *he was convinced*, p. 257 B. 100.

CHAPTER VIII. CONCERNING TECHNIQUE (PAGES 105–123)

P. 105 *Let no man*, S. 3 B. 85.

P. 105 *Experience*, p. 34 B. 85 vol. I.

P. 106 *a rein*, S. 40 B. 85.

P. 106 *a rational*, S. 50 B. 85.

P. 107 *Among all*, p. 50 B. 15.

P. 107 *in an atmosphere*, S. 295 B. 85.

P. 107 *Take care*, S. 297 B. 85.

P. 109 *when you look*, S. 508 B. 85.

P. 111 *compels the mind*, p. 119 B. 7.

P. 111 *all our knowledge*, S. 1147 B. 85.

P. 111 *whatever is painted*, p. 34 B. 85 vol. I.

P. 112 *Many a time*, p. 90 first B. 23.

P. 114 *if one wanted*, p. 266 B. 100.

P. 115 *a certain race*, S. 501 B. 85.

P. 116 *Above all*, S. 551 B. 85.

P. 116 *selecting the light*, S. 520 B. 85.

P. 117 *the first thing*, S. 17 B. 85.

P. 118 *clay models*, p. 256 B. 100.

P. 118 *And if you should*, S. 796 B. 85.

P. 118 *The boundaries*, S. 49 B. 85.

CHAPTER IX. AN INTERPRETATION (PAGES 125–138)

P. 127 *so gentle*, S. 844n. B. 85.

P. 127 *great pleasure*, p. 257 B. 100.

P. 127 *you, O Man*, S. 1140 B. 85.

P. 128 *Now you see*, S. 1162 B. 85.

P. 133 *Anaxagoras*, S. 1473 B. 85.

P. 134 *Observe the motion*, p. 155 B. 78.

P. 136 *did not adhere*, p. 25 B. 74.

P. 136 *nature is full*, S. 1151 B. 85.

CHAPTER X. THE COURTESAN (PAGES 139–151)

P. 146 *that art can*, p. 209 B. 16.

P. 146 *life-size portrait*, p. 145 second B. 23.

P. 147 *he did believe*, p. 156 first B. 23.

CHAPTER XI. FROM PALACE TO MUSEUM (PAGES 153–161)

P. 153 *to restore those*, p. 18 first B. 8.

P. 155 *by the entreaties*, see E. Muntz, *Léonard de Vinci*, Paris 1899, p. 421.

P. 156 *first in esteem*, p. 213 B. 16.

P. 156 *virtuous Italian lady*, p. 18 B. 26.

P. 156 *the light*, p. 10 B. 72.

P. 158 *Truly*, p. 267 B. 32 vol. I.

P. 159 *Il a fait Lise*, p. 149 of *Versailles immortalisé*, vol. II.

P. 160 *the most valuable*, p. 34 first B. 8.

CHAPTER XII. FEMME FATALE (PAGES 163–182)

P. 166 *handsome brow*, p. 125 second B. 48.

P. 167 *Sade*, p. 33 of *Réalités*, April 1974.

P. 168 *She gazed*, p. 293 B. 81.

P. 168 *beautiful sphinx*, p. 51 of *Elle et lui*, Paris 1937.

P. 168 *courtesans*, Goncourts' *Journal* for March 11, 1860.

P. 168 *Taine*, p. 216 B. 16.

P. 169 *Dollfus*, p. 335 second B. 48.

P. 169 *Clément*, p. 221 B. 24.

P. 169 *Michelet*, p. 89 of *Histoire de France*, vol. IX, Paris 1879.

P. 170 *Houssaye*, p. 334 second B. 48.

P. 171 *cousin Heine*, letter by Sand, Oct. 18, 1835.

P. 171 *she is beautiful*, p. 251 B. 43.

P. 171 *shall never forget*, p. 248 B. 43.

P. 172 *a pure masterpiece*, p. 10 first B. 48 vol. II.

P. 172 *cut-rate*, p. 254 B. 81.

P. 172 *The faces*, p. 24 B. 38.

P. 174 *La Gioconda is*, p. 121 B. 73.

P. 175 *fair strange faces*, p. 67 B. 37.

P. 175 *Dürer's Melancholia*, p. 91 B. 92.

P. 180 *Rocky formations*, p. 90 of Lin Yutang, *The Chinese Theory of Art*, London 1969.

P. 180 *Mallarmé*, p. 987 of *Oeuvres complètes*, Pléiade 1945.

P. 180 *d'Annunzio*, p. 52 B. 81.

P. 180 *Péladan*, p. 254 B. 81.

P. 180 *Hofmannsthal*, p. 294 B. 81.

P. 181 *Conti*, p. 261 B. 81.
P. 181 *Field*, p. 48 of Penguin *Poetry of the 'Nineties*, 1970.
P. 181 *Dowden*, p. 294 B. 81.
P. 181 *two mirrors*, p. 510 B. 66.

CHAPTER XIII. CONCERNING PHANTASMS (PAGES 183–195)

P. 184 *psychoanalytic novel*, p. 134 B. 36.
P. 186 *He once happened*, p. 90 B. 36.
P. 186 *A tail*, p. 85 B. 36.
P. 187 *not by the side*, p. 91 B. 36.
P. 187 *In words which*, p. 107 B. 36.
P. 187 *It may very well*, p. 110 B. 36.
P. 188 *Thus we learn*, p. 111 B. 36.
P. 188 *So, like all*, p. 117 B. 36.
P. 189 *Pfister*, p. 115, B. 36.
P. 189 *The key*, p. 150 B. 88.
P. 189 *nibbio*, S. 1363 B. 85.
P. 191 *tail-in-the-mouth detail*, p. 152 B. 88.
P. 192 *Pigeons*, S. 1224 B. 85.
P. 192 *the kite*, S. 1221 B. 85.
P. 192 *the beaver*, S. 1222 B. 85.
P. 192 *One of them*, p. 144 B. 74.
P. 194 *projection of the anima*, p. 185 B. 52.
P. 194 *The scientist*, p. 248 of A. Ehrenzweig, *The Hidden Order of Art*, London 1970.

CHAPTER XIV. JOURNEY TO ITALY (PAGES 197–215)

There are conflicting versions of some of the details of the disappearance and recovery of the painting, and the Apollinaire-Piéret episode is particularly hard to get straight. The account given here is derived largely from B. 64, with additions and corrections from other sources.
P. 202 *Pieret*, p. 24 B. 12 and p. 80 B. 76.
P. 203 *I had already*, see *Paris-Journal*, Aug. 29, 1911.

P. 204 *the chief*, see *Paris-Journal*, Sept. 13, 1911.

P. 204 *Avant d'entrer*, p. 83 B. 76.

P. 205 *German film*, see *Der Kinematograph*, Düsseldorf, Nov. 13, 1912.

P. 206 *Sizeranne*, p. 117 of *Revue des Deux Mondes*, Nov. 1, 1912.

P. 209 *After taking out*, see p. 332 of *Historia*, No. 65.

P. 215 *British "accomplice,"* p. 364 B. 51.

P. 215 *d'Annunzio*, see *Tribune de Genève*, Feb. 10, 1947.

CHAPTER XV. GIOCONDOCLASTS AND GIOCONDOPHILES (PAGES 217–237)

P. 217 *Friesz*, in *Gil Blas*, Jan. 1, 1914.

P. 218 *Souffici*, p. 223 B. 16.

P. 219 *What I really*, p. 3 second B. 10.

P. 220: Duchamp's corrected ready-made was published in the Dadaist review *391* in March, 1920.

P. 221 *Perhaps the visitors*, p. 217 B. 29.

P. 222 *I do not think*, p. 54 second B. 49.

P. 222 *The Italian*, p. 58 B. 56.

P. 225 *I had walked*, p. 21 B. 84.

P. 225 *He painted*, p. 350 B. 96.

P. 226 *submarine goddess*, p. 110 first B. 23.

P. 227 *He opened*, p. 33 B. 56.

P. 227 *German soldiers*, p. vii B. 33.

CHAPTER XVI. ANOTHER QUESTION (PAGES 239–242)

P. 241 *Malraux*, see *Le Monde*, Jan. 10, 1963.

INDEX

Page references are in normal type,
illustration numbers in boldface.

LT 60935 -
A Albion Book Sale.
£3.25